Teach Yourself
VISUALLY™
Digital Video, 2nd Edition

Visual

by Lonzell Watson

WILEY

Wiley Publishing, Inc.

i/10
wiley

Teach Yourself VISUALLY™ Digital Video, 2nd Edition

775
WATSON, L

Published by
Wiley Publishing, Inc.
10475 Crosspoint Boulevard
Indianapolis, IN 46256
www.wiley.com

3 1257 01893 8562

Published simultaneously in Canada

Library of Congress Control Number: 2009940284

ISBN: 978-0-470-57097-5

Manufactured in the United States of America

10 9 8 7 6 5 4 3 2 1

Trademark Acknowledgments

Contact Us

For general information on our other products and services please contact our Customer Care Department within the U.S. at 877-762-2974, outside the U.S. at 317-572-3993 or fax 317-572-4002.

For technical support please visit www.wiley.com/techsupport.

WILEY
Wiley Publishing, Inc.

Sales
Contact Wiley
at (877) 762-2974 or
fax (317) 572-4002.

Praise for Visual Books

"Like a lot of other people, I understand things best when I see them visually. Your books really make learning easy and life more fun."

John T. Frey (Cadillac, MI)

"I have quite a few of your Visual books and have been very pleased with all of them. I love the way the lessons are presented!"

Mary Jane Newman (Yorba Linda, CA)

"I just purchased my third Visual book (my first two are dog-eared now!), and, once again, your product has surpassed my expectations.

Tracey Moore (Memphis, TN)

"I am an avid fan of your Visual books. If I need to learn anything, I just buy one of your books and learn the topic in no time. Wonders! I have even trained my friends to give me Visual books as gifts."

Illona Bergstrom (Aventura, FL)

"Thank you for making it so clear. I appreciate it. I will buy many more Visual books."

J.P. Sangdong (North York, Ontario, Canada)

"I have several books from the Visual series and have always found them to be valuable resources."

Stephen P. Miller (Ballston Spa, NY)

"Thank you for the wonderful books you produce. It wasn't until I was an adult that I discovered how I learn – visually. Nothing compares to Visual books. I love the simple layout. I can just grab a book and use it at my computer, lesson by lesson. And I understand the material! You really know the way I think and learn. Thanks so much!"

Stacey Han (Avondale, AZ)

"I absolutely admire your company's work. Your books are terrific. The format is perfect, especially for visual learners like me. Keep them coming!"

Frederick A. Taylor, Jr. (New Port Richey, FL)

"I have several of your Visual books and they are the best I have ever used."

Stanley Clark (Crawfordville, FL)

"I bought my first Teach Yourself VISUALLY book last month. Wow. Now I want to learn everything in this easy format!"

Tom Vial (New York, NY)

"Thank you, thank you, thank you...for making it so easy for me to break into this high-tech world. I now own four of your books. I recommend them to anyone who is a beginner like myself."

Gay O'Donnell (Calgary, Alberta, Canada)

"I write to extend my thanks and appreciation for your books. They are clear, easy to follow, and straight to the point. Keep up the good work! I bought several of your books and they are just right! No regrets! I will always buy your books because they are the best."

Seward Kollie (Dakar, Senegal)

"Compliments to the chef!! Your books are extraordinary! Or, simply put, extra-ordinary, meaning way above the rest! THANK YOU THANK YOU THANK YOU! I buy them for friends, family, and colleagues."

Christine J. Manfrin (Castle Rock, CO)

"What fantastic teaching books you have produced! Congratulations to you and your staff. You deserve the Nobel Prize in Education in the Software category. Thanks for helping me understand computers."

Bruno Tonon (Melbourne, Australia)

"Over time, I have bought a number of your 'Read Less - Learn More' books. For me, they are THE way to learn anything easily. I learn easiest using your method of teaching."

José A. Mazón (Cuba, NY)

"I am an avid purchaser and reader of the Visual series, and they are the greatest computer books I've seen. The Visual books are perfect for people like myself who enjoy the computer, but want to know how to use it more efficiently. Your books have definitely given me a greater understanding of my computer, and have taught me to use it more effectively. Thank you very much for the hard work, effort, and dedication that you put into this series."

Alex Diaz (Las Vegas, NV)

Credits

Acquisitions Editor
Aaron Black

Project Editor
Sarah Cisco

Technical Editor
Michael Guncheon

Copy Editor
Scott Tullis

Editorial Director
Robyn Siesky

Editorial Manager
Cricket Krengel

Business Manager
Amy Knies

Senior Marketing Manager
Sandy Smith

Vice President and Executive Group Publisher
Richard Swadley

Vice President and Executive Publisher
Barry Pruett

Project Coordinator
Katie Crocker

Graphics and Production Specialists
Andrea Hornberger
Jennifer Mayberry

Quality Control Technician
Susan Moritz

Proofreading
ConText Editorial Services, Inc.

Indexing
Potomac Indexing, LLC

Screen Artists
Ana Carrillo
Ronald Terry

Illustrators
Ronda David-Burroughs
Cheryl Grubbs
Mark Pinto

About the Author

Lonzell Watson is an Apple Certified Final Cut Pro Professional and Certified Avid Xpress Pro user. He is the author of *Final Cut Pro 6 for Digital Video Editors Only* and the *Canon VIXIA Digital Field Guide,* both from Wiley Publishing. He is also the author of *Final Cut Express 4 Essential Training* for Lynda.com. Lonzell began his career as a videographer and digital video specialist for the Web. He then used this experience to become a writer, director, and producer. His work includes national commercials and television programs for PBS, Fox Sports, the Outdoor Channel, and C-SPAN, and video editing for pop superstar Mariah Carey. As well as being an experienced adventure race, wildlife, and news videographer, Lonzell's talents have also served him well as a syndicated writer with hundreds of published tutorials and tips that relate to film and video production. He now writes for Studio Monthly, and his syndicated content is read by thousands of unique visitors each month.

Author's Acknowledgments

Special thanks to Jody Lefevere and Aaron Black, without whom this project would not have been possible, and thanks to the project editors who have made this book a truly creative and wonderful way to learn Digital Video. I would also like to thank the graphics department for their outstanding work articulating complex concepts through amazing visual works of art. You guys are absolutely amazing. I would also like to thank technical editor Michael Guncheon for working with me again, overseeing the accuracy of the exercises in this book as well as the terminology.

Special thanks go to Laura Clor, my lovely wife, Robyn, Shannon Johnson, Lisa Waters, Danya and Sean Platt, and Rian Harnig for their assistance as I wrote this book.

Table of Contents

chapter 1 Understanding Digital Video

chapter 2 What You Need to Get Started

chapter 3 Preparing to Shoot Video

chapter 4 Recording Great Audio

Table of Contents

chapter **5** Controlling Exposure and Focus

chapter **6** Exploring the Color of Light and Lighting

chapter 7 Basic Principles and Event Videography

chapter 8 Shooting Great Footage Through Composition

Table of Contents

chapter **10** Editing Video and the Postproduction Process

Table of Contents

chapter 12

Sharing Your Video with the World

Understanding Digital Video

Are you ready to learn more about how digital video works? This chapter introduces you to the concept of digital video, the benefits of going digital, the different types of digital video cameras, the digital video workflow, and essential digital video terms.

What Is Digital Video?

Digital video is a relatively inexpensive, high-quality video format that utilizes a digital video signal rather than an analog video signal. Consumers and professionals use digital video to create video for the Web and mobile devices, and even to create feature-length movies.

Analog versus Digital Video

Analog video is variable data represented as electronic pulses. In digital video, the data is broken down into a binary format as a series of ones and zeros. A major weakness of analog recordings is that every time analog video is copied from tape to tape, some of the data is lost and the image is degraded, which is referred to as generation loss. Digital video is less susceptible to deterioration when copied. You can convert analog video to digital video with the proper hardware and software configurations, but you cannot increase the quality of the analog signal.

Recording Media versus Format

The recording medium is essentially the physical device on which the digital video is recorded, like a tape or solid-state medium (a medium without moving parts, such as flash memory). The format refers to the way in which video and audio data is coded and organized on the media. Three popular examples of digital video formats are DV (Digital Video), HDV (High Definition Video), and AVCHD (Advanced Video Codec High Definition).

Acquiring Digital Video

Digital video can be acquired from a range of sources, including cell phones, some digital still cameras, as well as digital video cameras. Digital video can be recorded to a tape, DVD, flash memory card, or hard disk drive. Some digital video cameras offer more than one of these methods of acquisition. If you buy a video camera today, it will most likely be a digital video camera.

Using Digital Video Technology

You can attach your digital video camera, mobile device, or digital still camera with video capability to a TV set for previewing or to a computer. After you transfer the video from the device to a computer, you can edit your video, add graphics, and add music to make your own video production. You can then take your video work of art and create your own DVD, or upload it to popular video sites such as YouTube, MySpace, and Vimeo to share with the world.

Understanding the Benefits of Going Digital

Digital video provides you so much more than just the ability to capture great footage; it provides you with the flexibility to share those moments with others. You can create sleek video presentations of your footage with video editing programs, and then make DVDs of the footage and send copies to family and friends. You can even create your own Web page showcasing your videos.

Maintain Picture Quality When Copying

When you view a copy of a copy of a wedding, shot over 10 years ago in analog format, image deterioration is noticeable. Digital video data is broken down into defined, individual bits of data, a binary format as a series of ones and zeros. Because of this, it is not susceptible to what is referred to as generational loss, as experienced with analog video when copied.

Take Advantage of Video-Editing Software

Digital video can be transferred from your video camera to a computer to take advantage of powerful video-editing applications. Programs such as Apple iMovie and Adobe Premiere Elements give you the ability to manipulate video footage, add effects and music, and even create titles. Many video editing programs also provide various means for sharing your video with others.

Digitize to Restore, Enhance, and Preserve Old Video

You can digitize old videos of weddings, birthday parties, and special moments that were captured with non-digital cameras. Converting your old VHS tapes to digital form stops the deterioration process caused by heat and humidity due to improper storage of videotapes. You can use a video editing application with color correction tools to help enhance the colors and minimize some of the effects of aged video. Your captured digital files can then be organized and archived on hard drives, DVDs, and CDs.

Distribution Options

Your digital video files can be edited within a video editing program and made into a high-quality DVD to be shared with friends and family. Many video editing programs come already bundled with software that enables you to create DVDs and share your video on popular Internet sites such as YouTube. Programs such as Apple iMovie and Adobe Premiere Elements have special export options for getting your video onto mobile devices such as video-capable iPods.

Discover Digital Video Cameras

When you understand how a digital video camera works, you are able to make more informed decisions when it comes to investing in a camera. Understanding how a camcorder works also helps you to take higher-quality video footage.

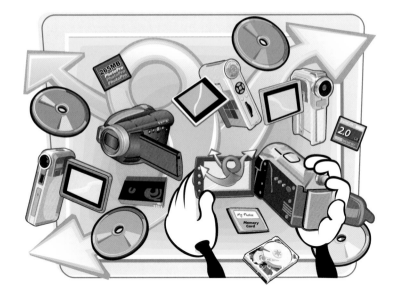

How Digital Video Cameras Record Pictures

Digital video cameras translate the analog information received through the lens into bytes of data. Light from the image you are shooting enters the camera lens and is focused onto an image sensor located behind it. Some higher-end cameras utilize multiple sensors for a higher-quality image. The surface of the sensor(s) is covered with millions of light-sensitive pixels, the building blocks of all digital images. The moving image data, including colors, is then converted into a stream of zeros and ones, and then stored as digital video.

Types of Image Sensors

The majority of digital video cameras on the market use one of two types of image sensors: a charged-coupled device (CCD), or a complementary metal-oxide semiconductor (CMOS). You are likely to find less-expensive consumer cameras using a CMOS sensor or a single CCD. The more-expensive, higher-end cameras utilize three CCDs. Although there are some differences between CCD and CMOS technology, they both are capable of creating high-quality images.

Resolution and Image Quality

The quality of the image that a video camera can produce is largely dependent upon the resolution, which is a measure of pixel density. By and large, the greater the number of pixels on an image sensor, the cleaner and crisper the image. The physical size of the CCD also plays a role in picture quality. Many entry-level high-definition camcorders have a resolution between 3.3 and 5 megapixels, which is 3.3 million or 5 million pixels.

The Digital Video Workflow

There are a series of steps you need to follow, known as a workflow, in order to take a video production from concept to finish and share your work with others. Understanding the digital video workflow enables you to better execute a plan in the field to achieve the highest-quality video possible.

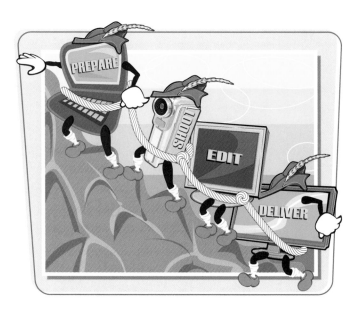

Prepare to Shoot Great Video

How well you prepare for the shoot can be as important as the shoot itself. You should carefully consider what you may need before you leave for the event. Know how long you will be shooting, and make sure that you charge your batteries the day before you go. Create an equipment list, as well as a possible list of shots you want to get during the shoot. Will you require a tripod, or will you be shooting in close quarters with minimum space? Print your checklist and mark each item off as you place it into your camera bag.

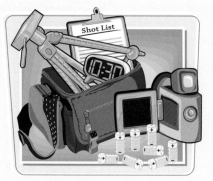

Shoot the Video

The acquisition of the video footage can be quite an adventure. When you hit the record button on your video camera, the lens becomes your eyes and it is your job to find the story. Make your shot selection deliberate and purposeful, and always make sure you are safe. By recording from a variety of interesting angles and clearly identifying a main subject, you will have plenty of footage, thus setting yourself up for success in the editing room.

Edit the Video

The editing process is where you bring the story together by putting the video clips into sequence and fine-tuning the relationship between clips. During the editing process, you can add titles to the project, record narration, add music, add still photographs, balance colors, adjust audio levels, and even add special effects.

Deliver the Video

After your project is complete, it is time to share it with the rest of the world. There are many avenues available to you for getting your video seen, such as DVD authoring, video sharing sites, and mobile devices. Consider purchasing a video editing program that includes delivery options such as these as part of the program. You can also create your own Web site to showcase your movies and maintain your own video blog.

Essential Digital Video Terms

Learning common digital video terms enables you to make better decisions about what video camera to purchase and helps you to understand the digital video process.

Master the Megapixel

Digital video resolution is measured in megapixels. *Pixels* are collections of tiny dots that comprise a digital video image. One megapixel is equal to 1 million pixels; therefore, 5 megapixels equals 5 million pixels. A high density of pixels in a picture results in a larger, crisper, sharper image. A low density of pixels results in a lower-quality image. A good rule of thumb is that the higher the megapixel count of the camera, the higher quality the image it can produce.

Aspect Ratio

The *aspect ratio* is the width of an image to its height on a viewing screen. Standard-definition video has an aspect ratio of 4:3, and the aspect ratio for high definition is 16:9. The standard-definition 4:3 aspect ratio is the most common and has been seen on television for years. The 16:9 aspect ratio, often referred to as widescreen, is usually associated with cinematic viewing, but with the rise in HD programming and HDTVs, it is becoming increasingly popular. Many of today's digital camcorders can record in both the 4:3 and 16:9 aspect ratios.

Interlaced versus Progressive Scan Video

The video that you see on television is usually drawn as a series of horizontal lines that comprise the entire image on screen during a scanning process. *Interlaced video,* which is often signified with an (i), such as 60i, is drawn in two passes, with every other line drawn on each consecutive pass to create the picture that you see. *Progressive scan video,* which is often signified with a (p), such as in 24p, is referred to as *non-interlaced video,* and all resolution lines are drawn in one pass. Most consumer camcorders record interlaced video, and many cameras offer progressive recording modes.

FireWire and USB Connections

Nearly all Mac and PC computers come equipped with a FireWire (IEE-1394) and USB port. The IEE-1394 connection is called FireWire by Apple and i-LINK by Sony. Depending on which digital camera you purchase, a FireWire or USB connection is used to connect the camcorder to the computer to transfer digital video, audio, and timecode, which is a system for identifying individual video frames with units of time. FireWire 800 and USB2 Hi-Speed boast faster speeds than their previous versions.

The HDMI Interface

Connections made with the High Definition Multimedia Interface (HDMI) terminal give you the highest-quality playback, transporting high definition video and audio through a single connection. This connection can be made only with a high definition camcorder and an HDTV. HDMI cables are somewhat expensive, and are usually not shipped with high definition camcorders or HDTVs.

What You Need to Get Started

Creating your own video productions is a very exciting venture. If you are new to digital video, feeling a little overwhelmed in the beginning is natural. Understanding the nuts and bolts of what it takes for you to record, edit, and deliver high-quality digital video is essential to your success. In this chapter you learn what features to look for when buying a video camera, as well as what accessories help you get the most out of your camera. Editing and distributing digital video takes formidable computing power, so you also learn what to look for when purchasing a computer for digital video work, and how to upgrade the computer you may already have.

Explore Popular Digital Video Camera Features

Besides your personal budget, features and performance are the two most important factors in deciding which digital video camera to buy. Features are the selling points of the camera, such as how many megapixels it has, or if it boasts cinema mode for added control over the image. To gauge the performance of a camera requires trying out the camera and reviewing footage before buying. Looking for some of the following camera features can help you identify a solid camcorder.

Evaluate High Definition and Standard Definition

Although quite a few standard definition video cameras are still being sold, the industry is definitely trending toward high definition. High definition (HD) is the latest technology in the digital video field, offering more vibrant colors and clearer picture quality than standard definition. High definition camcorders record images at a resolution of 1080 interlaced pixels or 720 progressive pixels from top to bottom of the picture. One thing to consider is that when viewing on a television set, you do not get the full effect of HD recording if you do not have an HDTV. With that being said, the video quality is still impressive.

Explore Sensors and Megapixels

Higher-end, more expensive cameras utilize multiple sensors for a higher quality image. If your plan is to do professional-level work, a camera that utilizes three image sensors is the way to go. Most consumer cameras use CMOS sensors. Although the CMOS and CCD technologies have differences, they are both capable of high quality video. The number of pixels located on the surface of the sensor also influences the quality of the video captured, as well as the size of the sensor. The greater the number of pixels on an image sensor generally means the cleaner and crisper the image. The size of the chip is usually measured in fractions of an inch. In the arena of one-chip cameras, you can arguably achieve a better quality image with a camera that has a physically larger image sensor and fewer pixels than a camera with a physically smaller sensor and more pixels. The actual size of the pixels themselves also play a role in picture quality, so more pixels does not always mean a better camera.

Examine Record Media

Digital video cameras offer several media on which to record, each with benefits and shortcomings. Some cameras use solid-state storage (no moving parts), such as internal flash memory or memory cards. HDD (Hard Disk Drive) video cameras utilize internal drives ranging from 40 to 120 gigabytes of space. The advantage of these cameras is that you do not have to bother with tape, which is especially beneficial when you are ready to import video footage into your computer. Cameras that use actual hard drives tend to be more fragile, and some memory-card-based cameras offer less recoding time than conventional tape.

Automatic and Manual Settings

Just about all digital video cameras on the market have automatic settings with the exposure, focus, and audioare controlled completely by the camcorder. Automatic settings work well in general shooting situations, but for more professional video, you need the option of manual control over these settings to control the look of your video. In less-than-perfect shooting environments, automatic settings can become confused and can yield less-than-desirable results. Choose a camera that provides you both automatic and manual control.

Cinema Features

Some video cameras enable you to give your video a cinematic look by adjusting color and tonal characteristics, so it appears similar to film. This feature is often offered with a 24-frame-per-second progressive frame rate (24p), providing filmlike motion characteristics to further enhance the cinematic look of your video. This is a great feature if you are an independent filmmaker who wants to capture the aesthetic of film for your work.

Explore Consumer High Definition Video

High definition video comes in a variety of flavors. The fundamental difference between the formats is the compression method, or how the images are stored on the record media. Becoming familiar with popular high definition video formats can aid you in choosing the best camera for your needs.

High Definition (HD) Specification

The important thing to note about HD video is that manufacturers and software developers universally recognize it as a specific technical specification, most noticeably in the areas of frame size and image dimensions. Standard definition (SD) images have fixed dimensions of 720×480 pixels for NTSC and 720×586 pixels for PAL. NTSC, National Television System(s) Committee, and PAL, Phase Alternating Line, are the two standard analog television encoding systems used in broadcast television. NTSC is used in North America and Japan, and PAL is used nearly everywhere else in the world. High definition video displays resolutions of 1280×720 pixels and a larger 1920×1080 pixels. These two HD specifications are often referred to as 720p or 1080i, the *p* and *i* standing for progressive and interlaced scanning.

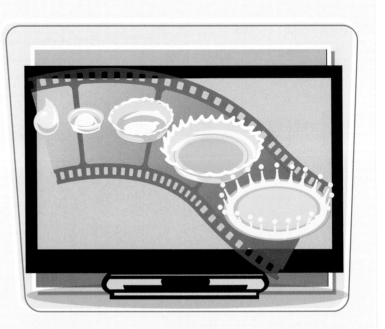

Get To Know HDV

The HDV (High Definition Video) format brought high definition video to inexpensive cameras and is still one of the most popular high definition camera formats on the market. HDV stores 16:9 high definition video supporting resolutions of 1280×720 and 1920×1080 while recording to the same Mini-DV tapes used for standard definition. Not all HDV cameras record in both the 1280×720 and 1920×1080 resolutions. This format was developedby JVC and later supported by Sony, Sharp, and Canon as an HDV consortium.

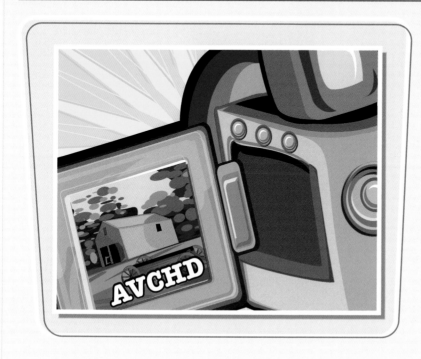

Discover AVCHD

AVCHD (Advanced Video Codec High Definition) is quickly becoming the most popular consumer HD video format on the market. This format offers a variety of resolutions including 1080p (progressive), 1080i (interlaced), and 720p. Cameras that record in the AVCHD format can also record to a number of media such as flash memory, memory cards, hard disk drives (HDDs), and DVDs. Quality between consumer HDV and AVCHD cameras remains debatable, but increases in technology, specifically bit rate, and variety in record media have placed AVCHD at the head of the game.

Explore Aspect Ratios

Aspect ratio describes the ratio of the width of an image to its height on a viewing screen. Learning about aspect ratios helps you understand how the video that you shoot is displayed.

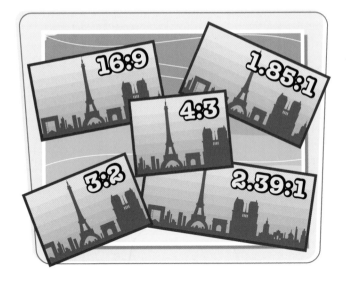

Video Dimensions

Width and height are very important visual characteristics used when discussing video. The width and height of digital video is measured in pixels, which is also referred to as its dimensions. For faster playback, a video played over the Internet may have rather small dimensions such as 320×240, meaning that the video is 320 pixels wide and 240 pixels high. A video downloaded and then played on the desktop may have larger dimensions, such as 640×480. Consumer DV cameras can produce 720×480 images, and high definition video can have dimensions as high as 1920×1080.

Understand Standard 4×3

4×3, sometimes shown with a semicolon as 4:3, is an aspect ratio used for traditional televisions or SDTVs (Standard Definition Televisions) and is the aspect ratio of standard definition video. In a nutshell, aspect ratios depict the fractional relation between a video's width and its height. So, a 320×240 video and a 720×480 video can both be considered 4×3 video.

Widescreen 16×9

16×9, sometimes shown with a semicolon as 16:9, is an aspect ratio used for modern HDTV (High Definition Television) and is the aspect ratio of high definition video. With its wider horizontal viewing area, the widescreen image is more comparable to how the human eye views the world than the standard image. 1280×720 and 1920×1080 high definition video are both in the 16×9 aspect ratio. Some high definition cameras have the ability to shoot in 4×3 and 16×9. Some standard definition camcorders have the ability to manipulate a standard image into a widescreen format.

Choose the Right Digital Video Camera

It can be overwhelming to walk into an electronics store and wade through all of the camera options available. Before you put your hard-earned money into a camera, you need to know exactly what you are looking for. You need to define your intentions for the camera, read reviews, choose the features that help you achieve your goal, and perhaps most importantly, determine a budget.

Determine Your Budget

Price is probably the single most influential factor in deciding which digital video camera to purchase. If you are looking to spend around $300 or less, you are most likely going to end up with a consumer standard definition camera or an ultra compact HD camera. If your budget is a little more flexible and you can pay about $600, you slowly enter the more versatile higher-end cosumer cameras.

Define Your Intentions

What are you planning to shoot with your camera? Will it be strictly used for home and vacation moviemaking, or are planning to start your own video service where you build a clientele of paying customers? If only friends and family will see your videos, a less expensive entry-level camera may suffice. If you are looking to get paid for your work, the advanced features of a prosumer camera may help you edge out the competition by offering a superior product. Ask these tough questions to help you gauge how much camera you need and determine which features are essential to your goal plan.

Read Reviews

Reading reviews and viewing sample videos on the Internet are good ways to help you gauge the performance of a camera. Many sites such as camcorderinfo.com and cnet.com post reviews for new camcorders and provide forums for discussion. Pose questions to owners of the camera you are looking at and make them aware of your intentions. There is a good chance that you can find another user who has "been there, done that" and can steer you in the right direction.

Choose a Recording Medium

For some camera owners, the recording medium of the camera is the deciding factor as to which camera they purchase, especially if they have had bad past experiences with another. Perhaps you prefer a camera that records to a hard disk drive because you want to free yourself from tape, and like that it offers larger storage capacity than cameras that record to memory cards. Maybe you do not trust hard drives because they have failed you in the past, and so you go the solid-state route.

continued

Getting the right camera for the job is crucial when investing in a digital video camera. Take into consideration the camera's image sensor or sensors for achieving the picture quality you desire. For the maximum amount of control over your recordings, choose a camera that provides manual adjustment options for exposure, white balance, shutter speed, as well as audio recording levels. Try out the camera before you make a purchase and always buy from a reputable dealer.

Evaluate Image Sensors and Megapixels

A camera that utilizes multiple image sensors can yield more professional results in the realm of picture quality, but it is more expensive than its single chip counterparts. Most of the consumer cameras under $1,000 utilize a single CMOS chip. The number of pixels on an image sensor and the size of the pixels also affect the image in terms of resolution. In general, a higher pixel count can yield a higher quality image. Expect to pay more for cameras with higher pixel counts.

Determine Sound Needs

The more expensive prosumer cameras possess professional audio inputs known as XLR inputs. XLR inputs enable you to connect to professional microphones and pro audio equipment for the best audio. If your plan is to shoot events for money, most of the sound equipment used at events use professional XLR connectors, so you may want to consider a higher-end camera. There are also XLR adapters you can connect to cameras that use a simple mini jack, but if your camera is very compact, the adapter can prove very bulky for handheld shots.

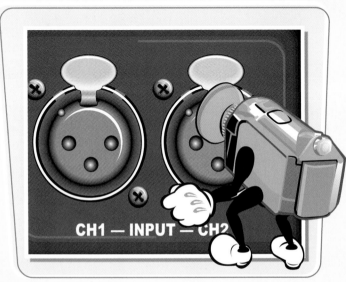

Evaluate Manual Settings

The more the camera lets you manually adjust settings such as exposure, white balance, shutter speed, and audio, the more control you have over the image. The more manual control you have over the image, the more flexible you can be to get the best video under changing conditions. The automatic settings perform well and are a great convenience, but no automatic system can get it right every time.

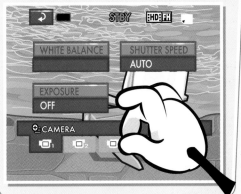

Try It Out

You would not buy a car without driving it first; do not buy a camera without getting some hands-on time. You do not want to buy a camera and discover that your fingers are too large for the buttons, or the menu or button layouts are not intuitive and are frustrating. Even if you have found a good deal online for a camera, go to your local electronics store and get it in your hands first.

Buy Reputable and Shop Around

Always buy from a reputable dealer; this is more of an issue when you are shopping online for a digital video camera. Shop around and look for the best deal, but if you see a dealer with a price hundreds of dollars lower than the competitors, be diligent and do your research. Some sell gray market units from other countries whose warranties will not be honored. Others may charge you extra for accessories that are actually included with the camera.

Know the Parts of a Digital Video Camera

Digital video cameras place plenty of creative power at your fingertips. Manufacturers have designed them for ease of use, some being more successful than others, but before you can tap into that creative power, you must know your way around your camera. Being able to identify some of the major parts of a digital video camera helps you conceptualize many of the future topics discussed in this book.

Lens

Modern camera lenses utilize several optical elements called *lens elements* to cancel out lens aberrations. Lenses also utilize a special coating to minimize lens flares and ghosting. To save money, many of the consumer digital video cameras offer limited optical zoom range supplemented with a digital zoom, which simply magnifies the image to make it appear closer. You can purchase lens converters that can lengthen the camera's optical zoom or provide a wider angle. Check to see if your lens accepts filters, and then take note of the filter size for your lens if you plan on buying them.

Sensor

Digital video cameras also utilize sensors located on their fronts to help them perform an accurate automatic focus. The sensor determines the distance between the camcorder and the subject, and quickly adjusts the lens so that the image is in sharp detail. The automatic focus can quickly shift to a new subject without your intervention.

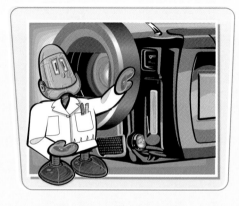

Flash

Many digital video cameras are also digital still cameras, and have a flash located on the front of the unit. Just like a still camera, the flash can help your images by adding extra light when shooting still images in very dim locations. Some also offer a red-eye reduction function and various states for the flash such as auto, on, and off. The flash is only useful for taking still photos.

Stereo Microphone

The microphone is generally located under the lens of the camera. The stereo microphone captures sound as you record your movies without the help of extra sound-recording equipment. Built-in microphones are notorious for picking up plenty of ambient noise in all directions, so you have to keep them at a relatively close distance to the subject for the best audio. Digital video cameras can also allow for higher quality audio accessories to be attached by an audio input.

Mini Video Light

Some video cameras have a built-in video light located on the front of the camera that offers more light in dim shooting conditions. You can turn on the mini video light in dark places to illuminate your subject while shooting video or taking still photos. This light is very concentrated and can be much like shining a flashlight. This light tends to be effective up to about five feet.

continued

The more comfortable you are navigating your video camera, the quicker you can respond to your subject matter while recording in the field. If you take time to practice with your camera before you begin the actual shoot, you set yourself up for a more enjoyable shooting experience.

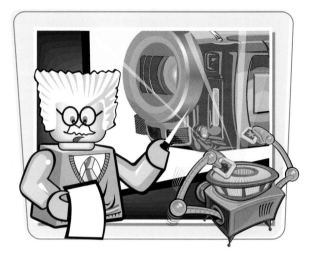

Viewfinder

Depending on the camera, you may not have a viewfinder but only an LCD to peer through the eye of the camera. The viewfinder is the place where you place your eye to the camera so you can compose the scene. If the camcorder does have a viewfinder, you can mostly likely find a dioptric adjustment lever that enables you to adjust the viewfinder for your particular eyesight. If you have a problem focusing on the scene while looking into the viewfinder, you may need to adjust this lever. If you still have problems focusing after you have adjusted the dioptric lever, you may simply not have focused the camera properly.

LCD Screen

Many video cameras are equipped with a widescreen multiangle LCD panel to monitor your images. The LCD screen works much like the viewfinder; it is a window that you look through to compose your scenes. However, the LCD screen is more versatile than the viewfinder. The versatility of movement you can achieve with this screen makes it possible to shoot and view your subject from many different angles. More and more, manufacturers are starting to equip video cameras with LCD panels only, without viewfinders. Some video cameras that possess both a viewfinder and an LCD display also utilize the LCD as a built-in light. You would simply activate the video light and flip the screen toward the subject.

Record Button and Thumb Controls

Digital video cameras are designed with the buttons you use the most conveniently placed at the tip of your fingers, namely the record or start/stop button. When holding your camera as if you were shooting, the record button is operated with the thumb. You can also find a camera mode button in the vicinity of the thumb controls, for cameras that you have to place in various modes of operation such as video and photo.

Zoom Lever

The zoom lever, or rocker, is operated by the pointing finger and is strategically placed on the top of the camera in the vicinity of the pointing finger. Depending on which camera you have, the zoom may be operated by moving the lever from side to side or the rocker from front to back. Some digital video cameras enable you to choose from various zoom speeds, which enable you to perform either very fast or very slow zooms.

Camera Modes

Video cameras offer various setups to access their various operating modes. Some offer a series of buttons, switches, dials, or even touch screens to change the camera between video mode, still image mode, and other playback modes. You may also find that many of the functions offered by a given digital video camera may only be accessible when the camera is in a specific mode.

Consider Digital Video Camera Accessories

Most digital video camcorders are capable of recording amazing images right out of the box, but whether you plan to use it for home videos or independent films, your camera needs to be versatile. Accessories help you adapt to various shooting environments where the bare minimum just will not cut it. This section offers essential accessories as well as some wish list items you will find intriguing for your video camera.

Tripods

The tripod is perhaps the most essential accessory that you can buy for your camcorder. A tall, sturdy, lightweight tripod is what you need for steady shots, smooth pans, and tilts. You get what you pay for, so make sure that you get the best tripod you can afford. Make sure that the tripod you purchase is made for a video camera. Tripods made for still photography might not have the proper handles for panning or tilting, or they may allow for too much movement with no way to lock down vertical movement for smooth pans. A fluid-head tripod offers the smoothest motion. A monopod has a single leg setup and can work well in tight shooting situations where there is not a lot of standing room.

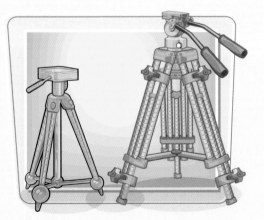

Alternative Camera Stabilizing Devices

If you are recording on the move and require a steady shot, a camera support system may be just what you need. If you Google "stabilizing systems for camcorders," chances are your search results will return a bunch of professional rigs for larger cameras. Some companies do offer devices for smaller, lightweight cameras. These devices offer weighted support and balance that reduce shaking when running or walking while recording. Make sure that you try out these devices before you make a purchase.

Lens Converters

The lens of your camcorder works fine in typical shooting conditions, but there are occasions where you need to get up close to the action, and moving physically closer to the action is not possible. Alternately, you may be shooting in a cramped area and cannot fit the entire subject matter into the shot. If your camera allows, you can screw on a telephoto lens converter or a wide-angle lens converter to get closer to the action or achieve a larger angle of view.

Lens Filters

Lens filters can be quite advantageous for video cameras that can accept them. Lens filters are specifically crafted pieces of glass that attach right to the lens of your camera and manipulate light as it passes through the camera lens. A simple lens kit with a circular polarizing filter, a warming filter, and an ultraviolet filter provides you recording flexibility, creative aesthetics, and lens protection while shooting in various conditions. Keep in mind that whatever effects you achieve with lens filters become a permanent part of your video.

WARMING FILTER

continued

Extra batteries and chargers, extra recording media, and a good camera bag are essential accessories for your digital video camera. Consider lighting accessories for those less than perfect lighting situations so you can record the best video possible.

External Microphones

When the shoot requires better quality audio than is possible using the built-in stereo microphone, you can use external microphone accessories with cameras that have external audio capabilities. Depending on the camera, the Mic terminal or XLR input, as well as the advanced accessory shoe, enables you to attach camera-mounted microphones, handheld microphones, and lavaliere and lapel microphones for the best audio possible.

Lighting Accessories

Some digital video cameras enable you to attach a light source to the hot shoe located on top of the camera. A camera-mounted light can offer you minimal lighting setup for recording in dark environments. For more lighting options, you can add a basic lighting kit that consists of floodlights, stands, and umbrellas for diffusion.

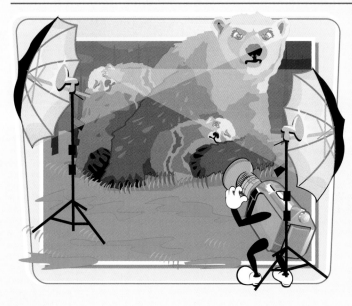

Extra Batteries and Chargers

Extra batteries are an essential part of your camera accessories. It is also good to keep a mixture of different battery capacitates on hand for longer shoots where you do not have access to an electrical outlet. Most batteries are charged while attached to a camera while using an adapter. You can purchase an extra charger so that you can recharge extra batteries while you are using another to shoot.

Extra Recording Media

Make sure that you purchase plenty of extra tapes, DVDs, or memory cards, depending on which type of digital video camera you have. The amount of recording time a memory card offers depends on whether the footage is standard definition or high definition and the capacity of the card. Make sure that you purchase the proper memory card for your camera.

Get a Good Camera Bag

A good bag is essential for protecting your camera. When traveling with your camera, you need space to pack a power cord, batteries, extra tapes, DVDs, memory cards, and other accessories, so make sure it is large enough. Most camera bags have interior dividers fastened to the wall of the case by Velcro, providing compartments for your accessories. Make sure that the bag is weather-resistant and can take a tumble. A good bag is also useful for storing your gear when not in use.

Explore Battery Options and AC Adapters

Batteries are often marketed by how long they last in the field. The more expensive batteries are generally the longer lasting ones, but beware of off-brand batteries because some of them may not perform as well as stated. You can get the most out of your batteries if you know which ones to look for and how to take care of them.

Choose Batteries Carefully

An important thing to keep in mind when buying extra batteries is to always use the recommended batteries and the manufacturer's AC adapter for your camera. Many off-name brands boast higher capacities at cheaper prices, but the truth is that the guts may not be the same. It is not unheard of to buy an off-brand battery that is unable to hold a charge. At the end of the day, you really do get what you pay for.

Explore Battery Life

Be mindful of the weather in which you use your camera and store your batteries. Extreme temperatures, hot or cold, have an effect on the performance of the battery and can even cause damage. Keep the battery in a climate-controlled environment as long as possible, before you begin shooting. Whether you are shooting outdoors in Alaska in the winter or Phoenix in the summer, consider keeping the batteries in your car with the heater or air conditioner running until it is time to shoot.

Proper Battery Care

Do not overcharge your batteries. Make sure that you remove the battery from the camcorder after the indicator says that the battery is full. Overcharging the battery has an adverse effect on its performance. A partial charge puts less strain on the battery than a deep one, so it is also a good idea to fully recharge the battery even if it has not been fully discharged. This ultimately increases the longevity of your batteries. Do not fully charge or discharge your battery if you plan on storing it for a prolonged period. Charge the batteries to about 40 percent and store them in a cool and dry environment to ensure a stable storage condition.

Explore Computer Essentials for Video

Digital video requires a powerful processor, lots of memory, a big hard drive, a FireWire or USB port, or a memory card reader. As you go up the digital video food chain, the hardware requirements become more demanding and more specific. Most Macs are ready for consumer-level digital video. Because the PC arena has a wider range of performance levels, you need to know what you are looking for. By understanding what to look for in a computer, you can assess if your system is ready for digital video.

Macs and Processing Power

Whether you are a Mac or PC person, keep in mind that the more power the better. Each new Mac comes equipped with iMovie installed and is ready for consumer-level video work. A new Intel Mac is compatible with the newer high definition formats (AVCHD). Entry-level MacBook laptops can do basic editing but cannot handle the more professional applications. Basically the more expensive Mac you purchase, the more high-end the system will be.

PCs and Processing Power

Power is supreme and dual processors are great, especially when dealing with higher-end video editing applications. The important thing to keep in mind is that capturing and processing digital video requires more computing power than your standard applications. Go for a 3GHz (gigahertz) processor and do not go below a 1GHz processor.

The Importance of Memory

Next to the processor, memory is one of the most important elements for speed on your computer. A machine with a fast processor can be made sluggish when faced with an insufficient amount of RAM (Random Access Memory). Video editing applications require a lot of RAM, so the more the better. Get a system with at least 2GB of RAM. Anything less that 1GB may not be adequate.

The Importance of Hard Drive Space

Video takes up a lot of space on your hard drive. Five minutes of standard definition video eats up about 1GB of hard drive space. When dealing with high definition video, your hard drive space can disappear fast. If you are planning to do a lot of video editing and burn DVDs, you need a place to store all that video. 200GB should be the absolute minimum, and 400GB of internal hard drive space is much better.

Monitors

The LCD (Liquid Crystal Display) monitors on the market come in two flavors: the standard 4×3 ratio and widescreen 16×9, which is the same format as HDTVs. Widescreen computer monitors are a better choice for video editing, and the higher the resolution the better. Do not go below a 1280×800 resolution. Also, unless you have a 30-inch Apple or Dell monitor, consider using two monitors for more screen real estate.

FireWire and USB Ports

Depending on which camera you have, you need a FireWire (IEEE 1394) or USB port to import video from your camera onto your computer hard drive. With the exception of the MacBook Air, just about any Mac that you purchase has these ports, but you need to make sure that your PC does. If you already have a PC, you may need to install a FireWire card to get it ready for digital video. Keep in mind that Sony also refers to the FireWire connection as an i.LINK.

Check Compatibility and Optimize

Make sure that the video editing software that you purchase is compatible with not only the hardware specifications, but also the operating system. Windows systems use software tools known as *drivers* to operate the various components of a PC. If you update your hardware, operating system, or video applications, but let your drivers become outdated, you may experience a drop in the performance of your PC. In this scenario, outdated drivers can even cause the computer to crash (become unresponsive). Make sure that your video display drivers are always updated.

Most new Macs made in the last three to four years work well with consumer-level digital video. If you are dealing with a Mac that does not have at least a G5 PowerPC processor or more, it may be more practical to buy a new or even refurbished Mac than to upgrade. By upgrading your Mac you can improve the performance when it comes to digital video.

Upgrading Memory

Digital video editing is memory intensive. Sometimes by upgrading your memory, you can see a definite increase in the performance of your computer. The important thing is to make sure that you purchase memory specifically designed for your Mac model, its processor type, and speed. Mac memory comes on little cards named DIMMs (Dual In-Line Memory Modules) and snap into memory slots on the computer's motherboard.

Upgrading Hard Drives

You can personally replace a hard drive in virtually all Mac desktops with a bigger one. The all-in-one iMac is not so easy. When you buy an iMac, make sure that you configure it with the biggest drive you can afford at the time of purchase, because it is not practical to upgrade it later. Only buy hard drives that have been recommended for your specific Mac model and make your purchase from a Mac retailer. Replacing your drive with a bigger one means you have to reinstall the operating system, so make sure you can locate the installation disk. Consider adding an external FireWire or USB drive for video storage.

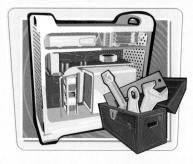

Upgrading the Operating System

To use the latest and greatest video editing applications, you may need to upgrade your operating system so that the applications are compatible. Make sure that you back up all of your important files on your hard drives to an external drive before you perform the upgrade. Backing up important files provides you added security in case something goes wrong with the upgrade. To be safe, also make sure that you have the install disks for all of the applications currently installed on your computer. Make sure your computer meets the hardware requirements for the upgrade.

Upgrading Mac Programs

For optimal system performance, it is important that you keep the software on your computer updated. Apple is constantly providing free software updates for its computers. Mac OS X automatically checks for updates each week, making it convenient for you to keep applications running smoothly. To manually check for updates, click the Apple symbol in the top-left corner and choose System Preferences. You can click an update in the list to read a brief description.

Explore Video Editing Applications for a Mac

Apple does a fantastic job supplying you with powerful, easy-to-use video editing applications. The iLife suite of software comes preinstalled on each new Mac and offers a variety of digital video software. As you outgrow basic video editing applications, it is very easy to move into more professional applications produced by Apple and other software developers such as Avid and Adobe.

Apple iMovie

If you have recently purchased a Mac computer, you already have access to popular digital video applications preinstalled on your computer. iMovie is a high-quality, entry-level video editing application that is part of the iLife suite and ships with each new Mac computer. The iLife suite also includes iDVD for DVD creation, GarageBand for music creation, and iWeb for designing your very own video blog.

Apple Final Cut Express

Final Cut Express is a more robust video editor for your Mac, but without the professional sticker shock. In the hierarchy of Apple-produced video editors, Final Cut Express is in between iMovie and Final Cut Pro on the totem pole. You can purchase Final Cut Express for around $199. The great thing about Final Cut Express is that it uses a nearly identical interface to Apple's Professional video editing application, Final Cut Studio, which makes for a smooth transition.

Professional Video Editing Applications

Professional applications pack professional price tags but provide you the most options and power. Avid produces one of the most popular and advanced video editing applications on the market with its Avid Media Composer software for around $2,000. Apple Final Cut Pro has possibly become the hottest video editing application sold. Final Cut Pro comes bundled in a suite of high-end, well-integrated digital video production applications called Final Cut Studio for around $1,000. Adobe Premiere Pro offers another high-end video editing application for Macs for around $800.

If you own a PC it could quite possibly benefit from an upgrade, but it may or may not be easy. Upgrading your computer hardware requires expertise and a clear game plan. Start with the computer's manual to see what types of upgrades are possible for your particular computer. If your computer is still under warranty, make sure that you read the terms because some upgrades may render the warranty void.

Install a New Hard Drive

The price of storage has come way down over the last few years, and you can find a big drive for a really good price in just about all the major electronics stores. Make sure the speed of the drive is at least 7200 rpm (revolutions per minute). A drive's speed is usually listed on the packaging. Check your computer documentation to see if the type of drive you are looking at is compatible with the system. If you are replacing the system drive, you will need to install the operating system on the new drive, so make sure you can locate the installation disk.

Upgrade Your PC Memory

Perhaps the quickest way to improve the performance of your computer is to add more memory. A motherboard has a limited number of slots, so make sure that you gauge how much room you have for new memory before you buy. The memory you choose must also be compatible with your system, so check the documentation to see which type it accepts. The bare minimum of memory may get you up and running, but if you want to edit more efficiently, add as much memory as you can. Upgrading your memory is a very cost-effective way to keep your computer performing at an acceptable level for a longer period of time.

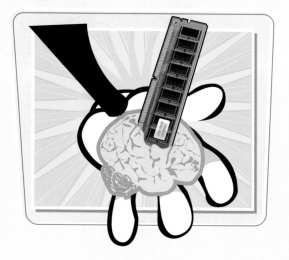

Upgrade Windows

If you are currently running Windows XP, you can use Microsoft's online Upgrade Advisor to ensure that your computer is ready for Windows 7. The Upgrade Advisor inspects your computer system to see if there are any compatibility problems. Back up all of your important documents and consider using the clean install option rather than the upgrade option to prevent future issues. Check for online updates after installation.

Install a FireWire Card

In order to connect a video camera that uses a FireWire connector to your computer and transfer images, you need a FireWire port on your computer. If your PC does not have a FireWire port, you need to install a FireWire card. To install a FireWire card you need to have an empty PCI (Peripheral Component Interface) slot used for attaching hardware devices. Before you purchase a FireWire card, read the box to make sure that your computer meets the standard system requirements. Some FireWire cards also come with a video editing program.

Explore Video Editing Applications for a PC

There are way too many options for video editing software for PCs on the market to list them all here. You can read reviews and participate in forums to find out which is the best for you. What you can find here is a list of some of the most popular video editing applications that can get you going in the right direction.

Basic Video Editing Applications

There are low cost, even free, video editing applications such as Windows Movie Maker (known as just Movie Maker if you are running Vista), which is bundled with the operating system. Inexpensive FireWire cards often come with video software such as Ulead VideoStudio. Some digital video cameras also come with a video editing application, such as Pixela ImageMixer does with the Canon VIXIA high definition camcorders. These programs are very basic and offer limited features.

Intermediate Video Editing Applications

The intermediate level of video editing software is where you can find more advanced features at an affordable price. Adobe Premiere Pro Elements is one of the popular ones in this category for around $100. Pinnacle Studio and CyberLink PowerDirector are other applications that provide affordable video editing, effects, titles, and graphics to your work. These programs also give you the ability to create and burn DVDs of your video projects.

Professional Video Editing Applications

Professional video editing applications provide you the most creative options, but at a premium price. On the lower end of the price scale is Sony Vegas Pro for around $600. Other options include Adobe Premiere for $800 and the long-time industry leader in video editing, Avid, with its Media Composer software for about $2,000.

Choose the Proper Lighting Gear

The ability to adapt to light is a crucial part of recording great video. As a videographer, you need to be able to adapt your camera at a moment's notice to an environment where there are less-than-perfect lighting conditions. Extra lighting equipment can help you produce better video when there is too little light.

Consider a Lighting Kit

Producing a high-quality image in very low light situations is very difficult. Adding an inexpensive lighting setup into the equation changes the game by giving you more options. You can close the blinds and supply your own light. You can design creative lighting setups for a more dramatic scene. As little as one floodlight, stand, and umbrella can serve as your lighting kit when you need it the most.

Reflectors and Diffusers

Video loves soft, even lighting. News reporters often conduct interviews in the early morning or at night with a single light, stand, and diffuser that goes over the light called a *soft box*. This casts a soft, even light on the subject. You can also consider using umbrellas to diffuse a simple floodlight while conducting interviews or simply adding more light to a room. Light kits, reflectors, and diffusers can be purchased at photography and video stores.

Camera-Mounted Lights

A simple camera-mounted light can act as your light kit. Some video cameras have a hot shoe located on the top of the camera that enables you to attach a light source. Some manufacturers also produce infrared LED lights that enable the camera to record in complete darkness. Make sure that you get the right light for your camera's hot shoe. If you buy your camera online, many times the compatible accessories are featured alongside the video camera.

CHAPTER 3

Preparing to Shoot Video

Good preparation for a video shoot can help pave the way for the success of a project. When the time comes to shoot, you want to be able to hit the ground running. You need to know if there are any legal matters concerning the shoot. You will want to plan the shots you will record, pack all necessary equipment, and know your recording environment.

Explore Legal Issues

If you are planning to shoot a video for commercial purposes, be aware of the legal restrictions and regulations that apply. Make sure that you have the permissions and proper release forms signed to protect yourself in the event that someone challenges your right to have a person or piece of property appear in your video. General shooting that will be viewed at home and among friends does not require release forms.

Model/Talent Release Forms

Individuals have the right to control commercial use of their image. No matter how briefly someone appears in a video that you plan to broadcast on television, in a film you plan to distribute, or for promotional purposes, you need to have them sign a talent release. This also includes video you plan to show on the Web. A release form is a formal agreement between you and the talent to use footage of that person in your video.

Property Release Forms

In general, shooting in public places is permitted, but make sure you are familiar with your local laws because property regulations can vary from state to state. Keep in mind that stores and shopping malls are not public places and are privately owned. You need permission to shoot in these locations. Even when shooting in your friend's or neighbor's house, get a release form signed. You do not want to find out later that you are being sued because your video shows something that violates city code in a friend's or neighbor's yard. A property release form helps to cover your back.

Age Requirements

A person must be of legal age to sign a release form. The legal age for signing releases in the United States is 18 years old, so if you have someone less than 18 in your video, be sure to have a parent or legal guardian sign the release. You must be very sensitive about recording any children who are not your own. Contact an attorney to understand your local laws regarding videotaping minors.

Contact the Film Commission

You can find sample release forms online that you can modify for your own purposes, but make sure that you do your homework because not all cover the proper legal loopholes. If your state has a film commission, you can contact it for the proper forms. If you do not have a film commission and are unsure about a city law, contact the local authorities. The time has never been better to get your video seen, but make sure that you protect yourself legally before you do so.

Plan a Video Shoot

How you prepare for a video shoot can either make or break your success. Although not all video shoots require the same amount of preparation, whether you are recording a birthday party or your first movie, having a clear plan of action helps things go more smoothly. You can never be too prepared.

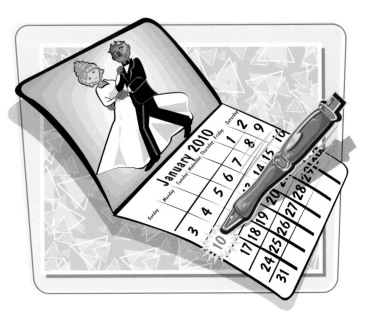

Define the Purpose and Audience

A great place to start when planning a video production is to ask yourself what is the purpose of the video and who is the audience. Are you capturing a graduation, recital, or vacation for friends and family to enjoy, or are you creating a promotional video or launching a film career? Knowing the answers to these questions can help you visualize the overall presentation and place the proper emphasis on the main subject.

Scout the Location

Go to the location of the shoot before the day you are to begin recording. If this is not possible, get to the shoot early. Scouting the location before you begin recording can help you anticipate problems that may pop up during the shoot. Will you be recording in an area where there is a lot of foot traffic? Will there be enough room to use a tripod? Are there electrical outlets where you will be shooting, or will you need to purchase more batteries? What is the lighting situation?

Plan What to Shoot

A great way to make sure that you capture all of the highlights of an event is to make a list of all the shots you want to capture. If the event has an itinerary, use it to devise a plan. If you are shooting from a script, break it down into days with the scenes you need to shoot. Always plan to shoot much more footage than you think you will need, so that you can have some options when you edit the video later. You do not want to be editing your video and then discover that you need more footage.

Plan for the Unexpected

Having a clear, laid-out plan helps to ensure the success of your video production, but do not be surprised when the unexpected occurs. Perhaps the event has to be held in a different room at the last minute, where there is less light and the electrical outlet is out of reach. Pack extras in your camera bag, such as a camera light and an extension cord, to give you options.

Create an Equipment List

An equipment list is a very important part of the planning process, especially when dealing with larger video productions. The main purpose of an equipment list is to make sure that you do not forget anything when you go out for a shoot. Some key things should be on your list other than the most obvious, the camera.

Make a List

Create an equipment checklist in Microsoft Excel or Word before an event that you can print off and use when packing your camcorder bag. Do not assume that something is in the bag, and make sure that all of the equipment on the list has been visually accounted for in the bag and checked off of the list, especially if more than one person uses your equipment. The last thing you want is to discover at the shoot that a memory card you thought was in your camera is actually inserted into the card reader at home.

Bring Extra Recording Media

Whether your camera records to tapes, memory cards, or DVDs, you need to make sure that you have packed plenty of extras before you go on a shoot. If the event is only one hour, bring more than one 1-hour tape, just in case the event goes over, or if one of the cassettes has been damaged. Packing more record media than you need helps protect yourself from unwanted surprises in the field.

Pack Extra Batteries, an Adapter, and Duct Tape

Have all your batteries charged the day before the shoot and make sure that you pack extras in the camcorder bag. The last thing you want is for the program to run longer than expected and you miss part of the event because you did not bring enough batteries or have access to an electrical outlet. Pack an AC adapter just in case you have a chance to use an electrical outlet, and keep an extension cord handy if the outlet is far away. If you have to use an extension cord in an area where there is a lot of foot traffic, consider packing duct tape to tape down electrical cords, so no one trips.

Protect Your Camera

If you shoot outdoors you may occasionally get caught in the rain or snow. Make sure that you not only take the proper rain attire for yourself, but also for your camera. You may purchase a rain cover made especially for your camera or use a plastic department store bag, but make sure that you protect your camera by keeping it dry, as well as dust- and sand-free.

Choose the Proper Camera Bag

Your camera is the most important piece of equipment in your digital video arsenal, so you must ensure that it is well protected. The proper carrying case can shield your camcorder from moisture and dirt, and can even take a tumble, leaving the camera unharmed. There are some key attributes to look for when purchasing a bag for your camcorder.

Camera Bag Size

A good camera bag not only protects the camera, but is also large enough for you to store your accessories such as the power cord, batteries, extra tapes, DVDs, flash card, and other necessities. Most camera bags come with interior dividers fastened to the walls of the case by Velcro, providing compartments to place accessories. Make sure that the camera can be packed securely in its own compartment and does not roll around when you are walking. Camera bags usually come with information about the size of camcorder they accommodate, so make sure you do your research.

Waterproof Bags

You and your camera may occasionally get caught in the rain or snow, so make sure the bag that you choose is water resistant. A water-resistant bag also protects the camera from dust and other debris such as sand. Always make sure that you keep the inside of your bag clean and periodically vacuum the interior.

Rugged Bags

Choose a bag made of strong material so that it can not only take a tumble and still protect the camera, but also hold up during everyday wear and tear. Nylon, canvas, or thick leather is a good choice. Ensure that the bag closes securely with a zipper to keep the camera completely concealed when transporting and when stored for long periods.

Know Your Recording Environment

Walking around the area in which you will be recording to get a feel for the environment is very important, especially if you are recording a special event for which you are getting paid. Asking some important questions while scouting the location can help ensure a successful shoot.

Assess the Lighting Situation

Will you be shooting indoors under dim light, or will there be a mixture of natural and artificial light? Are you shooting outdoors in bright sunlight, at night, or will it be overcast? These questions can help you devise a plan of whether you will need to bring extra light or request it. They help you configure your camera settings in preparation for the event and allow you to make adjustments. If you are shooting at night for the first time, consider shooting some night footage beforehand so that you can become acquainted with the nuances of recording in very low light with your camera.

Assess Your Shooting Position

How far will you be from the main subject or action? If you are shooting a sporting event or wildlife, you might want to pack a telephoto lens converter to get those close shots. If you are shooting wide vistas such as landscapes, you may want to consider packing a wide-angle lens converter. Consider the best place for you to shoot and be aware of anything that can obstruct your view during the shoot.

Assess the Audio Situation

The ability to gauge any audio issues before the shoot can help you better prepare for them. Are you shooting next to a busy intersection during rush hour? Will you be sitting close enough to the speakers to hear the subject speak or will you be relying on a P.A. system? Become aware of any background noises that may compete with your video, such as loud music, machine noise, or even loud insects such as cicadas. With this knowledge you can adjust camera audio settings in preparation for the shoot.

Making Special Requests

You may need to make special requests with the organizer of the event so that you can shoot the best video possible. Perhaps the best angle for you to set up for the shoot is a spot that is already occupied. You can ask the event coordinator if you can possibly set up there. This may particularly become necessary if that area has the nearest electrical outlet for a 4-hour event. You always want to be respectful of the event and the coordinators.

Recording Great Audio

It is very easy to focus solely on the video and let the audio fend for itself. However, the video is only part of the equation that makes up the special moments you record. The ability to acquire clear, understandable audio is essential for the success of your videos. There is no single solution for every audio situation, so you must understand how to adapt to various recording environments and know what to listen for.

Understanding the Importance of Sound

Quality sound is essential to your video — the overall audio quality can be just as important as what is shown on-screen. You will be working with essentially four important elements of audio as you record your video and edit them into a movie: speech, ambient sound, sound effects, and music. Understanding the importance of these four elements can help you produce solid audio for video.

Acquire Clear Dialogue

Dialogue and speech help to define the moment and provide the emotional impact that you want to relive through your videos. Hearing the bride and groom recite their wedding vows and capturing every word of the graduation speech is crucial to the success of your video. If the audience is unable to hear what is being spoken, the entire meaning can be lost. A well-produced voiceover can also help the audience understand what is going on in the video.

Understand the Power of Ambient Sound

The ambient sounds of chirping birds in the park, five o'clock traffic, or the roar of the fans in the stadium can complement your video by providing depth. But, they can also compete with your primary audio, which may be the human voice, or the music at a summer concert. Make sure that you properly use the appropriate sound equipment to ensure ambient sound is a complement, and not a distraction.

Use Sound Effects

Some video editing programs come equipped with their own sound effects libraries. These effects are really handy for some of your more creative work. If you need a door knock, dog bark, or the whiz of a passing car, a video editing program with a sound effects library can help you create a very believable soundscape.

Utilize Music

Music can establish both a rhythm and emotion for your video. Some video editing programs enable you to create your own personal soundtrack for a video project, using prerecorded samples of musical instruments. The appropriate background music can make your video a hit.

Bring It All Together

You will use a video editing program to bring all of these audio elements together into a clear and coherent presentation. The care you took during the acquisition of the audio proves key at this stage. Although there are some audio processing techniques that can help you tweak less than perfect audio, the phrase "Garbage In, Garbage Out" remains true.

Audio & Volume Controls

Monitor the Sound

When you sit down to edit your video, what you acquired in the field is what you will have to use. If the recording levels were too low, too high, or a combination of both, that is simply what you have to work with. You must monitor your audio in the field as you are shooting to get the best audio possible.

Visit the Location Beforehand

Whenever possible, and this cannot be stressed enough, visit the location before the shoot to assess the audio situation. Stand in the area where you will be shooting, close your eyes, and just listen. Listen for any noises and sounds that may compete with your main subject. Listening for competing sounds gives you the opportunity to configure your camera settings for the best sound prior to the shoot.

Use Headphones

In order to ensure the quality of your audio, you need to hear what the camera hears as it records. Invest in a quality pair of headphones with padded cushions that fit over the entire ear for better sound quality. You have a better chance of avoiding an audio nightmare during the editing process by being able to make audio adjustments in real time while you are shooting.

Monitor the Recording Levels

Many digital video cameras come equipped with an audio level indicator that lets you monitor the levels of your recorded audio while shooting. This indicator can normally be found in the Audio Video menu of your camera. The indicator is viewed either in the viewfinder or in the LCD window when flipped open. The ability to monitor the audio as you record enables you to make audio adjustments in the field, to ensure the audio is at optimal levels.

Understand Recording Levels

Optimal audio levels for your digital video camera are at an average of -12 decibels (dB) on the digital audio scale, with the occasional peak above and below. Anything around 0dB on the meter is way too loud and will probably be distorted. Some video cameras allow you to adjust audio recording levels manually.

Adjust In-Camera Audio Settings

Some digital video cameras enable you to manually adjust the audio recording levels. You can learn how to adjust the audio levels for your particular digital video camera to ensure that you acquire optimal audio levels. Understanding your camcorder's audio recording options, and performing test runs, can help you acquire the best sound.

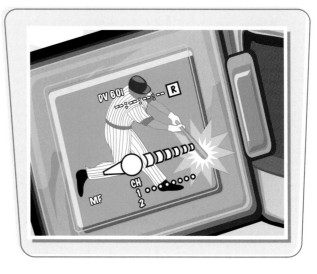

Manual Audio Adjustments

Monitoring audio by using a set of headphones and watching the audio indicator levels gives you the ability to see if you are recording at optimal levels while in the field. Some digital video cameras allow you to perform manual audio level adjustments by accessing a Microphone (MIC) option in a setup menu. Whether you are using the built-in microphone or an external microphone, you can turn the audio up or down.

The Microphone Attenuator

Some digital video cameras have a Microphone Attenuator (Mic Att.) option that prevents loud sounds from becoming distorted during recording. You can set this option to ON before recording fireworks, sporting events, and concerts. This option can usually be found in the Set Up menu under the Record In options of the camera.

Test the Volume

Doing a test run to preview how the audio will actually be recorded is good practice. This is especially true if you are using talent with speaking roles. You can perform a manual audio level adjustment with your camera by having the person begin talking at the level he or she plans to speak and see if it averages around -12 dB. A test run that involves recording and actual playback of the audio can help you work out any problems before you begin the primary recording.

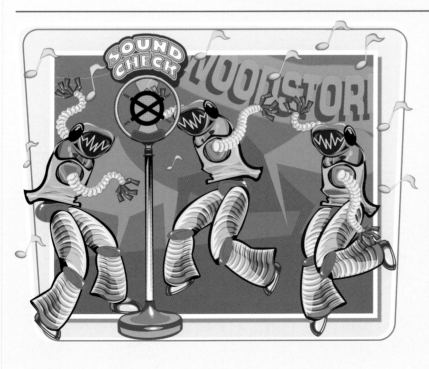

Use the Built-in Microphone Properly

Digital video cameras are all equipped with an external microphone; some of them can record Dolby Digital Sound right out of the box. Built-in microphones have inherent limitations that you need to be aware of before you begin recording. Understanding the limitations of built-in microphones and how to address those limits can help you acquire better audio.

Keep It Close to the Subject

Built-in microphones perform better when the subject is very close, and lose their effectiveness the farther away the subject is. Recordings are fuller when sound is projected toward the camera, so when possible, make sure that the subjects speak toward the camera.

Avoid Windy Conditions

Built-in microphones are difficult to shield when shooting in windy conditions and are very likely to pick up the sound of wind. Some built-in microphones come equipped with windscreen features that automatically reduce some low-frequency noises and background noises caused by wind, but the best option is to avoid recording in windy conditions.

Pick Up Multi directional Sound

The built-in camera microphone is usually omnidirectional, which means it picks up sound from all directions, including camera handling noises. Be aware that the microphone picks up sounds that originate from behind the camera as well as those in front and on the sides. For the best audio results, shoot in a controlled environment whenever possible, where there is minimal competition between extraneous sounds and your subject.

Explore External Microphone Options

The built-in camera microphone supplies acceptable audio for general shooting purposes but can quickly become inadequate. You can use audio accessories, such as external microphones, to improve your camera's audio recording capabilities. Think of audio accessories as tools. Knowing what tool to use for a given audio situation helps you achieve higher-quality sound acquisition.

Getting Connected

Digital video cameras can offer a couple of ways to connect audio accessories. Most consumer cameras have a 3.5mm Mic terminal that enables you to connect external audio equipment. Some have what is referred to as a *hot shoe* on the top of the camera, where external sources can be directly attached and controlled. Professional-level cameras possess XLR inputs for higher-end audio sources.

Lavaliere and Lapel Microphones

Lavaliere and lapel microphones are mostly used for seated interviews, such as those on "talking head" news shows. A wire runs from the microphone down a suit coat or blouse, leading back into the camera's 3.5mm Microphone terminal. When placed properly on the subject, lavaliere and lapel microphones record the human voice clearly while minimizing room noise.

Hand-Held Microphones

Hand-held microphones can be used for on-the-go interviews and are widely used by news reporters out in the field. These microphones can come in handy if you plan on having more than one person on camera at a time, because the speakers can just pass the microphone down the line. You can also attach a hand-held mic to a podium for a public speaker. Most hand-held microphones are unidirectional, meaning they pick up sound from one direction. Hand-held microphones attach to the 3.5mm microphone terminal of the camera and require batteries.

Camera-Mounted Microphones

You can firmly attach a directional, stereo microphone to the top of a camcorder equipped with a compatible hot shoe. This microphone is sometimes referred to as a "shotgun microphone" and is a hands-free alternative to the lavaliere and hand-held microphones. These microphones are usually equipped with a windscreen (a small sock covering the microphone) to shield it from wind noise. Consider this microphone for documentary-style shoots such as birthday parties, family reunions, or sporting events.

Boom Microphones

A boom microphone is a directional microphone mounted on a pole or arm and is used to capture clean dialog. These types of microphones are very popular in television and film production. The boom microphone requires a second operator to keep the arm out of the shot and for positioning it for the best sound. Consider this type of microphone for film production.

Learn to Use Lavaliere and Lapel Microphones

Lavaliere and lapel microphones are great for achieving high-quality dialog for seated interviews. Understanding the proper use of your audio accessories enables you to record the best audio available.

Attach the Microphone Properly

Make sure that the wire of the microphone is hidden as much as possible before you begin recording. If needed, ask the interviewee to run the wire down his shirt so that there are no exposed, dangling wires. Do not conceal the actual microphone itself. Concealing the microphone with a suit coat or collar muffles the voice of the speaker, and the subtlest of movements will create noise during the interview.

Minimize Movements

It is important that your subject remains relatively still during the interview. Because the microphone is attached to his or her clothing, it is very easy for it to pick up the sound of rustling clothes. Properly attaching the microphone to the subject and not concealing the actual microphone can minimize this issue. Excessive movement of the subject during the interview can shift the position of the microphone. If you know the person will be moving her head during the interview — possibly to face the interviewer — you should place the microphone on the side of the person's body in the direction she will be turning.

Test the Volume

Do a test run before you begin recording. Instruct the speaker to talk at the same level he or she will be speaking during the actual interview, and then make a manual audio level adjustment so that the levels average around -12 dB. Performing a test run can help you target and anticipate sound issues before the actual recording begins.

Monitor the Audio During Recording

Wear headphones and monitor the audio level indicator during the interview. Many times subjects can become nervous and actually speak more loudly or softly during the interview than they did in the sound check. If you can hear the audio and see the levels, you can make the appropriate manual audio adjustments to ensure you get the best audio. If an unforeseen issue occurs, you can reshoot the video, if necessary.

Get the Most out of Hand-Held Microphones

Hand-held microphones are popular for on-the-go interviews and are widely used by news reporters in the field. Their use is quite simple, but there are some notes to keep in mind when using them in the field. Understanding the proper use of hand-held microphones enables you to acquire higher-quality recordings.

Turn It On and Off

Hand-held microphones and many lavaliere microphones are battery powered and need to be turned on before using them. In the excitement of the moment, it can be very easy to forget to turn the microphone on, especially when you are not accustomed to powering on your camera accessories. Remember to turn off the mic between uses to conserve battery power. Always use a fully charged battery when recording. As the battery reaches a low level, audio quality diminishes. Keep in mind that a power indicator light does not necessarily mean that a battery has enough power; it generally means that there is some power, which may not be an adequate amount.

Hold It Close

The most widely used hand-held microphones are unidirectional, meaning that they pick up sound from one direction. Make sure that you hold the microphone close to the mouth of the speaker. Sometimes even the professionals forget this and subsequently the first two words get dropped before the microphone is in place. These microphones also pick up some ambient noises.

Hold On to the Microphone

Do not give up the microphone when conducting the interview. It is very common for a person to reach for the microphone as you move it toward their mouth. You know what should and should not be done with the microphone during the recording, and he or she probably does not. The interview will go more smoothly if you control the microphone.

Secure the Cord

Be mindful of the placement of the cord if you are conducting an interview in an area that has a lot of foot traffic. Avoid extending the cord in an area where people will have to step over it. The last thing you want to happen is for someone to trip over the cord and hurt himself while the camera and the microphone go crashing to the floor.

Operate Camera-Mounted Microphones

The camera-mounted microphone is often referred to as a *shotgun microphone* and can be attached to the top of a compatible camera for directional pickup. This particular microphone is a hands-free alternative to the lavaliere and hand-held microphones and is great for guerrilla-style, unscripted shooting. Understanding the proper use of camera-mounted microphones improves the quality of the audio in your recordings.

Check Compatibility

Make sure that the camera-mounted microphone you are looking to buy is compatible with your camcorder hot shoe before you spend your money. Digital video cameras can also utilize different-sized hot shoes and require microphones of compatible sizes. Some cameras use specialized advanced hot shoe technology that powers compatible microphones without the use of wires or batteries.

Cover the Microphone with the Windscreen

Make sure that the microphone is completely covered by the windscreen, or sock, that shields it from wind noise. The windscreen feature that some cameras utilize for the built-in microphone can automatically be deactivated when you attach a camera-mounted microphone.

The actual covering on the microphone may be your only line of defense in protecting your videos from howling wind in a windy shooting situation.

Find the Range

Position the camera-mounted microphone close to the subject for the best sound. The best way to find an acceptable recording range for the camera and the subject is to do a test. See how far away you can get before the quality diminishes. The camera-mounted microphone is not an ideal fix, but it can give you higher-quality audio than the built-in microphone. Camera-mounted microphones are directional, mostly picking up what is in front of them and diminishing ambient noise from the back and sides of the camera.

Operate a Boom Microphone

The boom microphone is a directional/shotgun microphone placed on a boom pole and is largely used in film and television for high-quality dialogue recording. This particular microphone is a good choice for freeing up subjects from a microphone, and for when you do not want a visible microphone in the shot. Being able to identify the proper boom microphone for your digital video camera and knowing how to properly use one can help you achieve some of the highest-quality audio possible.

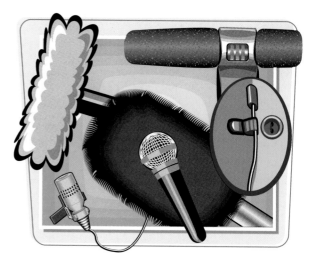

Get the Right Connector

A consumer camera has a 3.5mm (1/8) stereo or mono microphone jack to accommodate external audio accessories. Most of the boom microphones on the market are geared toward prosumers and use an XLR connector for more-professional cameras. If you are using a consumer camera, make sure that the microphone you buy has a 3.5mm (1/8) connector. Some companies such as BeachTek offer adapters that attach to the camera and can be connected to the 3.5mm (1/8) jack. You can then plug the XLR connector of the microphone into the adapter.

Keep It Out of the Shot

You need to find someone to operate the boom microphone while you operate the camera, and communication between the both of you is crucial. Not only does the boom operator need to keep the boom out of the shot, but shadows that the boom creates also need to be kept out of the shot. A shot where the boom pole dips in and out of the frame or where a shadow appears across the subject looks amateurish and is distracting to the viewer.

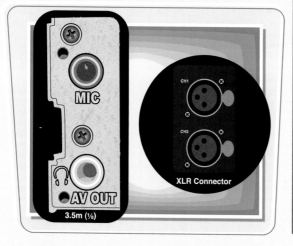

Place the Boom Microphone

The boom microphone and pole can be heavy when held for extended periods. Many boom operators hold the boom over their shoulders for leverage, but this can vary due to the composition of the shot. Sometimes you may need to hold the microphone just below the bottom of the frame to keep shadows out of the shot.

Control the Distance

Remember that a boom microphone is not necessarily good at picking up sound from a great distance; it is just a directional mic on a pole. Make sure that you get as close as you can to the subject and point the microphone toward whomever is speaking. Whether the subject is standing or walking, keep the microphone at a consistent distance from the subject to avoid fluctuations in audio levels.

Monitor the Audio

Always wear headphones to monitor the audio to ensure that the microphone is truly picking up what you are pointing it toward. Monitoring the audio also lets you know if you need to make any adjustments while you are recording. You do not want to sit down and edit your video only to discover that the audio was not as clean or as high or low as anticipated.

Controlling Exposure and Focus

A digital video camera has many settings that affect the appearance of the footage it records. The camera automatically controls many of these settings as it adjusts to the amount of light in a scene and for the distance between the subject and camera. Some video cameras give you more control over the image by enabling you to make manual adjustments to settings such as shutter speed and aperture value. By using a combination of automatic and manual adjustments, and with an understanding of the basic elements of videography, you can produce high-quality digital video.

Examine Types of Light

The abundance of light or lack thereof has a direct impact on the quality of your video. As a videographer, you should always be aware of light and how it interacts with your camera. Understanding various lighting situations and how to adjust your camera to them helps you record the highest-quality video possible.

Understand How the Camera Sees

The eye of the digital video camera does not work as well as your eyes; it needs extra help to see things the way you do. Through the lens of the camera, a dimly lit room might appear completely black. Recording a subject at the beach with the sun in front of the camera may make the subject appear very dark as the camera compensates for the sun. You are the brain of your camera, helping it to respond to various lighting situations.

Diffused Light

An evenly lit subject devoid of hard shadows denotes the presence of diffused, or soft light. Diffused light is not concentrated, but scattered, appearing to come from many different directions. A great example of diffused light is the sun shining through clouds on an overcast day, softening the rays before they reach the subject on the ground. Diffused or soft light makes for a very good shooting environment free of hard shadows and blown-out highlights.

Hard Light

A scene containing sharp shadows and a high contrast between the lightest and darkest areas denotes the presence of a concentrated light source aimed in a specific direction. A good example of this type of lighting is a spotlight aimed at a subject, casting a shadow against a wall. This can also occur when shooting outdoors on a bright, sunny day. High-contrast images such as these prove very difficult for a camera's sensor to balance the light in the scene automatically.

Backlighting

The intensity of the light source behind your subject can be unappealing if the light source is too strong. This issue is very apparent if you shoot someone indoors who is standing in front of a window with bright sunlight pouring through. You may only be able to see a dark silhouette of the subject if the camera is set to adjust exposure automatically as it compensates for the bright window.

Anticipate Lighting Situations

Before you go on a shoot, ask yourself a few questions to help you better prepare for that particular lighting situation. Will I be shooting indoors or outdoors? Will it be sunny, overcast, or a night shoot? If it is indoors, what is the lighting setup? Will the room have a combination of artificial light and natural light pouring in through a window? You can gauge whether you need to bring extra lighting equipment and anticipate problems by knowing the answers to these questions.

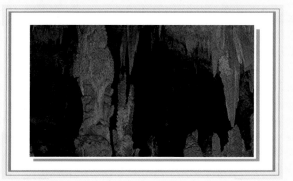

Understanding Exposure

The amount of light allowed to reach the camera's image sensor plays a large role in the quality of video recorded. A too-bright or too-dark image has an adverse effect on the appearance of your video. To get the most out of your digital video camera, you need to understand the importance of achieving the right exposure for various lighting situations.

Underexposed and Overexposed Video

Under- and overexposed video is one of the most common video problems and is the true mark of an amateur. A scene that appears too dark on account of too little light reaching the camera sensor is said to the underexposed. A scene that appears too light on account of too much light reaching the camera sensor is overexposed. If the image is too dark or too light, precious image data is lost in the darkest and lightest areas of the scene, as shown in these videos.

Light Sensitivity

Shooting in very bright conditions such as on a sunny day at the beach requires lower light sensitivity due to the overabundance of light. On the other hand, shooting at sunset requires a higher light sensitivity due to the lack of light, as shown in this video. A digital video camera can adapt to these various lighting situations by adjusting the shutter speed and the aperture, both of which are responsible for regulating light reaching the image sensor.

Fix Exposure Problems in Post-Production

Many video editing programs are equipped with color-correcting tools that enable you to fix exposure problems in post-production. If the image is too dark or too light, making adjustments with the software can provide some help, but does not completely fix the problem. By lighting your scenes properly and making the proper camera adjustments, you can prevent most exposure problems. Prevention is the best option.

Discover Exposure Settings

Digital video cameras offer several ways to control exposure settings. These options range from fully automatic special recording programs to options that enable you to set either the shutter or aperture value manually, while the camcorder adjusts the other automatically. Each option has its advantages and disadvantages, but all are capable of producing great video. Understanding exposure options helps you to make better decisions regarding exposure in the field.

Auto Mode

By default the camera is set to auto mode, or program mode, where the aperture and shutter settings are optimized for the best exposure for the scene. This option enables you to simply point and shoot and is great for quickly capturing a shot. Sometimes auto exposure can overcompensate when faced with an abrupt change in light, but it can yield fantastic results in general shooting situations.

Shutter Priority Mode

Some digital video cameras have a shutter priority mode that enables you to manually set the shutter speed value, while the camera automatically sets the proper aperture value for you. Shutter priority mode works well when you want to control the appearance of fast-moving objects. A faster shutter speed results in sharper, more-detailed images when recording motion, with less blur. A slower shutter speed shows motion blur, as shown in the waterfall.

Aperture Priority Mode

Some digital video cameras have an aperture priority mode that enables you to manually set the aperture value, while the camera automatically adjusts the shutter speed. Aperture priority mode is a great option for controlling depth of field, the area of the image that remains in focus. Higher aperture values result in deeper depth of field, whereas lower aperture values result in a more shallow depth of field, as shown.

Scene Modes

You can use preprogrammed automatic exposure settings, or what are sometimes called special scene modes, for optimizing both the shutter and aperture to your advantage for various lighting situations. Some of the most common modes available are portrait, sports, night, fireworks, beach, sunset, spotlight, and snow, as shown. The quality of these modes is fantastic, but like the other automatic modes, the extra convenience comes with some compromise.

Solve Exposure Issues

Automatic exposure settings are convenient and perform very well in ordinary shooting situations where the lighting is diffused and even, but no automatic system can get it right every time. Certain lighting situations can cause the automatic exposure to perform less than admirably, and you will need to use a manual exposure to get the best video.

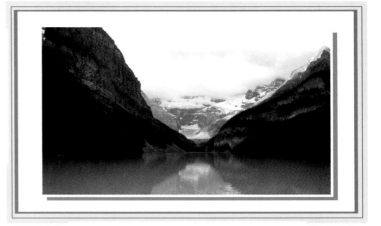

Examine High-Contrast Scenes

Images with a wide dynamic range, meaning they have a large disparity between light and dark areas, pose all sorts of problems for the automatic exposure. Depending on how the scene is composed, the camera overcompensates either for the darkest areas of the image or the lightest, as it attempts to expose the image properly. This overcompensation can lead to either an over- or underexposed image. Go into the camera's menu system and adjust the exposure manually until the scene appears acceptable within the viewfinder.

Shifting Exposure

When set to automatic exposure, the camera constantly calculates exposure settings in response to the changing lighting situation, and can overcompensate when faced with an abrupt change. Be mindful of shots where you are tracking a subject from a dimly lit area to a brightly lit area, because the picture may jump to a bright white or pitch black as the camera adjusts. The adjustment will be quick, but the transition may not be aesthetically pleasing when playing back the video. Also, limit tilting (rotating the camera in a vertical plane) and panning (rotating the camera in a horizontal plane) to avoid extremely light and dark areas from coming into view while using the automatic exposure.

Compromising Backlight

Automatic and manual exposure adjustments provide flexibility for navigating tricky shooting situations, but there are times when you will have to sacrifice not having perfect exposure for part of the image so that the subject is not neglected. If you are faced with a situation where part of the image will be less than perfect, always make sure that your subject looks the best. As shown in this video, the main subject, the building and tower, are properly exposed, whereas detail is lost in the sky. No matter the advancements in digital video camera technology, let your eyes cast the final verdict.

Learn About Aperture

The aperture is the opening and closing diaphragm behind the lens and controls the amount of light that passes through. Its function is much like the pupil of the eye. In low light conditions, it needs to be opened wider, and in bright conditions, it needs to contract.

Set the F-Stop

The relative size of the opening/aperture is called the f-stop, and the way f-stops are numbered can be a little confusing. It helps to think of them as denominators of fractions where 1.2 is larger than 1.8. The larger the number, the smaller the aperture opening, meaning less light passes through the lens to the image sensor, and vice versa. If you set the aperture value to 4.0 and then adjust it to 2.8, you effectively cut the amount of light entering the lens by half.

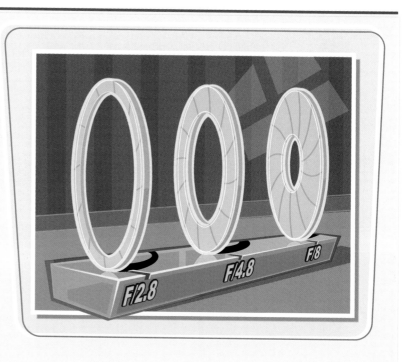

Set the Aperture

Out of the box, the default mode for most digital video cameras is to automatically adjust the aperture. Some video cameras have an aperture priority mode, which enables you to manually set the aperture value in a menu, while the shutter speed is automatically adjusted for you to achieve the highest quality video.

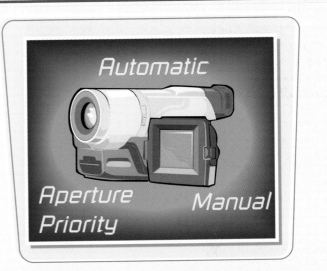

Manipulate Depth of Field

Using a larger or smaller aperture value affects the depth of field in a scene, the area in a scene from the foreground to background that remains in focus. A larger lens opening, meaning a lower aperture value like f/2.8, creates a more shallow depth of field. This can create a soft blur on the background for a portrait. A smaller lens opening, meaning a higher aperture value like f/8, provides a deeper depth of field where the overall image is in sharp focus. A deeper depth of field can prove beneficial for shooting scenery that contains multiple subjects, as shown.

Learn About
Shutter Speed

In consumer cameras, the shutter speed governs the interval of the off and on state of the image sensor as it is exposed to light. Some advanced camcorders have an actual shutter mechanism that opens and closes. Speeding up and slowing down the shutter speed has a direct effect on the look of your digital video. On fully automatic digital video cameras, the camera dictates the shutter speed, whereas some cameras let you adjust shutter manually. Understanding how shutter speed affects your video enables you take more control over the image.

Shutter Speed

Shutter speed is measured in fractions of a second on how long the image sensor gathers light. Shutter speeds can range from slow — 1/8, 1/15, or 1/30 — to fast — 1/500, 1/1000, or 1/2000. You can use various shutter speeds to control the appearance of fast-moving subjects in your videos.

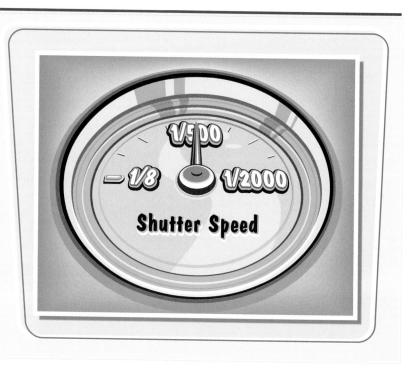

Low Shutter Speeds

The lower you set the shutter speed, the more light you gather. Lower shutter speeds, such as 1/8, 1/15, and 1/30, are great for recording in dimly lit places or at night, but you will definitely want to use a tripod to keep a steady shot. These videos of holiday lights in the park show the effect that a slow shutter speed and camera shake can do to a night shoot. The slower speeds add motion blur to fast-moving objects. A shutter speed of 1/60 is a great speed for smooth motion in general shooting conditions.

Explore High Shutter Speeds

The higher you set the shutter speed, the less light you gather; this results in sharper, more detailed, fast-moving subjects with less motion blur. High shutter speeds are great for shooting scenes that contain an abundance of light, such as a sunny day at the beach. For outdoor sporting events such as bicycling, or shooting from within a moving vehicle, use high shutter speeds such as 1/250, 1/500, 1/1000, or 1/2000. Use a high shutter speed to freeze a subject's motion, as shown.

Use Focus Modes

The lens of the camera is either adjusted automatically or manually to bend incoming light rays so that they form a sharp image. All digital video cameras have autofocus built in, whereas some possess manual options. Understanding the focus options of your camera is very important to the quality of your images, because a slightly out-of-focus, or *soft*, subject is very noticeable.

Automatic Focus (AF)

Automatic is usually the default setting for digital video cameras and performs very well in most circumstances. When you use automatic focus, the camera utilizes an external sensor to determine the distance between the camcorder and the subject, and quickly adjusts the lens so that the image is in sharp detail. Automatic focus can quickly shift to a new subject without your intervention, letting you focus strictly on the composition of the shot. Some cameras give you the ability to dictate the speed at which your camcorder can acquire an automatic focus.

Set Focus Manually

In some instances, automatic focus can prove more bothersome than effective; that is why some digital video cameras give you the ability to adjust focus manually. Shooting at night, or shooting fast-moving objects or reflective surfaces, can sometimes make the automatic focus indecisive as to what it should keep in focus in the shot. You can set the focus manually to pinpoint the area of interest in the scene, and make sure it is in sharp focus. Manual focus was used to shoot this video through a window and focus on the inside of this historical landmark.

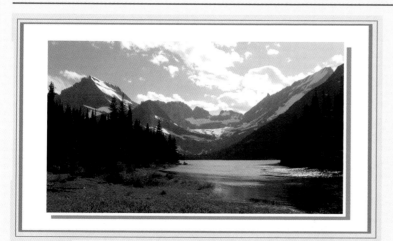

Infinity Focus

Focusing on faraway objects can also be a challenge, so some digital video cameras are equipped with a focus assist option called infinity focus. Use the infinity focus feature to focus on faraway objects such as a mountain range or fireworks. The infinity focus setting utilizes a wide depth of field, so that everything is in focus. The infinity focus option can usually be found with the manual focus functions of the camcorder menu.

Discover Focus Tips

The conveniences of using the auto focus features are not without their shortcomings in certain shooting situations. Understanding when to set focus manually instead of using the auto focus is key in capturing the best image possible. Whether you are using auto focus or adjusting focus manually, there are a few practices that can help you shoot better video.

Take Advantage of Auto Focus

Although professional videographers often talk about their misadventures using auto focus, there are times where it just makes sense. When filming social events, gatherings, or just real-world events in general, where there is no script, auto focus can make your life a whole lot easier. Especially if your camera is small and without a focus ring where you can manipulate the actual lens with your free hand. Automatic exposure frees you up from having to stop and adjust your focus.

Avoid Distractions during Automatic Focusing

One of the inherent drawbacks of automatic focus is that it can be distracted. If another object passes between you and the shot, the focus may shift. If you are recording a wide shot of a building, and a person walks between you and the camera, and appears large in the frame, the camera may think that the person is the subject. The focus may shift between the building and the pedestrian. When using automatic exposure, avoid composing shots where many objects are between you and the subject. This also goes for people walking through your shot.

Choose a Point of Focus

If you are using a camera that does not have a focus ring, it may be more practical to perform a manual focus only on static shots. Always have your shot lined up and your zoom adjusted before you perform a manual focus. For a sharp focus, zoom into a tight shot of the subject and adjust the focus until its detail is sharp. Some video cameras actually enlarge the image during a manual focus adjustment to assist in focusing.

Mind Low Light Situations

Low light situations can confuse the automatic focus system and slow the reaction time as it attempts to readjust to a new subject. Low light can also cause the automatic focus to choose improper focus points, leaving the subject slightly out of focus. In low light situations, consider finding a stationary target and zoom in to the subject to perform a manual focus adjustment and zoom back out. Physically set up close to the subject with a tripod and limit how much you zoom in. When you zoom in, it reduces the amount of light entering into the lens, making the subject even darker.

Exploring the Color of Light and Lighting

The color and positioning of light plays a huge role in the success of both indoor and outdoor shoots. In this chapter, you learn the importance of light and how it pertains to achieving a high–quality video image. You also learn how to adjust the camera to accommodate various lighting scenarios with automatic and manual settings, as well as learn lighting techniques to add depth to your videos.

Explore the Color of Light

Everything that you shoot with your digital video camera is painted with light. Learning the characteristics of light can help you understand how your camera interacts with it, enabling you to create high-quality video.

Light and Color

The temperature of light dictates the amount of a particular color within the light, which is largely due to its source. The color of light is constantly changing around you. You wake up in the morning and eat your breakfast under the yellowish-orange glare of tungsten lights over the kitchen table. Early in the morning, when you leave home for work, the rising sun bathes everything in reddish orange. You take your lunch break under the bluish light of the midday sun. After a long day at work, you return home under the bluish cast of a full moon.

Sunrise

When the sun rises in the morning, the sunlight must travel through more of the earth's atmosphere due to its angle to the earth than if it were directly overhead. Due to this low angle, more red light is let through than blue, which results in beautiful red hues and warm golds. The first and last hour of sunlight in the day are often referred to as the *magic hour*, or *golden hour*. Many videographers as well as photographers believe these hours of the day are the best time to shoot video and take pictures due to the beautiful ambience of light — passing through the atmosphere. The lighting is very soft at these times.

Midday

When the sun is directly overhead during the midday, the rays have less distance to travel through the earth's atmosphere. The warm and cool light effectively combines to form a bluish colorcast. Also, the light at this time can be hard, creating defined shadows from the objects below, and producing high-contrast images. This light can prove more difficult to shoot in on a sunny day. If time permits, you can wait until he sun moves behind clouds, which diffuses the light, before you begin shooting.

Sunset

Just before, during, and shortly after sunset, a spectacular variation of red, yellow, and gold permeates the atmosphere, which casts a rich and intense glow on everything below. This dramatic change in light is great for recording dramatic landscapes, cityscapes, and wildlife videography.

Household

Incandescent light or tungsten light, in reference to the coiled tungsten filament in these lamps, is commonly used in homes. Tungsten lights are in the warm color range and produce a yellow/orange cast, as displayed in this video. Much of the studio-based and field lighting for video is tungsten.

Fluorescent Light

Fluorescent light is generally used in public places and produces a greenish cast, as seen in this video. It may not be evident to your naked eye that the cast is green, but to the eye of the camera, it is green. Fluorescent light is not as forgiving on the skin as tungsten light. If not properly calibrated for, fluorescent lighting can really do a number on blonde hair, light skin tones, and white clothing, tainting them with an undesirable greenish hue.

Understanding White Balance for Color Accuracy

Along with the quantity of light, the color of light is an important component to recording great video. The white balance feature of your digital video camera helps to accurately reproduce colors when you are shooting in various lighting situations, so that neutral colors such as white and gray are truly neutral, and all other colors are rendered without undesired colorcasts. Understanding the importance of white balancing helps you to create higher-quality video.

Correct for Light

In spite of all the optical advancements of digital video cameras, the eye of the camera does not work as well as the human eye. Your eyes are many times more accurate than the camera's sensor; in conjunction with your brain, they can decipher a white envelope under a yellow light. The camcorder needs your assistance to reach that conclusion. Each time you shoot a scene under a different light source, you have to show your camera what constitutes a neutral color before it can accurately depict other colors. If the camera is not properly adjusted to the light, the scene colors can be muted, and the video shrouded in an undesired colorcast.

Color Temperature

Color temperature describes the spectrum of light emitted and is measured in degrees Kelvin. Here are approximate temperature measurements for various types of lighting: Tungsten bulbs (household) 1500–3500 K; fluorescent lamps 4,000–5000 K; sunset and sunrise (clear day) 5000–6500 K; overcast day 9000–1000 K. Understanding color temperature helps you make more informed white balance decisions in the field.

Automatic White Balance

By default, most digital video cameras are set to automatic white balance (AWB), which means the camera will automatically adjust for white balance, as well as other settings. Many video cameras also come equipped with additional preset options that can be chosen for specific lighting conditions such as daylight, shade, cloudy, tungsten, and fluorescent. The presets often perform better in very specific lighting scenarios than the automatic white balance setting.

Manual White Balance

The automatic white balance feature and white balance presets are very convenient, but in some situations, setting a manual white balance can yield better results. This is true in some circumstances where the automatic white balance overcompensates while attempting to balance the color in a given shot. When performing a manual white balance, you focus the camera on a white target and press a white balance button on the camera to adjust to light.

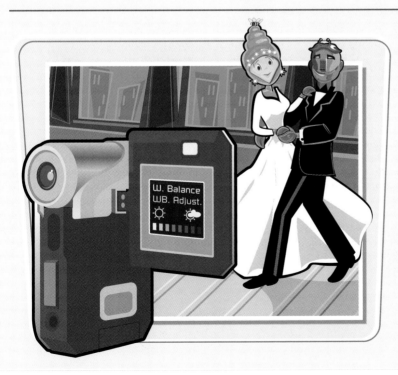

Use Auto White Balance Settings

Automatic white balance and white balance presets allow you to quickly adjust to the light in a scene. With this convenience also come some shortcomings in ever-changing lighting conditions. Understanding automatic white balance, white balance presets, and their shortcomings enables you to make better decisions when adjusting to various lighting conditions.

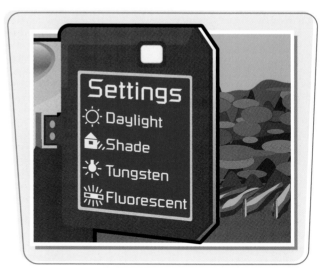

Automatic White Balance

By default, just about all cameras are set to adjust white balance automatically, meaning the camera performs the adjustments for various lighting conditions completely on its own. In essence, the camera performs calculations using the image from the image sensor to measure the color temperature of a scene the best it can. The automatic white balance is very useful when it is impractical to white-balance the camera manually during a shoot. The automatic setting is not as accurate as performing a manual white balance.

Automatic White Balance Issues

The automatic white balance can sometimes overcompensate to try and balance the color in a shot, such as when you zoom tightly into a face. The automatic white balance (AWB) feature is great for wide shots, but when you zoom into a face, depending on the skin, it can add too much blue to compensate. The automatic white balance also does not perform well in locations with mixed or multiple light sources. If the camcorder's white balance is adjusted for artificial indoor lighting, but the subject is bathed in natural sunlight pouring in from a window, this can result in muted colors and an undesirable colorcast as shown in this video.

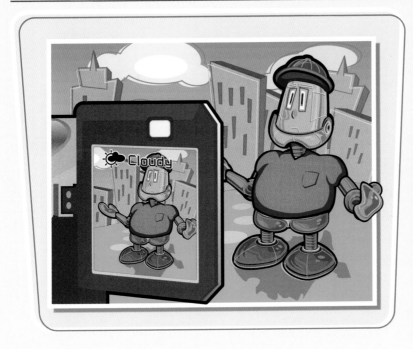

Preset White Balance Settings

White balance presets are preprogrammed camera settings that enable the videographer to make a selection in the menu system to quickly adjust for a particular lighting situation. If you are shooting on a sunny day, the daylight preset can adjust the white balance for that particular color temperature so that colors are accurately re-created. You can also use the settings for artificial light such as Tungsten and Fluorescent to adjust for indoor lighting. Some common white balance presets are Daylight, Shade, Cloudy, Tungsten, and Fluorescent. These presets are usually marked with symbols such as a sun, cloud, light bulb, and so on. The presets are not as accurate as a manual white balance.

Perform a Manual White Balance

Some cameras have a manual or custom white balance option. A manual white balance is usually the best option for accurate color reproduction. Performing a manual white balance means that you are providing the camera with a reference of what is true white. When you white-balance properly, the camera can most accurately reproduce colors in the scene. Understanding how to set a manual white balance can help you achieve the best color reproduction possible.

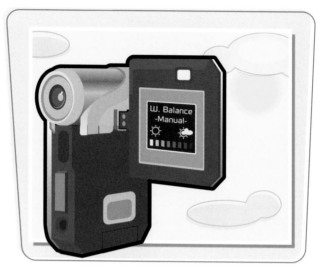

Set a White Balance

Setting a manual or custom white balance requires that you have something true white on which you can focus the camera. This can be a sheet of paper, white fabric, or a special white card made for such purposes. The white reference needs to be placed under the same lighting in which you are recording. You can go into the menu system and set the camera in manual white balance mode. Zoom into the white reference card so that it fills the entire screen and make sure that it is in sharp focus. Press the white balance button on the camera and the camera indicates when the white balance is complete.

White Balance at Every New Location

A manual white balance requires that you white-balance whenever the lighting changes. This can be from room to room, shooting indoors and moving outdoors, and even when the sun changes positions or goes behind a cloud. Always be aware of changing lighting conditions and adjust the white balance properly. Although some video editing programs have color correcting tools that can help with an improper white balance, the best results come from getting it right the first time.

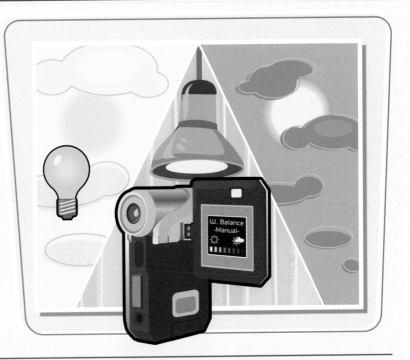

Inability to White Balance

If the reference card from which you are performing a white balance is over- or underexposed, you may be unable to perform the manual white balance, or at the least perform a poor white balance. Make sure that you perform a manual white balance in a place sufficiently well lit.

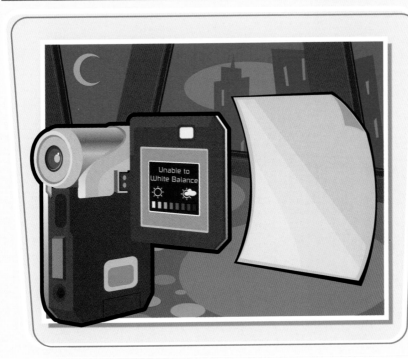

Use White Balance Settings for Creative Purposes

The white balance controls of your digital video camera have a direct impact on the color of your video images. You can use the manual or custom white balance feature of your camera to create a unique look and feel to your video. By understanding how to use white balance settings creatively, you can exercise more control of your video.

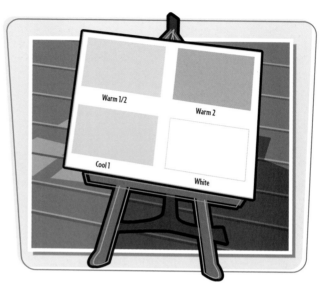

Experiment with White Balance Settings

The card that you use as a manual or custom white balance reference does not always have to be white. White balancing with cards that are different shades of blue and green, referred to as warm cards, can shift the entire range of colors in a recorded scene. You can create a warmer or cooler look for your video depending on which card you choose. Keep in mind that when you manipulate white balance settings creatively, the adjustments become a permanent part of your video. Although many of these effects can be achieved using color correcting tools in some video editing programs, warm cards can help you avoid processing the images in post production.

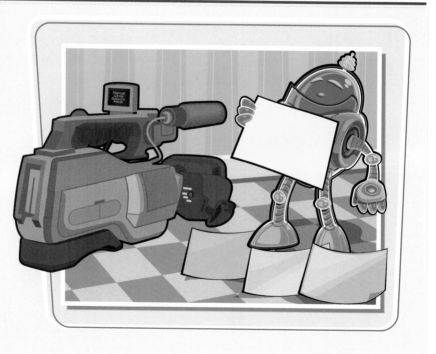

Cool It Down

Using a particular color shade as a reference neutralizes that card's particular shade from the image, shifting the entire color range. A card for a cooler white balance neutralizes warmer colors. A cooler white balance can provide a sense of suspense or even an unsettling feeling to your video. Make a cold scene look even colder or even less comfortable for creative purposes with a cooler white balance.

Warm It Up

You can use a warmer white balance to make a day at the beach appear especially bright and sunny. Warmer tones can be used to make neutral skin tones appear more vibrant, healthy, and flattering. You can choose from various shades of blue cards that can lessen or intensify the warming effect by eliminating cooler colors from the color range in the recorded video. When using these cards, make sure that color remains consistent throughout your shots, unless there is a specific reason for an aesthetic change.

Shoot Video Indoors

Without purchasing extra lighting equipment, most of your indoor shooting is done under the ambient light in a room, which can often be inadequate for recording high-quality video. If the lighting is not adequate, you notice more grain in your video. When you understand the challenges of shooting video indoors, you can better prepare for a successful shoot.

Deal with Mixed Lighting

Rooms can also have artificial light mixed with natural light let in through windows. This can cause problems if you are tracking shots across a room. As the light changes, the automatic white balance can fail you. Use stationary shots in a room with mixed lighting. If possible, avoid mixed lighting situations altogether or eliminate one of the light sources. Set a manual or custom white balance for more accuracy.

Use a Camera Light

Some digital video cameras come equipped with a built-in light that you can use if the lighting is inadequate. If your camera does not have a built-in light, you may be able to attach a camera-mounted light to the hot shoe located on top of the camera. Neither one of these options is ideal because built-in camera lights and mounted lights cast a hard light, but they can provide acceptable results. Make sure that the light is placed just below eye level of your subject to avoid creating any heavy eye shadows. Make sure that the subject is far enough way from any walls to eliminate shadows in the shot.

Set Up Extra Lights

An inexpensive lighting setup can do wonders for an inadequately lit room. A basic lighting kit with two floodlights, stands, and umbrellas for diffusion can provide you the light you need to adequately light your video. One light may serve as your lighting kit, but two or even three can prove much better for achieving the best-looking video. Multiple lights provide flexibility when shooting interviews or just improving the overall light in a room.

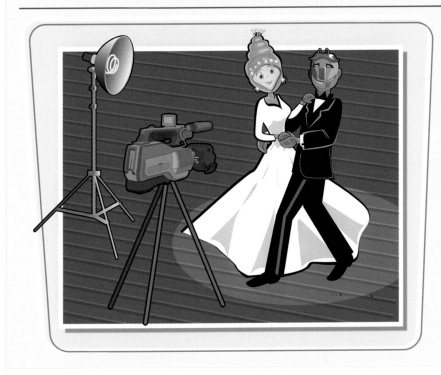

Use a Camera-Mounted Light

A camera-mounted light or a built-in light can be a minimal but effective lighting kit for general shooting. When shooting on the run where no other light is available, a single camera-mounted light can provide acceptable results. With that being said, camera-mounted lights have their drawbacks. By knowing your options for lights and understanding the issues that arise when using camera-mounted lights, you can make better decisions when using them.

Camera-Mounted Lights

Camera-mounted lights are small and create flat light, which is not flattering to the face. Lights such as these are akin to shining a flashlight directly into someone's face. The hard, concentrated light that camera-mounted lights produce can cast well-defined shadows from your subjects if you shoot them close to walls. If your goal is to remain inconspicuous during the party, a camera-mounted light does not help you do this. Camera-mounted lights work very well for run-and-gun shoots such as adventure racing, where you are forced to shoot in multiple lighting conditions, including low light conditions such as in shaded areas and caves. These lights are also good for countering strong backlight on a subject.

Soften the Light

One way to soften and diffuse the hard, concentrated light of a camera-mounted light is to use a light-diffusing material called Tough Spun. This material can produce a wider, less-intense light source that is kinder to video. The Tough Spun material is especially made to withstand the heat of concentrated lights much bigger and hotter than are used with small consumer cameras. For this reason, if your camera is small, you will have to cut the material to fit over your particular light, and attach it with a clamp.

LED Lights

A more practical choice for a consumer camera-mounted light is LED lights. These lights are compatible with most digital video cameras and attach to the hot shoe located on top of the camera—and, they do not get hot. Many boast that they are many times brighter than the standard bulb, but make sure that you read consumer reviews before investing in one. Some have built-in diffusers for more even lighting, and you will have to charge them between uses. These lights can be found in your local electronics store as well as online.

Do not aim a concentrated light source straight at your subject without some kind of diffusion. Diffused, even lighting is most kind to recording video. The ability to diffuse your lighting source, whether it is your floodlights or the sun, is essential to shooting great video.

Reflective Umbrellas

Although not appropriate for every location, reflective umbrellas can be a wonderful addition to your light accessories by providing even lighting for recording interviews, taking headshots, or improving the overall light in a room. You shine your light source into the umbrella, and the diffused light is cast back onto the subject. Reflective umbrellas also give you control over the direction and angle of the diffused light on the subject. You can find light kits, reflectors, and diffusers at photography and video stores.

Diffusing Gels

Gels are sheets of heat-resistant material, such as polyester or polycarbonate, which can be placed between the light source and the subject being lit. The purpose of the gel is to spread the beam of light, or filter the light, while maintaining the specific attributes of the gel itself. Many times this material is clipped to the light itself, but sometimes gels are applied to windows to diffuse the incoming sunlight as it enters a scene. Gels can be used to correct a lighting problem, like correcting tungsten lighting to match daylight or vice versa.

Use Surfaces to Diffuse Light

If you have the lights but no reflective umbrellas, you can aim the light at the ceiling or a wall and let the diffused light cast back onto the subject. A white surface is the most evenly reflective and tends to work best. Be mindful that the height of the ceiling can be a determining factor in the success of this lighting practice. If the ceiling is too high, the amount of light cast back onto the subject may be too little. If the ceiling is too low, the amount of light cast back onto the subject may too intense. Go with what looks good in the eye of the camera.

Inexpensive Diffusion Methods

You can use poster board to diffuse light and redirect it to your subject. You can have someone hold the poster board while you shoot, or if your ceiling is not white, you can tape poster board to a surface. When using homemade do-it-yourself solutions such as this, always be mindful of safety. Lights are hot, and if you set them up too close to the poster board for extended periods of time, the material may start to smoke and eventually catch fire.

Use Three-Point Lighting

Studio photographers and filmmakers have used the basic three-point lighting setup for many years to add more visual depth to their subjects. Understanding the basic guidelines of three-point lighting not only helps you to present more compelling subjects, but it also puts you well on the way toward creating more creative and dramatic lighting schemes for your videos.

Three-Point Lighting

The three-point lighting setup helps shape the subject using light and shadow for a more compelling and dramatic image. The three-point lighting setup involves as many as three and as few as one light placed in specific locations around the subject. Each light in the set performs a specific function in shaping the image. The suggested angles for the three-point lighting setup are not meant to be exact instructions, but merely starting points. Videographers use all kinds of light combinations to achieve the look they desire.

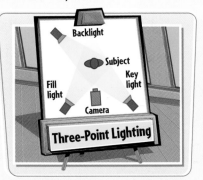

Key Light

The key light is the primary light source for your subject and is usually the strongest of the three. This light is usually placed at the half past seven or half past four o'clock position, to the left or right of the subject, shining on the subject at a 45-degree angle from above, aimed at the face. The key light can be a single floodlight with a narrow beam, but beware: When used alone, the light can create hard shadows on the subject and be unflattering to skin tones.

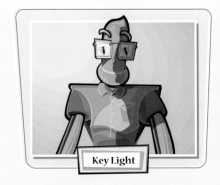

Fill Light

The purpose of the fill light is to soften and reduce shadows created by the key light and is about half the intensity. The placement of this light is very subjective, depending on the feel you are going for. The less fill light you use, the more contrast you create on the subject, giving a more dramatic feel. More fill light provides more even lighting, as is often used in news interviews. This light is placed at the four or eight o'clock position on the opposite side of the key light, raised to shine from a 45-degree angle above the subject. So if the key light is at the half past four o'clock position to the right of the subject, the fill should be at the eight o'clock position to the left.

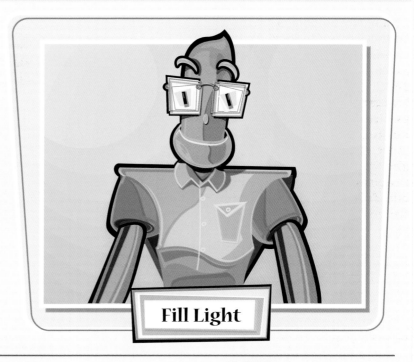

Fill Light

Backlight

Backlight provides light to the back of the subject, from a slightly elevated position to separate the subject from its background. This light is placed at the half past ten or half past one o'clock position with the light shining on the subject's head and shoulders, from a raised 45-degree angle.

Backlight

Shoot Video in Sunlight

Few environments offer the aesthetic benefits of shooting in the majesty and beauty of the great outdoors. With that being said, shooting outdoors does have its challenges. As the position of the sun changes throughout the day, so do quality, quantity, and direction of the sunlight. You must make sure that you have proper white balance and exposure. Automatic settings can perform well, but a manual white balance ensures that your whites are truly white. Being able to adjust to changing outdoor conditions is crucial if you want to produce the highest-quality outdoor video.

Adjust the LCD Display

When shooting in bright sunlight, the LCD panel of the camera can become increasingly difficult to see. If you rely heavily on the flip-out LCD to compose your shots, you need to know how to adjust the LCD display so that you can continue to monitor the shot. Some digital video cameras enable you to adjust the brightness of the LCD display for easier viewing in various lighting conditions.

Consider the Position of the Sun

The position of the sun can play a major role in how you set up for a shot. As a rule of thumb, lower the contrast by choosing an evenly lit area to shoot. If you are in a situation where you do not have a way to diffuse light, shoot the subject with the sun at your back and your subject facing the camcorder. If the sun is unobstructed and is facing the back of the subject, and you point the camera into it, you are likely to get a halo effect around the outline of the subject. You will also get lens flare, glare, and an underexposed subject.

Reflect Sunlight

You can choose a place in the shade in which to shoot your subject. If too much light is being blocked from the subject and the shot is too dark, you can always redirect sunlight to your subject with a low-cost reflector or even a white poster board. In this scenario, the reflector becomes the primary source of light. With the obstructed sun behind the subject at about the eleven or twelve o'clock position, you can stand the reflector between the four and eight o'clock position to bounce in some light. Keep the reflector close to the subject and just below eye level to limit the shadows around the chin, nose, and eyes.

Diffuse Sunlight

Buildings and trees are natural diffusers of light. Also, if you can wait it out, wait until the sun dips behind a cloud to begin recording. Clouds soften the rays of the sun before they reach the objects on the ground, resulting in more even, soft light. Another option for shooting in hard, direct sunlight is to diffuse the sunlight with a translucent white material of your own. You can place a white bedsheet between your subject and the sun to act as a diffuser. Use clotheslines, stands with clips, or even two friends to hold the material above the subject. This way, the light will be scattered before reaching the subject.

Use Lens Filters

A neutral density (ND) filter is an accessory that attaches directly to the front of the camera lens and helps to reduce the intensity of light on a bright day. There are times when the subject is evenly lit, but too much light is getting through the lens, resulting in an overexposed image. If your camera accepts lens filters, you should have this filter with you at all times before going out to shoot in sunny conditions.

Utilize Lens Filters

Some video camera accept lens filters, which are specially crafted glass that attach directly to the camera lens and are used to manipulate light as it enters the camcorder lens. Some have practical purposes such as filtering out ultraviolet (UV) light to reduce haze and blue cast; others are used to create effects. When you use filters to achieve a certain aesthetic while acquiring the image, the less you have to do in post. The only drawback is that the effect becomes a permanent part of the video and cannot be removed. By understanding the effect and use of lens filters, you are able to make better decisions on which are right for you.

Ultraviolet (UV) Filters

Ultraviolet (UV) filters are mainly used to protect the lens of a camera, and they also prevent blue colorcasts from appearing in your video when shooting at high altitudes. Consider using a UV filter when shooting in environments that you think may prove hazardous to the lens, such as sandy and dusty conditions. Be mindful that although UV filters offer great protection, they can sometimes cause lens flares and internal reflections, so consider going without, unless it is necessary. Make sure that you purchase the best multicoated UV filter you can afford because you do get what you paid for.

Neutral Density (ND) Filters

An ND filter is a neutral-colored or gray piece of glass that reduces the amount of light that can pass through the lens by absorbing light evenly throughout the visible spectrum. This particular filter does not affect the overall color of the image, so it is great for preventing overexposed video while shooting on a bright, sunny day. One particular type of ND filter is a graduated/gradient filter, which is heavily tinted at the top and fades to transparent at the bottom. The graduated filter helps tame the brightness of the sky but does not darken the rest of the image.

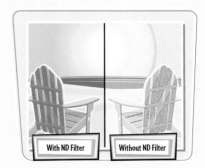

With ND Filter Without ND Filter

Polarizing Filters

Polarizing filters reduce glare in water, glass, and other shiny, nonmetallic surfaces. This is a great filter to own if you expect to shoot through display cases. Polarizing filters also intensify colors, making them bold and rich, so they are great to have when you are shooting vegetation and flowers to showcase their vibrancy.

Color Correcting Filters

Color correcting filters can be a creative tool to help you set the tone for a short film. A cool blue or green tint can lend an air of mystery, whereas highly saturated warm colors can add an upbeat feel. Keep in mind that whatever effect you achieve with your lens is permanent. To keep your options open on how you will use the video in the future, consider adding effects such as these during the editing process.

Shoot Video in Low Light

Digital video cameras on the market today are a lot more sensitive to light than what they were just a few years ago, but without extra lighting accessories, producing a high-quality image in very low light is hard. You need to understand the nuances of shooting in low light with your camera and how to address them before you begin the shoot.

Examine the Characteristics of Shooting in Low Light

The video you record in low light is not going to look as good as the video you shoot in a well-lit environment. Video shot in low light can be grainy, and your automatic focus is not as responsive or accurate as you are used to. When shooting in low light, look for opportunities to carefully compose shots that contain highlights, playing on the ratio of darkness to brightness for interesting shots.

Avoid Zooming

When you increase the camera's focal length by zooming in, in turn, you are reducing the amount of light entering into the lens, making the subject even darker. This makes your subjects darker in the eye of the camera. Pull the zoom all the way out and use wide angles. If you need a closer shot, physically move yourself closer to the subject to get the shot you want. The image stabilizer is also less effective when shooting in extremely low light situations, so minimize your movements and use a tripod to stabilize the camera.

Use Extra Lights

Bring your own light accessories if there is no extra light at the location. A camera-mounted light is perhaps the most minimal lighting setup you can have, but it can be obtrusive. If there is a chance that it can disrupt the event, make sure that you get permission before you use one. If it is an important event, bring a lighting kit. A relatively inexpensive, basic lighting kit can consist of two floodlights, stands, and umbrellas for diffusion. Be sure that you have the space and the electrical outlets to set up all of your equipment before you arrive at the shoot.

Consider Night Mode

You can use the night recording mode on your camera to record in low light conditions. If you are unsure if your camera possesses such a mode, check your camera manual. Keep in mind that motion blurring can occur with fast-moving objects, given the use of a low shutter speed in this mode, and the autofocus can also struggle. Focus manually when possible.

Consider the Gain

Some cameras have a gain feature where the signal from the image sensor is amplified for a brighter picture. This feature is convenient for low light situations, but beware: This feature compromises the quality of your video. The higher you set the gain, the more noise or grain appears in the picture. Consider using the gain feature when you have already opened the aperture as far as it can go by setting it to the lowest value and the shutter speed is low, but the image is still too dark. Use this feature sparingly.

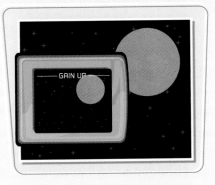

Practice Safety

Shooting in dark environments can be dangerous, so always take precaution to ensure that no one gets hurt. Bring flashlights to help you set up in the extreme darkness and secure any wires or cables that could be tripped over. If you are shooting in an environment unknown to you, keep an eye on the perimeter for any strangers who may invade your shooting space. Make sure that cell phones are fully charged in case of an emergency.

Solve Backlight Problems

A powerful backlight on a subject standing in a dimly lit area can cause problems for a digital video camera. A backlight much brighter than your subject can make the subject appear underexposed or overexposed depending on which light you compensate for. You can follow these tips to help eliminate backlight issues in your video.

Avoid Bright Backgrounds

The best way to combat backlight problems is to avoid them altogether. If possible, try moving the location of your subject to a more evenly lit area. If you are outdoors, try using natural diffusers of light such as trees and buildings. Do not shoot your subject with his or her back to the unobstructed sun on a clear day. When shooting indoors, avoid placing the subject in front of a window with bright sunlight pointing in. Choose your shooting location carefully and keep in mind that video likes soft, diffused, even light.

Perform a Manual Exposure

The camera's automatic exposure can overcompensate for the powerful backlight and properly expose for the brightest parts of the images, making the subject too dark. If your camera enables you to set exposure manually, do so, and expose properly for the subject. By manually setting exposure, you are able to focus on the detail present in the main subject, even though it stands against a very bright backdrop.

Add Extra Light

To balance the lighting, you can add another light source to increase the light falling in front of the subject. It may be a light on a stand, overhead lights in the room, or a camera-mounted light. Narrowing the dynamic range, the disparity between the lightest and darkest parts of the image, makes it easier for the camera sensor to capture the scene. In a mixed lighting situation, make sure that you manually set the white balance to get a proper setting.

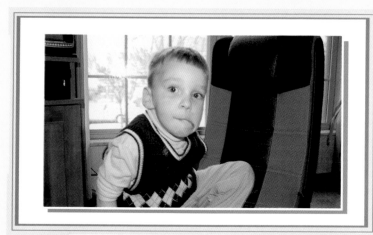

Use Automatic Backlight Correction

Some video cameras use automatic backlight correction, which automatically adjusts for a backlit subject that has been under- or overexposed. You can simply hold down this button on the camera when shooting a strongly backlit subject and let the camera make the necessary adjustments for a better exposed scene, as seen in this video.

Basic Principles and Event Videography

Shooting great video takes practice and patience, built on a firm understanding of common video principles. The quality of video that you produce is directly affected by either your success or failure to adapt to various shooting environments. In this chapter, you learn important video principles that help you get the best shot, as well as explore ways to help you find the story in your video. You learn how to get the most out of your camera, by mastering its functions and discovering tips on shooting high-quality event video.

Explore Important Video Principles

Shabby camera work can undo all of the preparation that you put into creating a great video. If your footage looks like garbage, making it appear as gold in the editing bay is impossible. When all is said and done, people are going to judge your video by the way it looks, as well as how it was executed. Following some common camera principles during recording can go a long way in helping you put together a great video.

Frame the Shot

Frame the shot in the viewfinder or the LCD before you push the record button. Your audience will greatly appreciate it if you avoid roaming aimlessly trying to find something to shoot while the camera is recording. This means that you have to know what you want to shoot. Quickly bouncing from shot to shot without defining a clear subject is frustrating for viewers because they never get to see anything clearly.

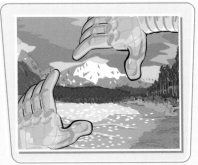

Hold the Shot

Try to hold a shot for at least five seconds or longer, and save the snapshots for still photography. Recording very short scenes of only two and three seconds is really not helpful to you when you go to edit the video. Really short scenes can make your video appear choppy and erratic. This tends to happen when you try to capture everything happening around you. Often you discover that you missed the best video by not staying with a shot long enough. Give your audience a chance to process each shot before you move on to the next.

Mind the Backlight

While using automatic exposure, avoid placing your subject against an extremely bright backdrop because it can result in the underexposure of the main subject. The automatic exposure can become confused as it attempts to compensate for the extremely bright background, rendering the subject as a silhouette. This can occur when shooting subjects against a bright sky, ski slope, or in a poorly lit room where your subject is standing in front of a window with bright light pouring in.

Minimize the Zooming

Avoid excessive zooming during recording and step into the shot when possible. Use the zoom on your camcorder to help compose shots, but do not overdo it. When you need to zoom while recording, make it slow and methodical. Too much zooming while recording can be a distraction and is the mark of an amateur.

Keep It Stable

Avoid excessively shaky video by using a tripod, monopod, or any other camera-stabilization device when possible. The image-stabilization capability of the camera can only do so much. If you need to track with the camera, try to limit most of your movement to forward and backward rather than up and down. While walking, try holding the camera away from your body, and let your arms and legs absorb some of the shock.

Capture the Story

How you frame the myriad stories occurring around you with your video camera is ultimately up to you, but do so purposefully. No one sees the world quite as you do, and this is a very powerful tool in your creative arsenal. Understanding how to formulate a story and convey a message with your video cultivates both originality and purpose in your videos.

Uncover the Story

To find the story during the editing process you have to be looking for it during the shoot. How you go about finding the story can vary depending on what you are shooting. During a mountain bike race, it could be a grandmother completing her first competition. In this instance, the story may not always be evident and you may have to dig for it. In other cases it may be more obvious, such as a piano or dance recital. Even in these examples there may be an angle on which to concentrate. Perhaps the story is intrigue and a little bit of mystery, as shown.

Shoot, Then Shoot Some More

Practice makes perfect. You will never know if an idea that you have for a video will work unless you try it. Sometimes an idea may play better in the mind's eye than it does on-screen. A great way to get some practice is to make a simple movie set to music. It can be as simple as recording your kids around the house with some light, playful music, or depicting how dreary it is on a cold and rainy day. Shoot the scenic areas of your hometown and make a music video.

Write a Script

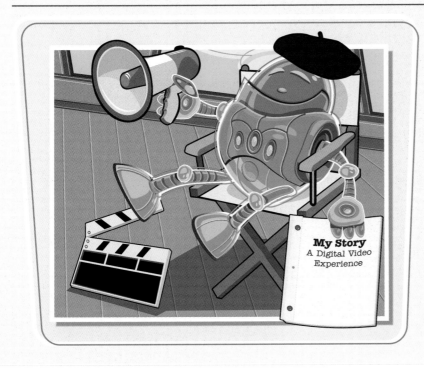

You can practice putting your story in the form of a script; then plan and shoot the script. This can be a fun, yet demanding process. There are many script-writing applications for you to try, ranging from free to quite expensive, that can get you going, and a ton of books on how to write scripts. Many people use Microsoft Word to write their scripts. Start small and then work your way up. Practice putting together a simple scene where a character leaves his living room, gets into his car, turns on the ignition, and then drives away. This can really help you practice varying shot angles as well as give you a chance to edit a story together.

Achieve Shot Continuity

Continuity in camerawork is very important to the aesthetic value of your video, and consequently, to the message you are trying to convey. The color, exposure, and contrast of each shot should be consistent as you cut between them. Unexplained inconsistencies direct the audience's attention to the content of the production rather than the story. Here are some things to look for to ensure that shot continuity is maintained throughout the video program.

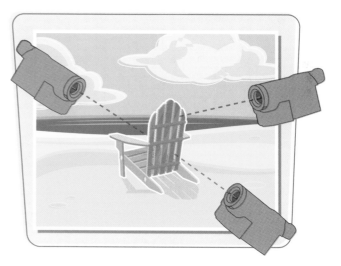

Maintain a Sharp Focus

Maintain a sharp focus from shot to shot. If your focus is sharp on a subject in one shot and soft the next, the inconsistency lowers the quality of your camerawork and is distracting to viewers. If your camera utilizes an automatic focus only, beware of objects passing between you and the subject, which can cause focus shifts. If your camera has a manual focus ring that lets you adjust the focus on the actual lens, use the manual focus and keep the subject in focus.

Mind the Color of Light

Make sure that you properly white-balance your camera to adjust for changing light situations, if you do not, the aesthetic change that incurs may not be desirable. If you are recording someone on an overcast day, make sure that you white-balance under those lighting conditions for a proper color balance. If the sun comes out from behind the clouds, perform a white balance. Be mindful of constantly changing lighting conditions and shoot accordingly.

Watch the Exposure

Light paints every image that you capture, so make sure that your exposure is consistent from shot to shot. If you are using automatic exposure control or setting exposures manually, make sure that you adjust them whenever the lighting situation changes. If there is a significant change in the quantity of light between each shot for no apparent reason, you break continuity and your story quickly becomes a mere series of disconnected shots.

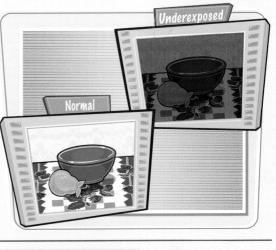

Keep Lighting Consistent

If your shooting schedule is broken up over a period of days, take notes on the lighting setup and exposure settings so you can maintain the same lighting style when you reconvene. Take notes on the positions of the lights, the height of the lights, and light intensity to maintain continuity throughout the entire

Mind Scene-to-Scene Audio Levels

Each location that you shoot contains its own unique ambient noise. Inconsistencies in ambient noise levels, especially when they go from very loud to very low, and for no apparent reason, can make your video appear choppy to an audience. Many of these abrupt transitions can be softened during the video editing process, but save yourself a lot of work and watch out for these issues while recording.

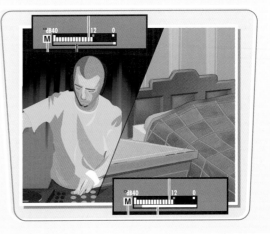

Avoid Timecode Breaks

Timecode is a method associating frames of video in a clip with a unique, sequential unit of time in the format of hours:minutes:seconds:frames. The camera creates the timecode, and the video editing software controls the DV device that the tape is in (the camera) when capturing. If the timecode is broken in an area, capturing the footage can be very difficult. These practices can help you avoid timecode breaks when using a tape-based digital video camera.

Avoid Reviewing Tape

Avoid reviewing the footage between shots. When you try to find where you previously stopped recording to begin recording again, you most likely will not be able to find the exact spot. Not only is it possible to record over the footage you have already recorded, but you could leave a small gap between scenes. This can result in a timecode break that can later impede the capturing process.

Use the End Search Feature

Some digital video cameras have an end search feature that enables you to avoid timecode breaks after reviewing the tape, by preventing gaps between recorded scenes. You can place the tape back into the camera and press end search, or select it from a menu, and the camera cues the tape to the point where the last recording finished. You can then continue shooting from where you previously stopped, preventing a gap and subsequent timecode break.

Pad Before and After Takes

If you must review the tape between shots and your camera does not have the end search feature, leave seven or more seconds of space/pad before and after each scene as you shoot. This method does not prevent timecode breaks, but it does leave enough room for the video editing application to back up and capture the individual scene in its entirety. Some video editing applications are more automated in their approach to handling timecode breaks; others prompt you to configure how you want to deal with them.

Explore the Zoom

A zoom is a change in field of view, enabling you to go from a wide-angle view to a close-up. Zooming into a subject is a great way to capture its details, whereas zooming out to a wide angle can capture wide vistas or the totality of a given scene. Understanding how to best use the zoom in your video can help you produce higher-quality movies.

Discover Benefits of Zoom Speeds

Some digital video cameras enable you to change the speed of the zoom by choosing a slower or faster setting in the menu system. Zooming in for a close-up at a sporting event may call for a faster zoom speed than is needed for shooting a recital or a play. A faster zoom speed may work better for sporting events to catch those one-shot moments, whereas a slower zoom speed when shooting your child's play can supply you smooth, graceful movement.

Step In and Out

The zoom is often overused in amateur video, so keep it to a minimum. When possible, move into the shot to get close to the action instead of increasing the focal length. Never put yourself in danger to get a shot, but look for opportunities where you can mix it up with your subject matter and put the audience right there with you, as shown.

Fake a Whip Zoom

A whip zoom is a very quick change in the field of view performed with higher-end cameras that possess zoom levers. To best illustrate a whip zoom, picture a wide shot of an actress, where she can be seen from a distance, and a lightning quick zoom into a tight shot of her face that seems to happen instantly. This technique can be faked in the editing room. Shoot the wide shot, stop recording and zoom into the subject for a tight shot, and begin recording again. In the editing room, cutting from the wide shot to the close-up will appear as a whip zoom. There are also software and sound effects available that you can use to make this effect even more profound.

Examine Digital versus Optical Zooming

Most digital video cameras on the market have a digital zoom feature that boasts incredible zooming prowess, but beware. When you have surpassed the maximum zoom capability of the camera's lens (the optical zoom) by zooming in as far as possible, the digital zoom is activated. During this process, the digital zoom feature simply enlarges a portion of the image, simulating an optical zoom and degrading the image. You may want to disable this feature before you shoot. Consider investing in a telephoto lens adapter to increase the optical focus of your camera and stay away from the digital zoom.

Get Comfortable with Camera Settings

Mastery of your camera settings is essential to the success of your video shoots. The ability to call upon a feature or configure a setting for the optimal picture is a must if your goal is to produce high-quality, professional-grade video productions.

Camera Modes

Some digital video cameras do more than shoot digital video, so they need to be placed in specific modes. To take a still photo, you may need to be in still image mode; to shoot video you may need to be in a movie mode. To play back your video or review your still photos, you need to know how to place your camera in the appropriate modes. Get in the habit of having your camera in the proper mode when out in the field. You may have only one opportunity to get the perfect shot.

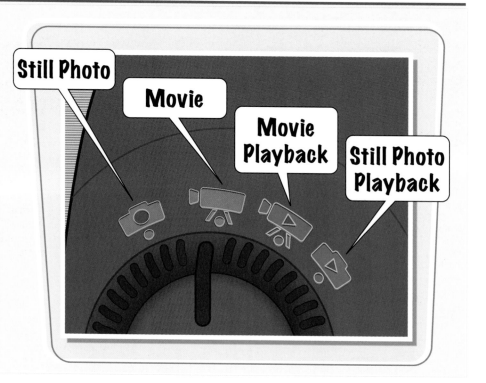

Camera Features

The features of your camera, such as automatic focus and manual focus, are generally the selling points that compelled you to buy the camera in the first place. When you are out in the field, it is not good enough just to know that your camera can do something; you need to know how to implement it at a moment's notice. You can take the camera manual with you, but you may not have the luxury of thumbing through the pages when you are on the spot. For example, if you are shooting in low light conditions with no lights, you need to know that you camera has a built-in video light.

Camera Settings

Many of the digital video cameras on the market can produce a pretty average image if all you want to do is point the camera and shoot. If you want more than a decent image, you need to become a student of your camera. You may not agree with the aperture value or shutter speed that the camera chooses automatically, so you need to know how to go in and tweak it to your own liking. Read the manual, practice and experiment with settings, and then review the footage.

Change Up the Perspective

Always look for the most interesting angles from which to frame a shot to add extra impact for your video. No matter if you are creating a corporate training video or a calling card video for a career in Hollywood, your work has to be visually interesting. Add interesting new perspectives in your video project to hold the audience's attention so that you can get your message across.

Get a Bird's-Eye View

If you ever get the opportunity to go up in a helicopter and shoot some video, do it! Aerial shots provide audiences a chance to view the world from a perspective that they seldom ever see. A quick pass over a snowy mountain range or a beautiful bird's-eye view of a marina in Hawaii can provide your video the WOW factor. Aerial shoots can be dangerous, so make sure you receive proper instruction and are working with professionals.

Low-Angle Shots

Low-angle shots can be very dramatic and are used to emphasize the stature of a person to evoke respect or even fear. They can also be used to add extra emphasis to the enormity of an object, like a skyscraper. Many times the backdrop of low-angle shots is the ceiling or sky, which can have a dramatic effect on exposure, so be careful when composing such shots.

High-Angle Shots

High vantage points are great for showing the lay of the land below. Elevating the camera above the action enables you to showcase many subjects and their relation to each other in the scene. What is lost in the absence of detail in each individual object, due to its smallness in stature as seen from a high angle, is made up for by its collective intricacies in the wide vistas of this nicely composed shot.

Establishing Shots

In film and video, an establishing shot is used at the beginning of a new scene to show the audience where exactly the action is taking place. For example, many sitcoms use a wide shot of the outside of a building just before a cut to a scene happening on the inside of the building. You can use establishing shots in your narrative videos to help the audience follow the story.

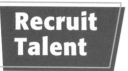

As you become comfortable with your camera and your overall video-production abilities, perhaps a short movie may be your next challenge. You have the equipment and the will; what you need now is the talent. There are a few points to consider when acquiring talent to appear in your videos. Whomever you get, protect yourself and have them sign talent release forms.

Use Friends and Family

Perhaps not the most highly skilled actors of the acting pool to choose from, but friends and family are a great place to start when looking for talent. Be prepared to wear many hats when making a short movie, most noticeably for this topic, that of casting director. Your job is to find actors to star in your movie that best fit your artistic aim. So, if Aunt Millie does not like speaking very much, do not cast her for a large speaking role. Friends and family are the most likely to work for free.

Find Amateur Actors

You can approach theatre students at the local college about being in your film. Being that they are in the building stage of their careers, they may be willing to work for the chance to put together a reel of their acting talent to show future employers. You can also seek potential talent by using MySpace, YouTube, and other social networking sites. When you put out the casting call, be prepared to get bombarded by tons of people who may or may not be what you are looking for. The audition can be informal, but make sure you print their speaking parts and have them act for you.

Campus Notices

Actors Wanted!

Actors wanted to appear in short, 45 minute video. No pay, but copies of video will be given to participants for their portfolio.

Actors needed:
- Male, scholarly, to play professor
- 6 young males/females to play students
- 1 male/female to play murderer
- 1 female to play murderer's sister
- 1 female to play detective
- 1 male to play coroner
- 1 male/female to play corpse

Off-campus Apt.
$300 month
· Nonsmokers
· No pets
Call Bill 555-5132

LOST
Burmese python named
'Sweetie'
Call Andrea @
555-7576

The thief crept quietly into the room, his eyes dangerous...

A Stranger is Watching

Acquire Voiceover Talent

Voiceovers can help your viewers follow the story. Finding voiceover talent could be as simple as noticing someone at your workplace or at the local convenience store that has a great voice, and asking them to audition. Voiceover work involves some acting skill, so choose wisely. If you can find someone who has done work in radio, you are already ahead of the game. Consider renting a soundproof booth for the best results during recording. For a cheaper option, you can invest in a good USB microphone and soundproof a room as much as possible.

Explore Event Videography

The art of capturing special events on video could very well be your next great business idea. Many videographers gravitate toward event videography as a hobby and sometimes a career. But make no mistake about it, documenting events on video can be a difficult venture if you do not know what you are doing. You can use these tips to help you capture the highlights of an event.

Anticipate the Course of Events

Many events have a program or schedule of events; secure a copy of the program and use it to plan your strategy. A printed program is an excellent way to see what will happen next. If there is not a program, contact the event coordinator and make a list of your own. Ask the coordinator if you can confer with her during the event. Many times event coordinators will be extremely busy, but can prove a good resource if you need to make a special request for lighting, sound, or a place to set up.

Devise a Course of Action

Use the program and talk to your client to help you prioritize the course of events into essential shots, shots you would like to get, and bonus shots. Factor in to your planning that some events may not happen when they are scheduled, and devise a list of must-have shots in each category. If you miss any of the big events, your video and your credibility as an event videographer can be damaged. It may help to bring an assistant.

Scout the Location

Visit the location or attend a rehearsal before the event and take note of where the electrical outlets are located and where you can possibly set up. Assess the lighting situation by visiting the location at the same time of day it will be held. Evaluate the best setup for sound. Will there be a PA system? Will you need special equipment to connect to the PA system, or do you need to place a microphone directly on the speaker? Good sound and proper lighting can be the most difficult tasks in event videography.

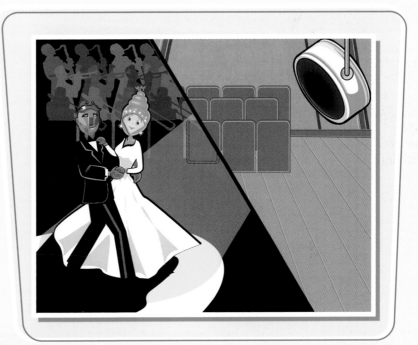

Examine Prosumer versus Consumer Performance

Consumer cameras are capable of taking brilliant images in general shooting situations, but the prosumer cameras are superior when it comes to shooting in highly volatile situations such as event video. This is on account of the increased manual control over the image that prosumer cameras offer. Automatic focus, exposure, and white balance can be a gamble in a constantly changing shooting environment. Prosumer cameras may also offer more audio options.

Record Amateur Sporting Events

Although each sporting event can require very different coverage, there are some basic points that can help you shoot better sporting-event videos.

Come Prepared

Whether you are shooting the entire game or getting the highlights, one thing is for sure: You need to have access to an electrical outlet or have a decent supply of batteries. You need to record each play to capture all of the highlights. You get only one chance to capture the ball going into the goal or a player crossing the goal line, so watch your battery power. Use the down time to switch batteries if you need to. The last thing you want is for the battery to die as the team charges down the field for a goal.

Set Up a Second Camera

Although you can cover a sporting event with just one camera, two provide more flexibility and wider coverage of the event. Having a second camera enables you to record multiple angles at once. One camera can be placed on a tripod at a wide angle covering all of the action, and the second camera can get the close shots. For sports that use goals on each end, like football, make sure that both cameras are set up on the same side of the field. When you sync both cameras for the edit and cut between the shots, the audience would be confused as to which direction the ball is supposed to be moving.

Avoid Shooting from the Stands

You have probably seen it before, and your first instinct may be to shoot from the stands, but do not. During the course of the game, spectators sit and stand, blocking your view of the action. You could also be directly in someone's view as you stand and twist and turn to follow a fast break down court. Finally, if you are sitting in the stands, you are most likely holding the camera with your hands. Avoid shaky video and put the camera on a tripod.

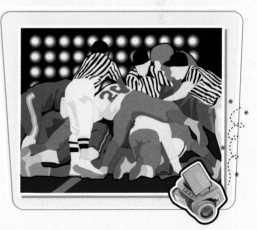

Avoid Shooting from the Sideline

Do not ever set up too close to the sideline; you might just find yourself in the direct path of a charging athlete. Consider using a telephoto lens adapter that can help you move in closer to the action. If your camera allows for it, use a manual focus to avoid excessive automatic focus shifting. Some cameras have a peaking function to help you see what is in focus by highlighting the edges of the subject in yellow, red, or blue.

Choose an Elevated Position

If you are shooting a video for a coach as an instructional video for the team, consider an elevated position in the rafters or to the side of the stands. From this vantage point all of the players and their positions on field can be seen at once during the action. These types of videos are more informative than entertaining, so as long as you follow the action, aesthetic value is not so big a deal.

continued

Record Amateur
Sporting Events *(continued)*

Even if you have little experience shooting sports, or limited experience using video cameras, there are some things you can do to ensure the success of the shoot. This section gives you tips on how to follow fast-paced action, set up your camera, and prepare for the shoot.

Follow the Action

A common occurrence for amateur videographers is they often lose the subject in the frame. This is particularly a problem when the videographer is not familiar with the particular sport he or she is shooting. If you are not familiar with a sport, spend some time watching it so you become familiar with where the play is happening. With one eye pressed to the viewfinder, you can occasionally use the other eye to assist you in following the action. If all else fails, zoom out to a wide shot until you find the action, and then zoom back in.

Practice Courtesy

Be courteous to those who are trying to enjoy the game and also to other videographers like yourself. Do not stand in other people's shot, and if you can, assist someone else on your down time if he or she needs you. If you shoot many games, you will likely discover that you see the same videographers every weekend. You may even get to know their names and you might need them for a favor one day.

Set the Shutter Speed and Gain

If you are shooting indoor sports, try a 1/100 shutter speed. 1/250, 1/500, and 1/1000 are great options for recording fast-moving objects, and 1/2000 is a good shutter speed for taping outdoor sports on a sunny day. When the evening game turns into a night game, the light may not be sufficient regardless of how far the aperture is open. Although it degrades the image, you can use the camera's gain feature to see the action.

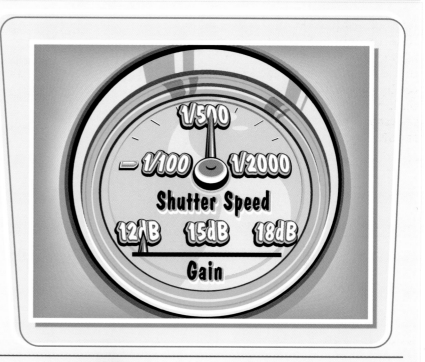

Use a Tripod or Monopod

A tripod or a monopod is great for keeping the camera steady during a shoot. If the area from which you are shooting is limited on space, a monopod may be exactly what you need because it takes less space on the ground. Setting up a tripod in a tight area can lead to it being kicked or bumped during recording. A monopod enables you to fit into a smaller space to shoot while keeping the camera steady.

Record Plays, Concerts, and Recitals

When recording events such as plays, concerts, and recitals, the videographer usually has little to no control over the sound or lighting. In fact, the lighting can actually change during the course of the performance. Preparation and adaptation are key in successfully shooting performances.

Know Your Audience

Are you shooting for the dance company, or are parents the ones buying your video? If the client is not happy, you will not be happy either. Knowing what your audience expects from you can help you decide where to place your emphasis in terms of shot selection. If the parents cannot see their daughter on stage at all times, they may be very disappointed. Understand the purpose of the video from the perspective of your audience so that everyone is happy in the end.

Consider Using Multiple Cameras

A multiple camera setup provides you flexibility by enabling you to incorporate more angles and coverage of the performance. You can use one camera for close-ups and another for a wide shot of the stage, both on tripods. Each camera needs to be white-balanced and exposed properly so that the footage matches up when you go to edit. Many video editing applications have color-correcting features that can help if the cameras are slightly off, but save yourself some time and match the cameras before you begin shooting.

Consider the Gain

If possible, have the house add extra light to prevent having to increase the gain on the camera. If the scene is intentionally dark for show purposes, you may be forced to increase the gain just so that the camera can see the action. The price will be image quality, but at least you can see what is happening.

Compose Shots Carefully

Understand your subject matter so that you are aware of the proper way to compose for the subject in a given performance. Cutting off the feet in ballet is a terrible move because the dancers are *en pointe* or *relevé*, when you need to see the pointing of the feet and the line of the body. Choreographers and instructors may prefer a wide shot for instructional purposes.

Shooting Great Footage Through Composition

Want to quickly improve your digital video? Understanding how to properly set up your digital video camera and how to use its many features is important, but knowing how to compose interesting shots and adapt to various shooting situations is what makes great-looking video. This chapter covers a variety of composition techniques that will immediately improve the overall look of your video. You also learn how to add a little style to your video and how to use depth of field to your advantage, and explore principles for shooting better video for the Web.

Understanding Composition

The composition of a scene is created by how you place the subject matter in the frame. It is important that you consider the aesthetic quality of your subject matter while recording, as people are going to judge your video by the way it looks. There are some widely used design principles that can help you construct a better shot. Once you have become comfortable, develop your own style and unique look.

Define Your Subject

The world is a beautiful bombardment of sensory overload and your job as a videographer is to make sense of it all. You cannot possibly capture it all at once, so you must determine your main subject, and then frame it, as if it were a window through which your viewers can peer. There is no mistaking the main subject in this video, a colorful streetcar in Darjeeling, India.

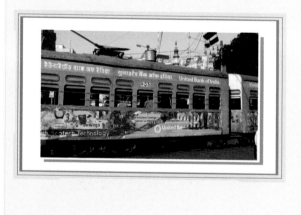

Consider Your Audience

Ask yourself "Why am I shooting this?" Are you trying to capture a mood or the sheer beauty of the moment? Ask yourself "How do I want people to respond to this video?" Are you going for the WOW factor, or maybe even suspense or fear? One of the most important things you should ask yourself is "Am I safe?" Do not take chances with your own personal safety, or anyone else's, to get a shot.

Consider Your Position

A scene can be viewed from many different angles, so ask yourself, "Am I in the best place to shoot?" Perhaps you need to be at a higher vantage point rather than a low one to portray how massive a crowd is, and possibly so you do not record any faces. Constantly look for the most interesting angle to shoot your subject. Viewers will appreciate the time and effort that it took for you to get an amazing shot.

Keep It Simple

Go for clean, steady, purposeful shots that do not contain an excessive amount of zooming and panning. Give your audience a chance to digest each shot before you move on to the next shot. Keep your scenes uncluttered by always making the composition tight, leaving out any excessive background distractions.

Critique Your Results

A great way to become a better videographer is to sit back and critique your own work after the shoot. If you get motion sickness after viewing your video, then you know you need to either bring a tripod next time, work on steadying your hands, or even brace yourself during recording. If the footage does not look the same when viewing it on a TV as it does in the LCD, you can then adjust the settings. The more you review and reshoot, the more the quality of your video increases.

Discover Rules of Composition

No compositional method is written in stone, but you can practice some of the most popular compositional techniques used by some of the greatest painters and photographers for hundreds of years. The techniques introduced in this section are great starting points for shooting more well-balanced and interesting shots.

Practice the Rule of Thirds

Your first instinct may be to place the subject in the middle of the screen. Try placing the main subject off-center. The rule of thirds is perhaps one of the most well-known compositional rules of thumb, and the concept is quite simple. Visualize an imaginary grid over the viewfinder where the scene is divided into thirds. The concept is to place your points of interest somewhere in the frame where the lines intersect or along the lines for a well-balanced shot. Some camcorders come with a Grid setting that helps with following the rule of thirds.

Keep It Level and Steady

Shots that appear tilted and shaky are distracting to the viewer, so always keep your composition level in the shot and use a tripod when possible. To prevent your subject from appearing as if it might slide out of the picture, always pay attention to your horizontal and vertical lines in the shot to keep the picture level. Many camcorders come with a Marker setting that provides a single horizontal line as a reference while shooting. You can also use the rule of thirds grid.

Keep It in the Shot

Do not place important subjects at the edge of the frame; they may get chopped off when viewing on a television. The amount of picture shown varies among television sets, so you need to keep important subjects in the Action Safe Area, which is ten percent smaller than a frame of video. When composing shots, always allow a little extra room around the top, bottom, and sides of your main subject in the shot.

Check Background Distractions

Objects in the background and surrounding your main subject can sometimes be distracting to the viewer. A shot composed in such a way that an office plant appears to be growing out of your subject's head can divert the audience's attention from the message. Always be mindful while looking through the camcorder viewfinder of any distractions that could possibly compete with your subject.

Shoot Talking Heads Properly

The term *talking head* refers to a person talking directly into the camera, such as during an interview or speech. Though talking heads may not make for the most exciting video shoot, they are common, and you can apply the rule of thirds and other compositional principals to compose a better shot.

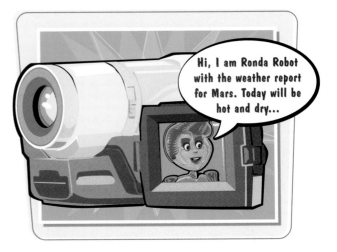

Hi, I am Ronda Robot with the weather report for Mars. Today will be hot and dry...

Apply the Rule of Thirds

The rule of thirds can be used to shoot just about anything, although its application may sometimes be unclear. In a shot composed mainly of a person's head and shoulders, the subject's eyes are a natural point of interest. Try aligning the subject's eyes with the top horizontal line in the grid. You can still position the subject more toward the left or right of the frame for a more interesting shot.

Watch the Headroom

When framing a shot, be mindful of the distance between the top of the subject's head and the top of the frame, which is referred to as *headroom*. Too much headroom can make the subject appear to be standing in quicksand. Make sure that you purposefully decide which elements you want in the shot, and fill the frame with your subject matter, omitting any extraneous space.

Mind the Chin

For a shot in which the head fills the screen, never cut off the chin of a talking head. Cut off the top part of the head as opposed to the chin. Consider composing the shot so that the neck is visible, so that when the person speaks, his or her jaw remains in the frame. A very nice, natural shot is from the collarbone up.

Frame the Moving Subject

Keeping a moving object in the frame can take some practice, especially if you are shooting something unscripted with unpredictable actions. If you frame the shot too loosely, you lose the detail of the subject and of the situation. If you frame the subject too tightly, it can get away from you by going in and out of the frame. Understanding a few principles of how to frame a fast-moving subject can help you shoot better video footage.

Anticipate the Movements

A good way to keep a fast-moving object in the frame is to anticipate its movements. In this video, the helicopter is given some nose room as it travels forward. If you are very familiar with a particular animal, you can anticipate its movements and habits while shooting. If you have never watched a soccer game, following the action through the camera lens is more difficult. Familiarize yourself with your subject as much as you can. These skills come with practice and experience.

Compensate for Movement

Be a quick learner in the field and figure out how loosely you can compose the subject without losing detail and without losing the subject in the frame. This takes some practice. If you follow a heron too tightly, it bounces around in the frame or gets cut off as it passes in and out of the frame. In this skateboarding video, the camera is zoomed out just enough to center the subject and leave room around it to minimize its movements on-screen.

Capture a Group of Fast-Moving Objects

To capture a group of fast-moving objects such as players during a soccer match or football game, or kids running in the backyard, consider establishing a wider shot and letting the players pass in and out of the frame. In a single camera setup, anything more may give your audience motion sickness when they watch your video. Shooting from a high vantage point is also advantageous for sporting events.

Keep It Stabilized

Keep in mind that the more you zoom into the object, the more even the tiniest of camera movements are magnified on-screen. Whenever possible, use a tripod to keep your shots stable as you follow moving subjects. If using a tripod is not an option when you are tracking the subject while walking, hold the camera out from your chest with both hands, and let your arms absorb some of the shock as you walk. You can also invest in a camcorder-stabilizing device.

Explore Shot Variety

It is not only important to choose your subject matter purposefully, but your video must be visually interesting as well to hold the attention of the audience. You may not be able to find an interesting angle for everything that you shoot, but mixing up angles and introducing viewers to new perspectives can make for better video. Here are some ways to add more shot variety to your videos.

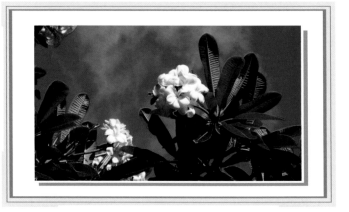

Change the Perspective

A change of perspective invites the audience to experience your video, and not just watch it. The next time you shoot a bed of roses, drop down on one knee and place the viewers right there with you, so they can almost smell them. Do not be tempted to shoot everything from your own eye level. Whether recording a child, pet, or flower, get down to the level of your subject. Let the dog sniff the camera lens, and get the bug's-eye view of the dandelions growing along the country road. This video shows a visually interesting perspective of a spiraling staircase.

Move into the Action

Do not rely so heavily on the zoom feature of your camera. When possible, step into the action and get your hands dirty, or soapy as seen in this video, and place the audience right there with you. Do not be intrusive; be inconspicuous, like a fly on the wall. At first, people will notice you as the guy with the camera, and possibly shy away from the camera or even put on a show, but as time progresses they become more comfortable. This is when you get the best footage.

Use Tilts, Pans, and Zooms

Using tilting, panning, and zooming sparingly between compositions helps to provide the viewer a sense of space. A shot composed of the front entrance of a building and then a slow tilt upward to reveal its many stories towering over the city, or a slow pan from a balcony to reveal that it overlooks the ocean — these shots give viewers a chance to really take in the scene. This shot began as a tight composition of the hikers and slowly zoomed out to reveal their location. A tripod makes tilting and panning more steady and smooth.

Explore Common Shot Names

Use a variety of shots to liven up less-than-exciting subject matter, such as a person speaking at a podium. A talking head is a talking head, but you can perform a slow zoom into a medium close-up, then out to a wide shot and even throw in a slow pan to show the crowd to keep the shot visually interesting. Here is a list of common shots that you can use.

Extreme close-up
Wide shot
Close-up

Medium Shot

Wide Shot

Use a Medium or Wide Shot

In general, a medium shot can be a full shot of the length of the person's body. The wide shot or long shot includes the entire subject, and is usually intended to establish a relationship between the subject and its surroundings. For example, you can use a wide shot to reveal the distance between the speaker's podium and the crowd, by including them both in the shot.

Define Medium Close-Up

A medium close-up is a shot halfway between a medium shot and a close-up where the subject is shot from the head and shoulders up. This is a very common shot used on talk shows, by reporters, and for interviews. You can use a medium close-up for a very basic shot, without becoming extremely focused.

Use a Close-Up or Extreme Close-Up

A close-up is generally a shot that covers a subject's head and neck. Close-ups are good for revealing emotion on a subject's face. Many times during an emotional news interview, you can see the camera zoom into the subject's face to capture the emotion. An extreme close-up is a shot with a very tight area of focus, such as a subject's eyes filling the screen. You see this used mostly in more-dramatic depictions including films and exposés.

Learn About Depth of Field

The term *depth of field* is used to describe the area of the image around the subject that remains in focus. To better illustrate this term, when you have a subject in sharp focus, a range in front of and behind the subject still remains in acceptable focus. Understanding the benefits of depth of field and the factors that affect it such as focal length, aperture value, and shutter speed, can help you use depth of field to create more dramatic video.

Explore Deep and Shallow Depth of Field

Depending on factors such as focal length, aperture value, and shutter speed, depth of field can be either deep, with a large area of the scene remaining in acceptable focus, or shallow, with less area in acceptable focus. Shallow depth of field is best depicted in still photos and theatrical film, and deep depth of field is best depicted in local news footage recorded with video cameras. This video depicts a very shallow depth of field.

Discover Benefits of Shallow Depth of Field

The ability to control which areas of your video scene are in focus can help you put dramatic emphasis on specific areas in the image, as done in photos taken with still cameras and movie film cameras. When shooting a portrait, a shallow depth of field can help separate the subject from the background, as seen in this video. A shallow depth of field can also be used to separate a single, vibrant flower from a group of many for added emphasis.

Manipulate Focal Length and Depth of Field

When you zoom the camcorder all the way out for a wide-angle view, the focal length is short, making the depth of field deep. When you zoom the camcorder all the way in, the focal length is long, producing a more shallow depth of field. For a more filmic, shallow depth of field, stand back from your subject and zoom into it. For a deeper depth of field, set up closer to the subject, as shown in this video.

Control Aperture and Depth of Field

The aperture controls the amount of light allowed into the lens and affects the depth of field. Higher aperture values mean that the aperture opening is narrower, which results in deeper depth of field. If you are shooting in bright conditions, your aperture value is set to a high value to control the amount of light passing through the lens, resulting in a deep depth of field. A low aperture value does just the opposite, as seen in this video.

Use Depth of Field Assists

Some camcorders are equipped with a special scene recording program, called portrait, that uses a large aperture setting and lets you focus on the subject matter while blurring the details of the background. You can also consider 35mm lens adapters for your video camera to achieve a very shallow, filmic depth of field as seen in this video.

Shoot for the Edit

When your plan is to edit the video after, you have the relief of knowing that you do not have to be perfect the first time with every shot. You may not plan to edit every piece of video that you shoot, but when you decide to, a few things you can do during the actual shoot can make your editing experience more successful.

Shoot More Video Than You Need

A good rule of thumb is to shoot a wide shot, medium shot, and close-up of scenes of the same subject to adequately cover an event. You do not want to find out later that you really need another angle of the bride's dress. You would be surprised at how much video you can go through for thirty seconds of video. This is especially true if you plan on making a fast-paced video.

Understand A- and B-Roll

Your footage needs to consist of what is referred to as A- and B-roll. A-roll is the main subject during the shoot, and B-roll is the supplemental footage that you can later use for cutaways such as beauty shots of the church, as shown in this video. The key is to make sure that you shoot all the important stuff first, and record the other footage for cutaways during down time or even before or after the main event.

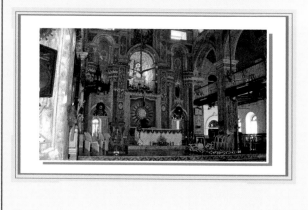

Give Yourself Some Room

Before you press the record button on your camera, make sure that you already have the scene framed in the camera viewfinder. Start recording five or more seconds before the action starts and continue recording five or more seconds after the action ends. This extra room gives you more control over the timing of edits and allows room to place a transition over a cut.

Avoid Specific Capture Issues

Do not begin recording the primary action at the beginning of a cassette tape. Start recording and let the tape roll for about ten seconds before you begin recording the primary action. If you do not do this, the capture process may be disrupted because the tape cannot back up far enough. Also avoid stopping the tape cassette to review your footage in between shots because this can result in a timecode break that can impede the capture process. Both of these examples are specific to cameras that record to tape.

Add Style to Your Video

The look of your video can create emotion and invoke a feeling for your subject matter. Start by asking yourself how you want the audience to feel after viewing your video. You can take steps while shooting and during the editing process to give a video a unique style and feel all your own. Adding style to your video can supply more depth to your work and grab the attention of the audience.

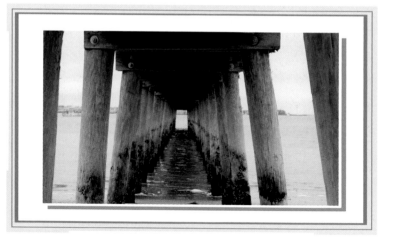

Use Light Creatively

What feeling do you want your viewers to walk away with once they see your video? When you have answered this question, you can modify light to help you achieve the mood you want. You can use light to compose a more dramatic scene, focus attention, and provide perspective.

Discover Image Effects

Many digital video cameras offer image effect options that enable you to manipulate color saturation, contrast, brightness, sharpness, and color depth while shooting. You can manipulate color saturation to make a day at the beach appear particularly warm on-screen, or emphasize both contrast and color saturation to make the colors of a flower garden bold and vibrant.

Avoid In-Camera Digital Effects

Some digital video cameras also come equipped with less-practical digital effects such as Sepia, Black and White, and Art effects that add a psychedelic color effect to the video. The most important thing to keep in mind about these effects is that they become a permanent part of your video. To give yourself more choices in the future as to how you will use your video, consider purchasing a video editing program that enables you to perform such effects.

Add Effects in Postproduction

Many of the most popular video editing programs on the market give you the ability to add Hollywood-type effects to your video for a unique look and feel. You can add motion and color effects, add flashy titles and transitions, perform compositing, and even add sound effects synchronized with your video. A paint effect makes this video appear as if it were fine art.

Shoot Video for the Web

Keep two important things in the front of your mind when shooting video for the Web: You are shooting for a much smaller window, and your video will have to be compressed. Due to these two factors, you can get away with some things in video made for television viewing that you cannot with video destined for the Web. Here are some tips that can help you shoot better video for the Web.

Keep Motion to a Minimum

Be mindful of your composition and keep the camera steady by using a tripod. Video takes up a lot of space and has to be compressed, reducing its quantity of data, before it goes on the Web. Compression is not kind to lots of movement, so minimize movement and eliminate pans of wide vistas. Avoid composing shots of fast-moving objects, or keep them to a minimum. Stay away from fancy motion transitions as well, and use simple cuts when editing.

Avoid High-Contrast Scenes

Compressed video also does not play well with high-contrast scenes that contain very bright and dark spots. Shoot under soft light or use diffused, even lighting whenever possible for scenes. You can redirect sunlight to your subject with a low-cost reflector or even white poster board.

Mind Your Graphics

If you plan on using graphics in your video, such as displaying identification beneath a person or place, make sure that you compose with that in mind during the shoot. Leave room to add your graphics later. Make sure your titles are large enough to be legible within a small viewing area, and use lower thirds with a solid backdrop of a contrasting color to the video over which it is being placed for maximum readability.

MY TRIP TO INDIA
2009

Keep the Background Simple

Avoid shooting subjects against backgrounds with complex patterns containing lots of details. Backgrounds like this create compression artifacts, or visual defects in the video. A great example of a complex background is shooting a subject in front of a tree with leaves blowing in the background. If you have no other option, try using a shallow depth of field to blur the background as shown in this video.

Acquire Good Audio

Acquiring good audio is essential regardless of whether you plan to view your video on a television or serve it on the Web. You may want to consider investing in audio accessories such as a lavaliere or hand-held microphone to acquire the best audio. Bad audio can spoil the entire video.

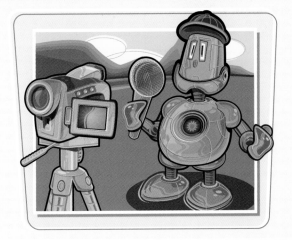

CHAPTER 9

Reviewing and Transferring Video

Shooting video is only the beginning of the video-making process. You can view the video footage you have shot on a TV monitor in a very straightforward process with just about any digital video camera. You can connect your video camera to a computer to transfer your recorded scenes and create incredible movies using graphics, music, and still images. One of the many benefits of digital video editing software is that it provides excellent means to organize those video clips and video projects on your computer hard drive.

Play Back Your Video on a TV Monitor

Playing your video on a TV set is a very straightforward process. You need to first make sure that the camcorder and TV monitor have the necessary hardware connections. Depending on your video camera, you may also need to configure a play-out option in the camera menu. You have multiple options for connecting to a TV, each yielding a different playback quality.

Set the Camera Mode and TV Type

Some digital video cameras require that you place them into video playback mode before you can play back the video you shot. This can be a switch on the camera or a lever that reads Play, or VCR/VTR mode. If you have a high definition camera you may need to go into the camera's menu and change the TV type to match the TV you will be playing back the footage on, in order to play it in the correct aspect ratio. Your choices are 4:3 or 16:9.

Locate Output and Input Terminals

Depending on your camera, you may have an AV Out, S-Video, Component Out, or high definition HDMI terminal. A camera may also utilize a combination of these outputs. A high definition HDMI connection is available only on high definition cameras and can be connected only to an HDTV. This connection provides the highest picture quality. When you identify the corresponding input on the TV, you can connect the two with the proper cable. Component cables do not carry audio, so you will have to make an audio connection as well.

Change the TV Input Source

In order to view your camcorder's video on a TV set, you have to change the source or select an input device. The options may be VIDEO 1 or VIDEO 2 in the menu or actual connectors such as AV, Component, or HDMI. You can press play on the video camera and the video plays on the TV set.

Optimize Your Viewing Experience

You can optimize your viewing experience by using the best connection available for your particular TV. The quality of picture from each connection ranging from highest to lowest quality is HDMI, Component, S-Video, and Composite.

Connect Your Digital Video Camera to a Computer

To transfer your video footage to a computer, you need the proper hardware connections. Depending on which type of camera you have, you may connect to your computer with a FireWire cable or USB cable. Either connection requires the computer to have that input port.

Power the Camera with the AC Adapter

Connect the power adapter to the digital video camera to power it. Some video cameras do not mount to a computer unless they are powered via the AC adapter. Using the AC adapter also enables you to conserve battery power while transferring images and editing video.

Get In the Proper Camera Mode

You may have to place the camera into the proper playback mode before you can successfully mount to a computer. A digital video camera could utilize a dial or a switch to place it in Play, VCR/VTR, or video playback mode. Read your camera's documentation to discover which method your camera uses.

Locate the Camera and Computer Inputs

Depending on your camera, you may have a FireWire or DV port, or a USB Port that can enable you to connect to a computer. These ports are often represented by symbols and concealed by a plastic covering on the camera body. Make sure that you insert the proper end of the cable into the camera and the computer. FireWire/DV cables are usually not shipped with digital video cameras, but you can buy one at any computer or electronics store.

Transfer Video from a File-Based Camcorder with iMovie

If you have one of the newer AVCHD cameras, you need to have one of the newer Intel-based Macs in order to use your camera with the iMovie software. Some of the newer video cameras record video to internal flash drives, memory cards, and hard disk drives as scene files. The method used in iPhoto for transferring file-based scenes from a video camera to a computer varies from a tape-based camera. iMovie uses Events, or categories, to organize your movies.

Transfer Video from a File-Based Camcorder with iMovie

① Connect the camera to the computer.

The camera mounts to the desktop like an external hard drive.

Note: *Connect the power adapter to the digital video camera to power it. Some cameras do not mount to the computer unless the AC adapter powers them.*

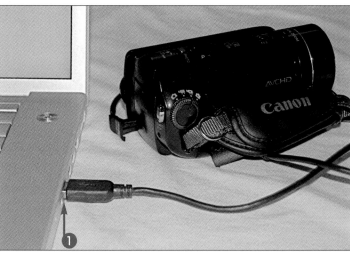

② Launch iMovie.

You are taken to the import window, and the Camera Detected Scanning Contents window closes. All video files on the camera are checked and ready for import.

③ Click **Import All** to import all video files on the camera.

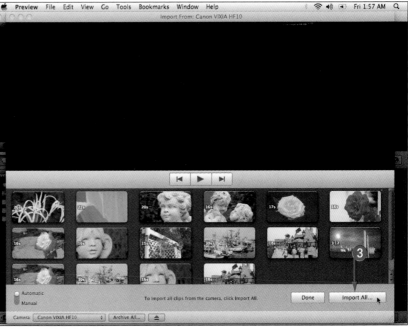

A dialog box opens prompting you to designate specifics about the import.

④ Type a descriptive name for the new Event.

Note: By default, iMovie is set to create a new Event, which is named by the date of import.

⑤ Click here to choose video dimensions.

Note: If importing from an HD camera you may be prompted to choose between Large-960x540 and Full-1920x1080. Be aware that choosing a larger video size takes up more disk space.

⑥ Click **Import**.

The scene files are downloaded one by one and are labeled as Imported when complete. A dialog box that reads Import Complete appears after the download is complete.

⑦ Click **OK** in the Import Complete dialog box.

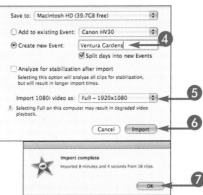

TIPS

Can I choose only specific clips to import?

Yes, you can click **Manual** (●) in the bottom-left corner of the Import window to select specific clips for import. You can click the **Uncheck All** option and then place a check mark next to specific video clips that you want to transfer. The Import All button turns into the Import Checked button. After you have imported clips, the word *Imported* appears below the clips.

Can I preview clips before I import them?

Yes. Simply select the video file that you want to play and it appears in the preview area. Click **Play** (▶) to review the clip before importing it into iMovie.

Capture Video from a Tape-Based Camcorder to a Computer with iMovie

The major difference between capturing video from a tape, as opposed to transferring from a file-based camcorder in iMovie, is the shuttling of tape. Capturing video from a tape in iMovie is also a very straightforward process, and you begin by connecting the camera to the computer. Some cameras are not recognized by the computer, unless the AC adapter powers them.

Capture Video from a Tape-Based Camcorder to a Computer with iMovie

① Launch iMovie.

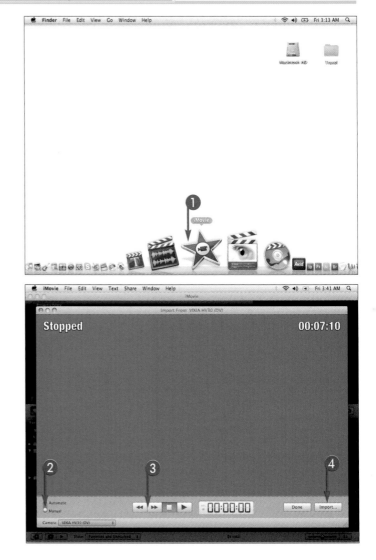

The Import window opens.

② Click **Manual**.

③ Click the **forward** () or **rewind** (◄◄) button under the preview areas to cue the tape for capture.

Note: The ►► and ◄◄ buttons are available only in Manual mode.

Note: You have to click ► and then hold down ►► or ◄◄ to seek forward or backward while watching video.

④ Click **Import**.

A dialog box opens prompting you to designate specifics about the import.

The import dialog box opens.

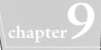

⑤ Type a descriptive name for the new Event.

*Note: By default, iMovie is set to create a new Event for each day the video was shot. You can uncheck **Split days into new Events** if you want iMovie to import the video into a single Event.*

⑥ Click **Import**.

iMovie begins capturing the video from the tape.

⑦ Click **Stop** to end the import.

The video is captured and another screen appears.

Note: You can use ⏩ and ⏪ to cue the tape to another scene for capture.

⑧ Click **Done** to close the import window.

TIPS

Can I set iMovie to capture the entire tape for me?

Yes. Click to move the switch located at the bottom left side of the import window to **Automatic** (●). Then, when you click Import, iMovie automatically rewinds the tape to the beginning so the entire contents of the tape are captured. Keep in mind that capturing an entire tape of video takes up a lot of hard drive space.

Where can I find the captured files on my hard drive?

You can find the captured files on your hard drive by navigating to Macintosh HD, Users (this is usually your user name), Movies, iMovie Events (●). You can also find your iMovie project files in the Movies folder.

Set Up a Project in Adobe Premiere Elements

Setting up a project in Adobe Premiere Elements is a straightforward process. You set up projects depending on the device and the type of footage that you are importing, including AVCHD, HDV, or DV footage. Premiere Elements enables you to prepare your projects for both NTSC and PAL standards.

Note: *Proceed with these steps after making the necessary hardware connections.*

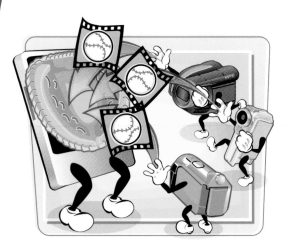

Set Up a Project in Adobe Premiere Elements

① Launch **Adobe Premiere Elements**.

Note: *If you downloaded the Premiere Elements software from the Adobe site, a dialog box may appear prompting you to install full content. You can either go to the specified Web site that it supplies or click **OK**.*

The Welcome screen opens prompting you to start an Instant Movie, Open Project, or New Project.

② Click **New Project**.

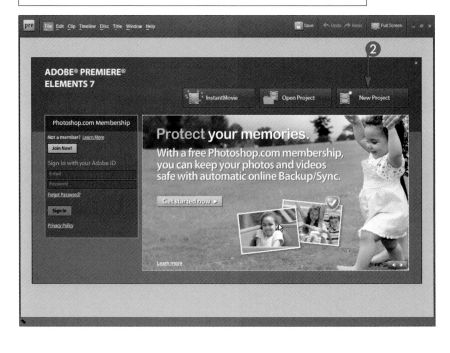

The new project dialog box opens.

*Note: You can click **Open Project** if you want to capture the footage to an existing project.*

③ Type a name for the new project.

④ Click **Change Settings**.

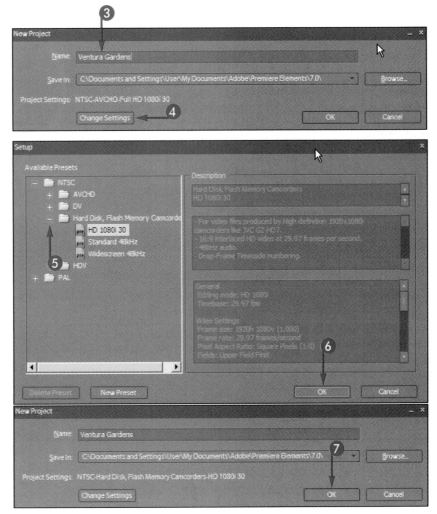

The Setup options appear.

⑤ Click here to expand the preset folders and select a preset that matches your video footage.

Note: The DV preset was chosen in this example.

⑥ Click **OK** in the Setup dialog.

The setup dialog closes.

⑦ Click **OK** in the New Project Dialog.

The Premiere Elements interface opens.

Can I change the project preset after starting a project?

No. It is very important when creating a new project that you choose the correct project settings for your source material/video. The project specifies the frame rate, aspect ratio, audio sample rate, and other important characteristics of your project. Your project can run into problems if the preset does not match the source files.

Can I create a project preset while in an open project?

Yes, but creating a new preset does not change the setting for the project that you currently have open; you only create a new project preset. You can create a project preset by going to the top menu and choosing **Edit**, **Project Settings**, and **General**.

Transfer Media from Still Cameras and File-Based Camcorders in Adobe Premiere Elements

You can also download media from devices other than DV and HDV camcorders in Adobe Premiere Elements. Content from file-based devices such as memory cards, mobile phones, DVD-based, and hard disk drive (HDD) camcorders can also be used in projects. Whether you choose the DVD, AVCHD, Digital Still Camera, or Mobile Phone and Players option, the download process is the same.

Transfer Media from Still Cameras and File-Based Camcorders in Adobe Premiere Elements

① Click **Organize**.

② Click **Get Media**.

③ Click the connected device.

Note: *In this example I am downloading from a Digital Still Camera, but the process is the same for the DVD, AVCHD, Digital Still Camera, or Mobile Phone and Players options.*

The Media Downloader opens.

④ Choose the connected device from the Get Media From field.

Premiere Elements connects to the device.

⑤ Choose **Custom Name** in the Rename Files field.

⑥ Type a descriptive name for the imported files.

⑦ Click **Advanced Dialog**.

A window opens displaying thumbnails of the images located on the device. All of the images have a check mark next to them.

8 Click **Uncheck All**.

All the images are unchecked.

9 Click the check box next to the files you want to import.

10 Click **Get Media**.

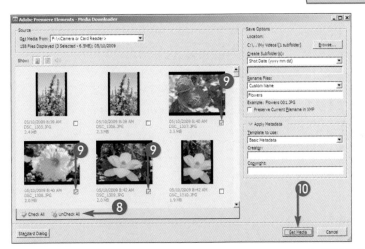

● The images are downloaded and appear in the Organize view.

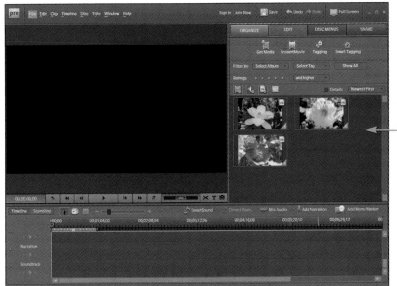

 TIPS

Can I capture images from my webcam?

Yes. You can click **Get Media** and then click the **Webcam or WDM Device** option to capture images from a webcam installed in your computer. The capture window opens and you are able to capture live video from the webcam. Close the capture window and the video appears with the other video files for that particular project.

Can I import a file located on my desktop?

Yes, you can import a file located on your computer hard drive by either clicking the **Get Media** (🖿) button and then choosing the **PC Files and Folders** option, or double-clicking in a gray area within the Organize window. The Add Media window opens, enabling you to browse your hard drive and import files.

Capture Video from a Tape-Based Camcorder to a Computer with Adobe Premiere Elements

Adobe Premier Elements enables you to easily capture DV and HDV video from your tape-based camera to your computer. Understanding how to properly capture your video gives you more options for importing a variety of media for use in your projects.

Note: Follow these steps after making the necessary hardware connections.

Capture Video from a Tape-Based Camcorder to A Computer with Adobe Premiere Elements

1 Click **Organize**.

2 Click **Get Media**.

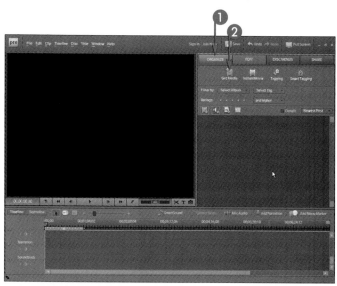

The device options open.

3 Click **DV Camcorder**.

The capture window opens.

Note: *Click the HDV Camcorder option if you are capturing from an HDV camera.*

Note: *You can capture video from a USB or FireWire connection when you choose the DV Camcorder device option.*

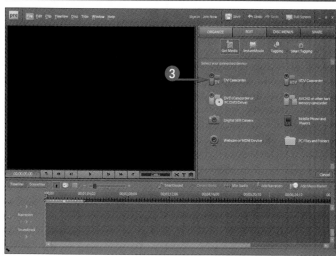

④ Uncheck **Capture To Timeline**.

Note: The Capture To Timeline option captures the video directly to the timeline. If you know that your video will need considerable editing, consider deselecting this option.

⑤ Uncheck **Smart Tagging**.

Note: Smart Tagging analyzes and marks less-than-perfect video, such as shake, blur, and so on. You are the best judge of your video, so consider always deactivating this option.

⑥ Type a descriptive name for the clips.

Note: Each scene will now be numbered in increments such as Florida_1 and Florida_2 as Premiere Elements splits scenes by timecode according to when you started and stopped recording on the tape.

⑦ Cue the video to the scene where you want to start the capture.

⑧ Click the **Capture** button to begin capturing.

Note: A red outline appears around the capture preview to signify that Premiere Elements is capturing the video.

⑨ Click **Pause** to stop capturing.

⑩ Close the capture window.

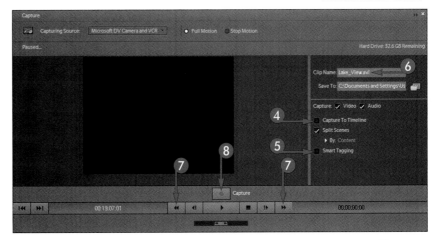

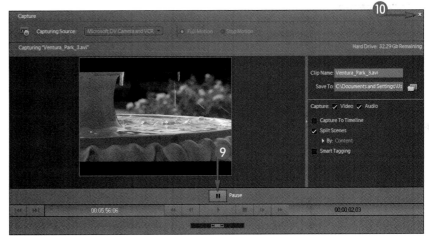

Where are my files stored, and can I change the location?

When you start a new project, you can click **Browse** in the New Project dialog box and navigate to a new location to save the captured files. You can also click the **Save To** icon (🖳) in the Capture window to browse to a new location on the hard drive and create a new folder to store the captured files.

How do I access capture settings for my project?

You can access capture settings by clicking the small arrows located at the upper right-hand corner of the Capture window. When you click the arrows, the Capture Settings and Device Control Settings options appear.

Learn About Analog-to-Digital Conversions

If you want to capture analog video from an analog source, such as a VCR or an old non-digital video camera, you need special hardware called a *capture card*. You can install a video capture card into a computer, or even use an external analog video converter that enables you to attach the analog device to the computer and convert the footage. Some video cameras allow you to do make analog to digital conversions.

Learn About Analog-to-Digital Conversions

The ability to convert analog video into digital video enables you to preserve old videos that are slowly deteriorating on VHS tapes. You can capture the footage to your computer hard drive, securing your family's classic video memories for many years to come, in a format providing a much longer shelf life. You can take the converted footage and re-edit it in a video editing program and create DVDs to share with friends and family. There are many different analog-to-digital devices on the market. Keep in mind that not all converters are created equal, and you generally get what you pay for.

Installing a Capture Card

A video capture card can be installed in an empty PCI slot inside of the computer. Before you purchase a capture card, make sure that it actually captures analog video. Some FireWire cards are also labeled as video capture devices, but only capture digital video and will not capture from an analog source. Make sure that your particular computer supports the capture card you are considering. If the capture card you have purchased has an S-Video terminal, use it instead of the yellow RCA composite video jack for a higher-quality video conversion.

Use Your Camera for an Analog-to-Digital Conversion

Your tape-based digital video camera may provide you the added ability of creating analog line-in recordings, which enables you to convert analog video signal from a VCR into digital video. To perform the conversion, you need to make the necessary hardware connections. The analog video is recorded from the analog source, such as a VCR, onto the Mini-DV tape inside of the camera, where it can then be captured onto your computer hard drive using a video editing program.

Merge Events to Organize Clips in iMovie

Upon import, iMovie keeps your videos in chronological order according to dates, and organizes them into categories called Events. You can choose to import the footage into an existing Event or create a new one. Be sure to give each import a descriptive name such as 21st Birthday Party, or Family Reunion 2010. If you import video taken over a period of days, iMovie breaks the video into separate Events and may list an import as Weekend Trip 1, Weekend Trip 2, and so on. You can further organize Events by merging/combining them.

Merge Events to Organize Clips in iMovie

① In the Event Library, select the Events you want to merge.

Note: *You can press and hold the Command key* (⌘) *to select multiple events.*

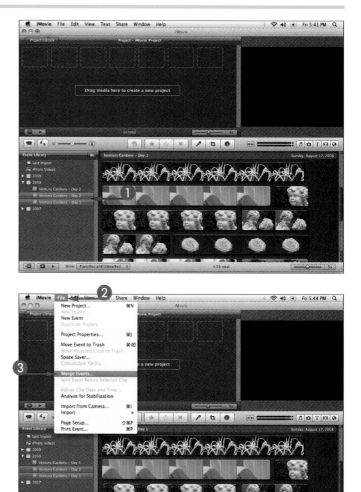

② Click **File** in the main menu.

③ Click **Merge Events**.

A dialog box opens prompting you to name the merged Event.

Note: You can also ⌘ -click multiple Events and drag them to another Event.

④ Type a new name for the merged Event.

Note: You can change the date of an event to change its chronological order in the Event Library. You can also delete an Event permanently.

⑤ Click **OK**.

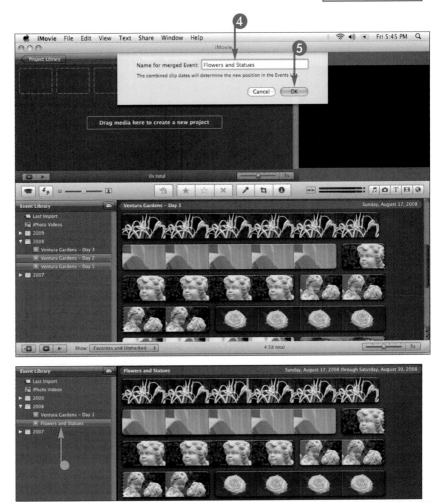

● The events are merged under the given name.

TIPS

Can I split an Event?

Yes. It is not uncommon to have a group of video clips under one Event that you later want to split into more specific categories. You can simply highlight the Event in the Event Library, click the clip in the Event where you want the break to occur, then go to File in the main menu and choose **Split Event Before Selected Clip**.

Can I move a clip from one Event to another?

Yes. You can press Option and click to select an entire clip, then simply drag it to another Event. Click **OK** (●) in the Move Clip to New Event dialog box that appears.

Move Clip to New Event

You are about to move this entire clip to a new Event.

Cancel OK

Organize with Folders in Project View in Adobe Premiere Elements

The typical video project may have dozens of video files, graphics, still photos, and audio files, so you must keep everything organized. Organizing your digital media in the Project view enables you to keep track of the many files used for a given video project and is one of the most practical means of media organization in Adobe Premiere Elements.

Organize with Folders in Project View in Adobe Premiere Elements

1. Click **Edit**.

2. Click **Project**.

● Project view opens, revealing the previously captured files.

Note: You can rearrange video clips alphabetically by clicking in the **Name** field.

Note: You can also rearrange the information fields such as Frame Rate and Media Type by dragging them to a new position. You can use the scroll bar at the bottom to move to the right and view more information regarding individual clips in the columns.

3. Click the **Folder** button.

● A new folder appears at the bottom of the list.

● All of the clips for the project appear under the Project view.

4. Type a descriptive name for the folder.

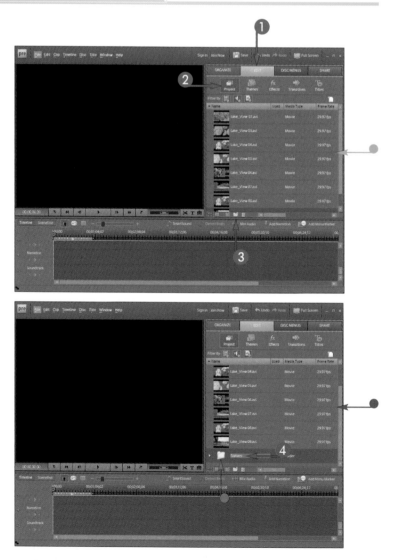

5 Select the clips that you want to move into the folder.

Note: You can press the Ctrl key (Ctrl) while clicking on clips to select multiple video clips.

6 Drag the clips into the new folder.

	Name	Used	Media Type	Frame Rate
⑤	Lake_View 04.avi		Movie	29.97 fps
	Lake_View 05.avi		Movie	29.97 fps
	Lake_View 06.avi		Movie	29.97 fps
	Lake_View 07.avi		Movie	29.97 fps
⑤	Lake_View 08.avi		Movie	29.97 fps
	Lake_Vi 6 9.avi		Movie	29.97 fps
	Statues		Folder	

7 Click here to reveal the new clips within the folder.

	Name	Used	Media Type	Frame Rate
	Lake_View 06.avi		Movie	29.97 fps
	Lake_View 07.avi		Movie	29.97 fps
	Lake_View 09.avi		Movie	29.97 fps
⑦	Statues		Folder	
	Lake_View 04.avi		Movie	29.97 fps
	Lake_View 05.avi		Movie	29.97 fps
	Lake_View 08.avi		Movie	29.97 fps

ORGANIZE · EDIT · DISC MENUS · SHARE
Project · Themes · Effects · Transitions · Titles

 TIPS

Can I filter which files I see in Project view?
Yes. In Project view, you can further organize your captured clips by filtering which types are viewable within the list. By default, all media are visible. Click the **Hide Video** (), **Hide Audio** (), or **Hide Still Image** () buttons so that only specific files are visible within the list. Click the button again to make that particular file type visible again.

Why are some of my video files in the Media Type column labeled movies, but others are labeled video?
Video clips that contain audio are listed as Movies and video clips that do not have audio are named Videos. You can use this information to create separate folders for videos that contain audio and videos that do not have audio.

10

Editing Video and the Postproduction Process

You have captured some amazing images with your digital video camera; now it is time to create a high-quality video presentation that helps you uniquely capture those special moments. There are many options for video editing applications, which span across both PC and Mac platforms. This chapter focuses on Apple iMovie '09 for Mac users and Adobe Premiere Elements 7 for PC users, both of which are very capable video editing applications that enable you to burn your movies as a finished DVD. This chapter introduces you to the basics of video editing, along with making audio adjustments for your programs and creating your own voiceovers and soundtracks for your videos.

Explore
Video Editing

Video editing programs enable you to place your recorded video in sequence, add titles, and add music to create a movie. You are able to enhance your video images by color-correcting, adding effects, and using transitions. Video editing applications also enable you to organize your video clips on your hard drive, and some even allow you to distribute your movie by burning DVDs or uploading to video-sharing Web sites and galleries.

Video Editing

Video editing is the process of editing segments of your video, along with music and sound effects, into a carefully crafted presentation. Every edit, whether it is to music, narration, or an emotion, sets a rhythm. Making an edit is simple, but unfortunately, it takes practice to advance your message or story, purposefully framing the action contained within each cut, and hold your audience's attention. Essentially, editing is the act of framing the appropriate action at the appropriate moment in time for the appropriate amount of time.

Fundamental Video Editing Terms

A cut is the instantaneous change from one shot to another and is the most basic of video edits. If you do not use a transition effect between two clips, chances are you cut to the next shot. A cross dissolve, or simply dissolve, occurs when there is a simultaneous fade down of the previous clip and fade up of the preceding audio or video clip in the sequence. A fade can be used to slow the pace or for a soft transition into another scene. A cutaway is a shot of something other than the principal action in the scene. A good example of a cutaway would be a clip of the Rocky Mountains playing while a park ranger is being interviewed about the state park system.

Three Point Editing

Three point editing is a methodology used by professional video editors and is supported by more-advanced video editing applications than iMovie and Premiere Elements. Three point editing uses three edit points to insert a video clip into the video editing timeline. The first two edit points define either the in and out points for the action in the clip or the in an out point in the timeline into which the clip will be edited. The third point can designate the in or out point for the action in the clip or the in or out point in the timeline if the other two points are located in the clip. If you require a more-advanced editing toolkit, consider upgrading to Apple Final Cut Express or Adobe Premiere Pro.

Explore Video Editing Principles

Editing your video into a presentation can prove a very exciting, yet taxing venture. If your approach is unorganized, it can prove to be a most frustrating experience. If you do not have a plan for how the presentation should look after your work is finished, editing your video can be a very time-consuming debacle. The following principals can help ensure the success of your video editing sessions.

Organize the Footage

As you acquire more and more video footage on your computer hard drive, solid organization of all your footage becomes an absolute necessity. Before you begin editing your movie, throw away any footage that you know you are not going to use, such as footage where you forgot to turn off the camera and were holding it to your side. You can save a lot of time by creating folders in which to place specific footage so that you do not have to go rummaging around for it while you are editing. That way, all of your interviews will be in one folder, and beauty shots, jet skiing footage, and so on will be in their respective folders.

Visualize the Edit

Have an idea of how your video presentation will progress as you are shooting the video. A great way to visualize what happens in your movie is to use 3 x 5 note cards. Write the timeline for what scenes will appear from first to last. This way, you can shuffle around cards and insert scenes as the program builds. You can also create a folder system that reflects the timeline of the show and populate it with the appropriate videos as you lay out the movie.

Keep Notes and Log Recording Media

Another way to help you visualize the edit, and also to make sure you use all the best footage, is to keep a notepad handy. You can write down a list of shots that are essential to the show, as well as write an outline for how the action will occur. During a shoot where you have recorded a lot of footage, labeling your tapes, DVDs, or memory cards is also a good habit to get into. That way, if you are looking for the tape on which Dad fell out of the raft in class 3 rapids, you can easily identify the tape.

Make a Rough Cut

As your video presentation takes shape, consider laying down loosely edited clips rather than trying to lay down perfectly edited clips. Laying down a rough cut not only helps you to edit faster, but also helps you lay out the actual presentation. A common problem for many video editors is that they start their projects strong and finish weak. They lay in the best shots first, and by the end of the project, they have little left that is interesting. Try to spread your best footage evenly throughout the show to keep it interesting from beginning to end.

Fine-Tune the Edit

After you have laid down the rough cut you can go back and make sure the time is right by fine-tuning the edit. Many video editing programs possess tools that enable you to cut video frame-by-frame to ensure that the action is on cue. When you reach this stage, you are putting the finishing polish on your video presentation, and your work is just about ready to be viewed by friends and family.

Why Use a Video Editing Program?

Video editing programs provide you so many more options than simply connecting your camera to a TV set and watching the footage. Video editing programs provide the means to transfer video from a camera to a computer hard drive, but also enable you to organize your video footage, create sleek video presentations, and provide many avenues to distribute your videos to friends and family.

Video Editing Programs

Many capable video editors are on the market that span both the PC and Mac platforms, and that offer a wide range of features as well as price points. Shop around and find which works best for you by using forums and downloading free test trials. Two comparable video editing applications that perform the same task can go about performing them quite differently. Give them a test drive before you buy, and as you are shopping always keep in mind that the software is just the tool. You are the artist. If you have an AVCHD camera, make sure that you purchase a video editor that can work with AVCHD video files.

Enhance Your Video with Video Editing Programs

Many video editing applications offer a host of color correction features and effects that can improve aesthetic mistakes that occurred during the acquisition of the footage, or just to enhance dull images. By taking advantage of the tools that video editing applications have to offer, you can take your creativity to a whole other level.

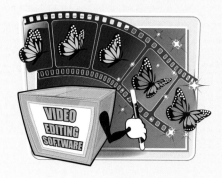

Organize Videos with Video Editing Programs

Video editing applications not only offer you a way to transfer video from your camera to a computer, freeing up space on record media such as memory cards, hard disk drives, and flash memory, but they also help to organize your video. Upon transfer from your video camera, video editing applications begin to organize your video in a logical manner on your hard drive, providing you easy access and improved searchability.

Deliver Your Video to Friends and Family

Many video editing applications provide export options for Web galleries, video blogs, and mobile devices, as well as DVD creation. You can conveniently build DVDs with professional menus complete with music that can be saved for later distribution. Not every video editing application is bundled with DVD software, so if DVD creation is your intention, make sure the one you purchase has the ability.

Explore the iMovie Workspace

This section introduces you to the main parts of the iMovie workspace: the Project Library, Project window, viewer, iMovie toolbar, Event Library, and Event browser. Knowing your way around iMovie helps you to work quickly and more efficiently.

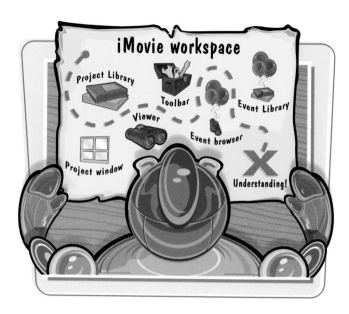

Project Library

The Project Library pane lists all of your movie projects so you can easily move from one project to the next. To better manage space, the Project Library is not revealed until you click the tab. Each project is depicted with a video frame from it, making the project easier to identify. You can also create a new project, identify projects you have exported, and select a project for playback in the Project Library.

Project Window

The Project window is where you assemble all of your video footage for a video project. The current project is portrayed as a series of filmstrips, frames from clips of the video you are editing, in the Project window. Controls in the Project window include playback options as well as the ability to zoom into filmstrips.

Viewer

The current frame of the current video clip is shown in the viewer. You can play the clip in the viewer by pressing the space bar on the keyboard or scrub through the video frames by moving the mouse pointer over a video clip. Depending on what action you are performing, the viewer can display controls as overlays for times when you may want to crop clips or apply pan and zoom effects to still images.

Toolbar

You can find most of the controls for manipulating content and for displaying hidden parts of the iMovie interface including the Music and Sound Effects browser, Titles browser, and Transitions browser. The toolbar contains three groups of buttons that enable you to perform functions such as importing video and manipulating selected clips.

Event Library

The Event Library enables you to browse all of the imported clips that will be used in your movies. Click the **Show or Hide** button (![icon]) to reveal and hide specific Events in the library.

Event Browser

The Event browser displays the video clips housed in the selected Event as filmstrips. To edit video in iMovie, click and drag a selection around the video in the Event browser and drag that selection to the Project window to place it into the movie. You can position your mouse pointer (▶) over the video shown in this Event browser in order to see it in the viewer.

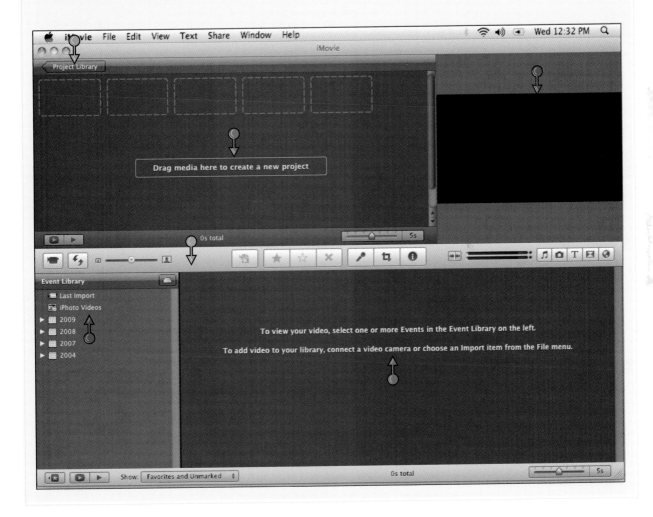

Edit Video in iMovie and Add Transitions

After you have finished transferring video files and closed out of the import window, your imported video files appear in the Event browser. You can either position your cursor over the video in the Events browser to skim over footage, or press the space bar on the keyboard to play the video. From this point, editing your video is very simple.

① Click **File** in the main menu.

② Click **New Project**.

A dialog box opens.

③ Type the name of the new project.

Note: iMovie prompts you to choose a theme. Use the default *None* for this example.

Note: The Apple-designed themes enable you to make backdrops, titles, and transitions look like variations of a photo album, bulletin board, comic book, scrapbook, or filmstrip.

④ Click **Create**.

The new project is made.

⑤ Select an Event in the Event Library.

The video contained in that Event appears in the Event browser.

⑥ Click and drag a selection around the video you want in the Event browser.

A yellow overlay appears around the video that you select.

Note: You can also just click the video, and iMovie selects 4 seconds of the video.

⑦ Drag the selection into the Project window and drop it.

The video appears in the project, and an orange line appears under the video you have just used in the Event browser.

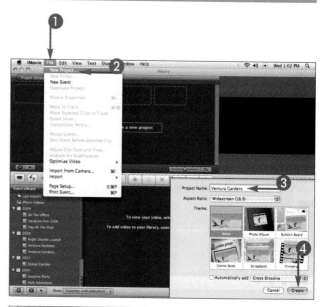

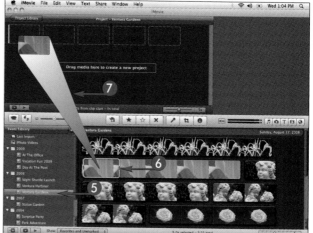

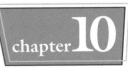

8 Select more video in the Event to add to the movie.

9 Drag and drop the highlighted video into the Project window next to the first clip.

The video appears in the project and an orange line appears under the video you have just used in the Event browser.

Note: A green overlay appears as you hold the second clip over the Project window, letting you know where it will be placed if you release it.

10 Click the **Transition** browser icon ().

The Transition browser opens.

11 Select a transition.

Cross Dissolve was chosen in this example.

12 Drag the transition to the middle of the two clips in the Project window and drop it.

The transition appears between the two edited clips.

You can now play back your two edits.

Note: You can place your ▶ at the beginning of the video in the Project window and press the space bar on the computer to play back the two edits.

Note: When you have completed building your full iMovie project, you can add chapter markers within your video in preparation for burning a DVD. Chapter markers let viewers navigate quickly between points in the movie when viewing your project as a DVD.

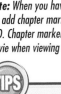

What happens if I drop a video clip onto another one in the Project window?

After you select your video in the Event browser and then drag and drop it over another video in the Project window, iMovie provides you more editing options. An overlay appears, enabling you to choose from options including **Replace** the current clip with the new clip, **Insert** the clip into the current clip, and add **Audio Only** of the new clip to the movie. You also have the option to **Cancel** the operation.

Can I trim the video after it is placed into the timeline?

Yes. You can drag a selection around the video that you want to keep in the Project window. Go to the top menu and choose **Edit**, and then **Trim to Selection**. Only the highlighted parts of the video remain and the extra frames are removed. You can also `Control`-click or right-click to choose **Trim to Playhead** from the pop-up menu.

Fine-Tune Edits in iMovie

The Precision Editor in iMovie enables you to make exact edits in your video to ensure that the first clip ends and the second clip begins right when you want it. The Precision Editor pane replaces the Event pane at the bottom of the iMovie interface, enabling you to zoom into a cut between two clips and providing you frame-by-frame control over edits in your project.

① Position the ▶ over the clip that comes after the transition you want to adjust.

An overlay appears in the bottom-left corner of the clip in the shape of a gear.

② Click the gear icon (⚙) to access the Action pop-up menu options.

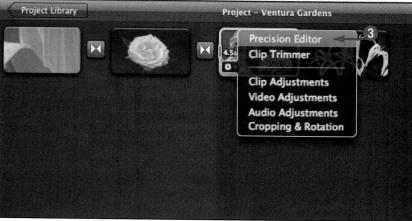

③ Click **Precision Editor** in the list.

The Precision Editor opens below in the Event pane, displaying the transition between the clip you clicked and the previous clip.

Note: *The top video displays frames from the first clip, and the bottom video displays frames from the second clip. The blue bar in the middle represents the transition effect. The highlighted frames represent video featured in the movie. The shaded frames represent footage that was recorded but does not appear in the movie.*

④ Drag the transition point to reposition it for both clips.

Note: *You can click and drag the left or right edges of the transition bar to adjust the start or end point of either clip.*

Note: *You can use the **Show Next Edit** (▶) and **Show Previous Edit** (◀) buttons to jump to different edit points.*

⑤ Click **Done** in the Precision Editor when finished reviewing the clip.

The Precision Editor closes.

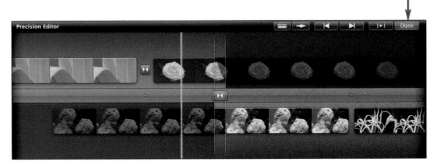

Does iMovie change the duration of my movie when I use the Precision Editor on a straight cut?

When you reposition the transition bar between two clips, frames are cut on one side of the transition while the clip is extended on the other side of the transition. The duration of your iMovie project does not change when using the Precision Editor. If you move the clips themselves while in the Precision Editor, you can affect the duration.

Add Music to Your iMovie Project

You can import music from your computer hard drive into iMovie to spice up your video project. Keep in mind that the music you have downloaded from iTunes as well as purchased on CDs is copyrighted material and you could get in plenty of trouble if you use them in your video projects. There are many online vendors selling royalty-free music that you can use in your projects. If you want to learn more about copyright laws visit www.copyright.gov to learn more about copyright laws.

Add Music to Your iMovie Project

① Click the **Music and Sound Effects** browser button (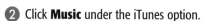).

The Music and Sound Effects browser opens inside of the Events browser.

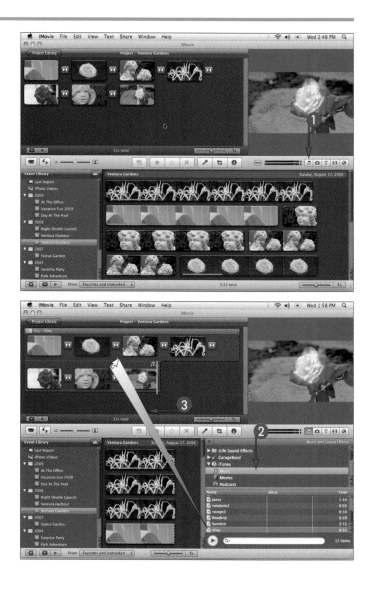

② Click **Music** under the iTunes option.

The music files are listed in the browser.

③ Drag a music file from the browser to the Project window and drop it.

A green overlay appears in the Project window signifying that the audio has been added to the project. When you play the movie, the audio begins at the very beginning of the movie.

Note: You can drag an audio file straight to a clip to have it play under a single clip only.

Note: You can select the green overlay and press Del to delete the audio you added to the project.

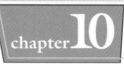

If you want the background music to start at a point other than the beginning of the movie, you can perform what is called *pinning* to have it start where you need it.

Pin Background Music in iMovie

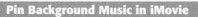

1 Drag the audio overlay from the top and drag it to the right.

The green overlay turns purple.

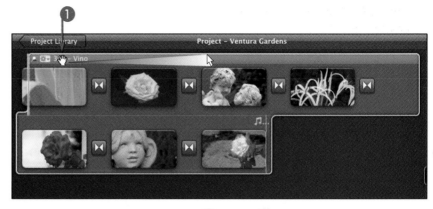

2 Pin the background audio where you want it to begin in the movie.

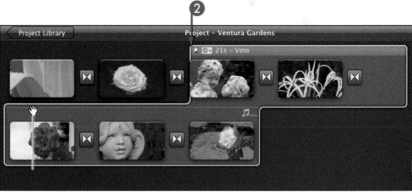

Using Sound Effects in iMovie

iMovie comes equipped with its own sound effects library. Under the Music and Sound Effects browser you can access sounds such as ambient noise, animal sounds, door knocks, and much more. Adding sound effects to your project is a great way to add an extra punch to your videos.

Using Sound Effects in iMovie

① Click ▣.

The Music and Sound Effects browser opens inside of the Events browser.

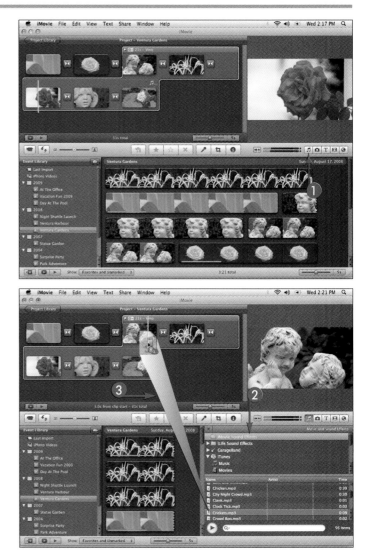

② Click the **iMovie Sound Effects** option.

The music files are listed in the browser.

③ Drag a sound effect file from the browser to a clip in the Project window and drop it.

The sound effect is represented in the movie as a green bar.

Note: *If you drop a sound effect into the gray area in the Project window and not on top of a clip, a green overlay encompasses the clips, instead of a green bar appearing beneath them, as seen in this example.*

④ Drag the sound effect icon to cue it up with a video clip.

Note: *Place the* 🔺 *over the sound effect icon and do not begin dragging it until the cursor turns into a hand (🖐).*

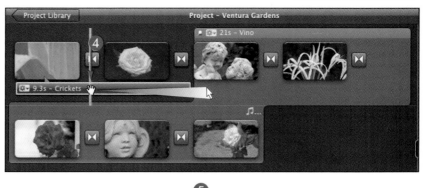

⑤ Drag the ends of the green sound effect icon to change the duration of the effect.

Note: *If the sound effect you are using is very short, such as a door closing, you may not be able to adjust its duration in the movie.*

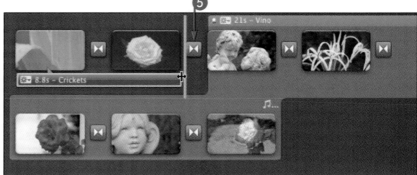

TIPS

Can I lower the audio level for the sound effect?

Yes. You can lower the audio level of the effect by simply double-clicking the green sound effect icon that appears in the Project window. The Inspector opens, giving you the ability to change specific settings for the effect. Choose the audio option in the Inspector controls to gain access to audio level controls.

What if I cannot hear the sound effect over the background music?

You can lower the level of the background music by double-clicking the background music overlay in the Project window and accessing the Inspector controls. You can also choose an option in the Inspector called *ducking* that actually lowers the audio level of the background music when the sound effect plays.

Record a Voiceover in iMovie

Recording your own narration or voiceover in iMovie is a great way to enhance your video projects. Narrations are a great tool for helping your viewing audience follow a story. Before you can record audio, you need to have a microphone and make the necessary hardware connections.

① Click the **Voiceover** button (![]).

 The Voiceover window opens.

② Choose a microphone or other sound input from the pop-up menu.

Note: *If your computer has a built-in microphone you can choose **Built-in Microphone**.*

③ Drag the input volume slider to set the baseline volume for your recording.

Note: *If you speak softly, make sure that you increase the volume appropriately.*

④ Drag the **Noise Reduction** slider to the right to reduce background noises from being recorded.

⑤ Leave **Voice Enhancement** checked if you want iMovie to try and improve the sound of your voice.

Note: *Experiment with this feature before using it for a real project.*

⑥ Check the **Play project audio while recording** option.

Note: *The Play project audio while recording option lets you hear the movie's audio while recording. You can check this option if you need to take cues from the movie audio. You want to wear headphones if you use this option; otherwise you will be recording movie audio too.*

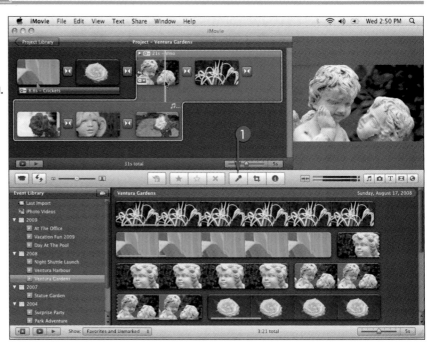

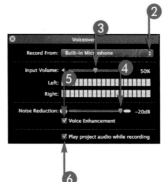

7 Click the video frame where you want the voiceover to begin.

iMovie begins to count down from three to one, and your audio recording begins.

Note: *Speak clearly into the microphone.*

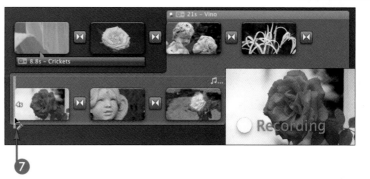

8 Click anywhere in the project to stop recording.

The recorded voiceover is shown as a purple bar in the Project window.

9 Close the Voiceover window.

Can I record multiple voiceovers for a project?
Yes. You can record more than one voiceover for an iMovie project. You can simply click another video frame within the Project window where you want the new voiceover to begin, record the voiceover, and click anywhere within the project to stop recording after you have finished. You can also move the voiceover to a different location and delete it just like a sound effect.

Manage Multi-Track Audio Levels in iMovie

When working with multiple audio tracks within a project, such as voiceovers, background music, and sound effects, you often need to adjust the audio levels so that the mix sounds right. iMovie makes it easy for you to manage multi-track audio settings to find the perfect mix for your project.

Manage Multi-Track Audio Levels in iMovie

① Double-click the audio track you want to adjust in the Project window.

The Inspector opens.

Note: You can choose any audio track including voiceovers, sound effects, and background music.

② Click **Audio** in the Inspector.

The audio controls open

③ Drag the **Volume** slider to adjust the audio level for the audio track.

④ Make sure Ducking is selected.

Note: *This option tells iMovie to fade the audio for all other tracks while this track is playing. You can use this option to ensure that a given track is heard over all others at any given point.*

⑤ Drag the **Ducking** slider () to set the volume for the other tracks.

Note: *You may need to test the new level a few times until you have found the proper volume.*

⑥ Click **Done**.

The Inspector closes.

TIPS

Why are the Ducking controls grayed out when I select the background music in my project?

The Ducking controls are available only for sound effects and voiceovers, and not background music because you cannot duck other tracks against the background music. You can lower the overall audio level for the background music by dragging the main volume slider.

Can I make an audio track play softly in the beginning and slowly grow louder?

You cannot create a custom volume curve on a track in iMovie, but you can in GarageBand. What you can do is use the ducking feature in iMovie, which enables you to lower all other tracks so that your target track takes precedence.

Use Still Images in iMovie

Still photos are a great way to supplement your video projects in iMovie. Each photo contained in your iPhoto library can be easily imported into iMovie and edited into the storyboard.

① Click the **Photos** button (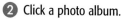).

The Photos browser opens.

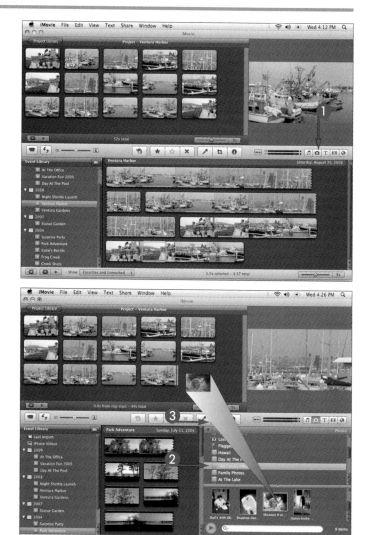

② Click a photo album.

The photos contained in that album appear.

③ Drag and drop a photo into an empty area in the Project window.

The photo is edited into the movie and is automatically animated.

④ Double-click the photo in the Project window.

The Inspector opens.

⑤ Type the number of seconds you want the photo to appear in the movie.

*Note: You can click the **Applies to all stills** option to set the new default duration for all still photos.*

⑥ Click **Done**.

The Inspector closes.

● The photo is inserted into the sequence with the specified duration.

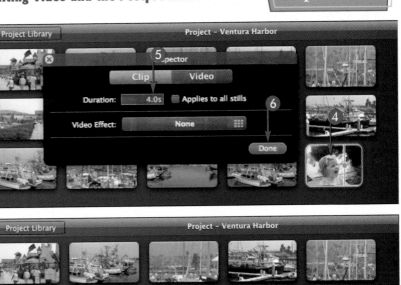

 TIPS

Can I crop photos after I have imported them?
Yes. You can crop your photos as well as add motion effects, and enhance photo images after they have been added to the project. Simply position the ▶ over the still image until the cropping overlay appears, and double-click the cropping option (●).

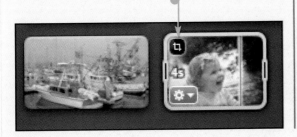

Is there another way to change the duration of a clip?
Yes. If you need to shorten the duration of a clip you can simply click the clip and drag either the right selection handle to the left or the left selection handle to the right. When you have achieved the length you want, press Control on the keyboard and click (●), or right-click and choose **Trim to Playhead** in the shortcut menu.

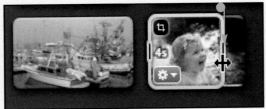

Set Up a Loops Project in Apple GarageBand

GarageBand is part of the Apple iLife suite of applications that ships with each new Mac and enables you to create high-quality music for your videos. Using loops is the quickest and easiest way to create music in GarageBand. The great thing about this application is that you do not need to be a seasoned professional to begin making professional soundtracks.

Merge

Set Up a Loops Project in Apple GarageBand

① Launch GarageBand.

GarageBand prompts you to create a new music project.

Note: *If you have not set the Welcome screen to not show when iPhoto is launched, click Close in the Welcome screen.*

② Click **Loops** for the type of project you want to start.

Note: *If you have used GarageBand before, it may open straight into the interface. If so, go to File in the main menu and choose New Project to begin.*

③ Click **Choose**.

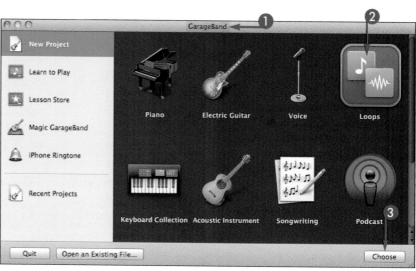

The New Project from Template dialog box opens.

④ Type a name for the project.

⑤ Designate a location to save the project.

⑥ Drag the slider to set the tempo.

Note: *If you do not know what tempo to set for your project, leave the default setting. You can change the tempo later if needed. About 100 to 140 is a typical rock song.*

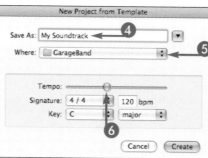

⑦ Choose the time signature.

Note: *If you are unsure how to configure this setting, you can leave it at the default setting and change it later.*

⑧ Choose the key and choose major or minor in the pop-up menu.

Note: *If you are unsure how to configure these settings, you can leave them at their default settings and change them later.*

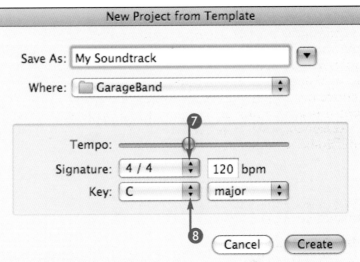

⑨ Click **Create**.

The New Project from Template dialog box closes and the project opens.

Am I locked into a particular template after I pick one?
No. You are not locked into any particular mode when choosing a project template. For example, if you chose the **Podcast** theme and later discovered that you wanted to work on a song that mainly involves the guitar, you can add guitar tracks and rearrange the project regardless of what you had previously chosen.

Create a Soundtrack with Apple GarageBand

The ability to create your own soundtrack gives you more creative control over your video projects, and enables you to establish the tone, tempo, and overall feel. GarageBand offers a large library of prerecorded loops and also enables you to record your own music to use in your project.

Note: *Launch both iMovie and set up a Loops project in GarageBand before beginning these steps.*

Create a Soundtrack with Apple GarageBand

1 In iMovie, open the project for which you want to create a soundtrack.

Note: *You can also select a project in the Project Library.*

2 Click **Share**.

3 Click **Media Browser**.

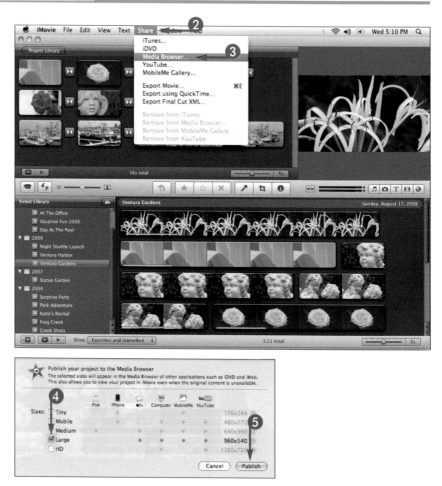

4 Click **Large** from the size options.

5 Click **Publish**.

iMovie prepares the project.

Note: *Depending on the size of your video, the publishing process can take a while.*

6 In GarageBand, click **Track**.

7 Choose **Show Movie Track**.

The movie track opens.

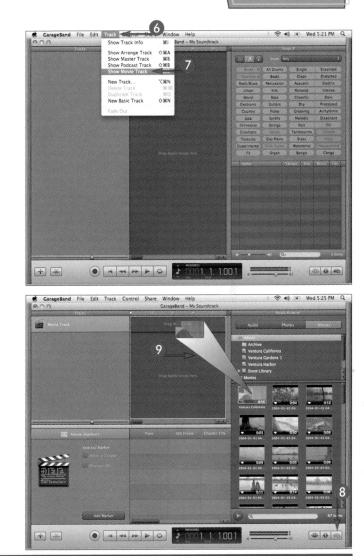

8 Click the **Media** browser button ().

The Media browser opens, revealing the saved iMovie project.

9 Drag the shared movie into the Movie Track.

GarageBand converts the movie and displays the thumbnails and soundtrack.

Note: GarageBand does not automatically save your projects like iMovie, so get in the habit of periodically saving your work.

TIP

Are there other ways to move video from iMovie into GarageBand?

Yes. You can drag clips directly from the Event Library in iMovie straight into the Movie track in GarageBand. What you have to keep in mind is that GarageBand does not have video editing capabilities, so any video clips that you drag from the Event Library possess only straight cuts. This drag-and-drop ability can sometimes be useful, but you will probably want to create a movie first in iMovie and then import it into GarageBand.

You can add your movie into the Movie Track within GarageBand and begin building the soundtrack with loops. The loops in GarageBand are grouped by musical genre, instrument, and themes.

Create a Soundtrack with Apple GarageBand *(continued)*

⑩ Drag the slider to adjust the movie sound.

Note: *When you bring your iMovie project into GarageBand, you may need to lower or raise the movie sound so that you can create music for the project. You can even choose to mute or delete the movie sound.*

⑪ Click the **Loop** browser button (⬛).

The browser opens, revealing the prerecorded loops.

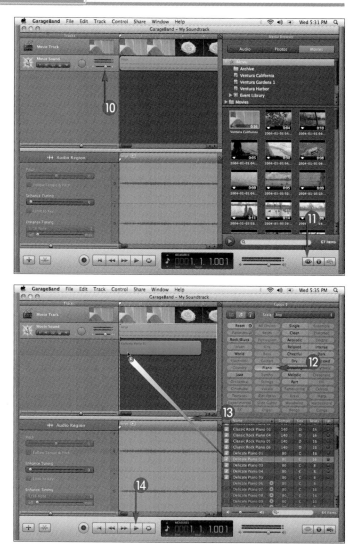

⑫ Click a category to locate the loop you want to use.

⑬ Drag the loop to an open area under the Movie Track to create a track.

Note: *You can use this method to drag more loops to the project.*

Note: *You can also drag the loop to a preexisting track. If you attempt to drag a loop to the wrong type of track, such as a Software Instrument loop to a Real Instrument track, GarageBand gives a warning.*

⑭ Click the **Play** button (▶).

Note: *Move the playhead back to the beginning so you can play the entire region.*

⑮ Drag the volume slider to raise or lower the volume of a loop.

⑯ Click **Share**.

⑰ Click **Export Movie to Disk**.

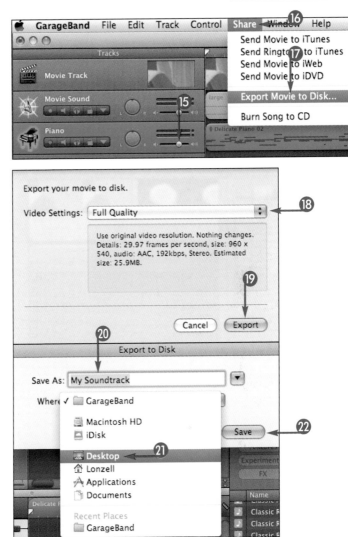

⑱ Choose **Full Quality**.

Note: You can choose Email, Web, Web Streaming, iPod, or iTV for specific use.

⑲ Click **Export**.

⑳ Type a name, if needed.

㉑ Choose a location to save the project.

㉒ Click **Save**.

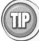

TIP

Are there other workflows for using GarageBand to create a soundtrack for my video?

Yes. You can create the music inside of GarageBand, and then export it for use in iMovie. Keep in mind that if you use this workflow you do not have the benefit of creating the music while cuing it to the video as it plays. Consider this method if your plan is to first create a great song and edit the video to the song, like for a highlight reel.

Explore the Adobe Premiere Elements Workspace

The Adobe Premiere Elements workspace is organized into the four major phases of a project: organizing media, editing the movie, creating DVD menus, and sharing your movies. The layout makes it easy for you to move between phases by clicking task buttons located at the top of the workspace. Knowing your way around Adobe Premiere Elements helps you to work more efficiently.

The Monitor Panel

The Monitor panel functions much like a TV and VCR by providing you options for viewing and playing back your video clips. You can also trim and split clips, apply effects, create titles, and position images. The Monitor panel switches its layout depending on what workspace you are in. The Monitor panel is available in all workspaces.

Tasks Panel

The Tasks panel is organized into four workspaces: Organize, Edit, Disc Menu, and Share. This pane is the central location for importing and organizing media, as well as locating, applying, and adjusting effects; creating DVD menus; and sharing finished projects. The Tasks panel is accessible in all workspaces.

Organize Workspace

The Organize workspace displays thumbnails of all of the video clips, still images, and audio files that you have imported into Adobe Premiere Elements. From the organize window you can access Get Media for importing, Instant Movie, Tagging, and Smart Tagging options.

Edit Workspace

The Edit workspace is where you spend most of your time. You can access your video clips and start editing them into the timeline from this workspace. The Edit workspace also gives you access to movie themes, visual effects, transitions, and titles for your project.

Disk Menus Workspace

After you have finished your movie and are ready to create a DVD, the Disk Menus workspace gives you access to preformatted menu templates along with your media.

Share Workspace

When you are ready to share your video with the world, you can access the Share workspace to optimize your movie for online viewing, or viewing on a mobile phone, a computer, videotape, or other devices.

TimeLine and Sceneline Workspace

The Timeline and Sceneline workspace is where you begin assembling your video footage into an actual show. You can use the Sceneline workspace to quickly assemble video clips, add titles, transitions, and effects. The Timeline workspace enables you to fine-tune your edits by giving you the ability to trim, layer, and choreograph your media. You can switch between both workspaces at any time.

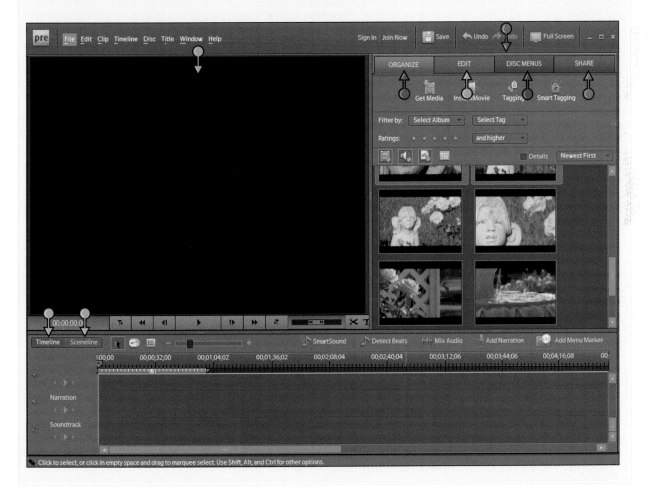

Edit Video in Adobe Premiere Elements

The Timeline workspace acts as a virtual storyboard, letting you place clips on it in the order in which you want them to occur, and giving you the flexibility to rearrange clips as the edit progresses. The Timeline is a quick and convenient way to put your movie together.

Edit Video in Adobe Premiere Elements

① Click **Edit**.

The Edit workspace opens.

② Click **Project**.

Project view opens, revealing the previously captured files.

Note: *You can rearrange video clips alphabetically by clicking in the column header.*

Note: *You can also rearrange the information columns such as Frame Rate and Media Type by dragging them to a new position. You can use the scroll bar at the bottom to move to the right and view more information regarding individual clips in the columns.*

③ Click **Timeline**.

④ Drag and drop a music file into the track labeled Soundtrack in the timeline.

The music file appears in the track.

Note: *If you look closely at the soundtrack you can see the actual waveform for the audio file. The peaks and valleys within the waveform represent changes in audio levels within the file, with peaks being high levels and valleys low levels. You can use the waveform as a visual cue for cuts to establish a rhythm for your edits.*

⑤ Double-click a video clip you want to use in the show within the Project view.

The preview window opens.

⑥ Drag the In point to where you want the action to begin in the clip.

⑦ Drag the Out point to where you want the action to end in the clip.

Note: You can play the clip in this window to determine the action you want to add to your movie.

⑧ Close the Preview window.

The clip is now trimmed in the Project view.

⑨ Drag and drop the clip from the Project window into the timeline.

The single clip appears in the timeline and is shown in the Monitor view.

Note: You can use this method to edit all of your clips into a movie.

Note: A green check mark is placed next to the clip in the Project view to signify that the clip has been added to the movie.

Note: You can play the entire clip in the Monitor view by clicking the Play button () under the window.

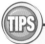

TIPS

How can I insert a clip between two clips instead of at the end?

You can insert a video clip between two existing clips in the timeline by dragging and holding a clip over another clip — Premiere Elements shuffles the clips downward, making room for the new clip — and then dropping the clip (●). If you have audio in the timeline, press and hold the `Control` key on the keyboard while inserting the clip, so that the audio does not split in the audio track.

How can I rearrange my previously edited clips in the timeline?

You can rearrange clips in the timeline by simply dragging them to a new location and holding down `Control`. When you drag a clip to a new location a blue line appears, signifying the location where the clip will be moved. Rearranging clips helps you to find the perfect combination of clips in your movie. If audio is edited into the timeline, press and hold `Control` and `Alt` while rearranging clips so you do not split the audio track.

Trim Video in the Timeline in Adobe Premiere Elements

When you trim clips, you are removing the excess video to frame a specific action occurring within that clip. Trimming is the essence of video editing and is how you reveal the story contained within the video footage you have recorded. Trimming video is a straightforward process in Adobe Premiere Elements, but requires some practice in order to perfect.

Trim Video in the Timeline in Adobe Premiere Elements

1. Open a project that contains four or more video clips.

2. Click **Edit** in the Tasks panel.

3. Move the current-time indicator to the point in the clip where you want the action to begin.

Note: *Scrub, or drag, the current-time indicator back and forth so you can see where the In point should be in the clip by viewing it in the Monitor panel.*

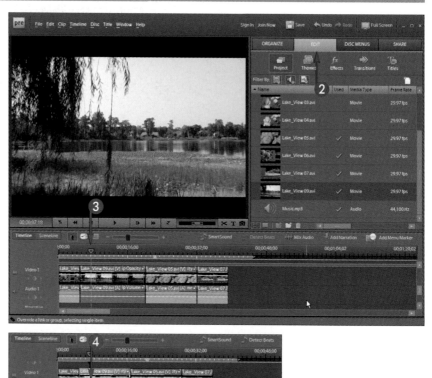

4. Position the mouse pointer over the left side of the clip, until a right-facing bracket with a double-headed arrow appears (⚎); then drag the clip to the current-time indicator.

 The clip snaps to the current-time indicator, and the In point of the clip is changed, shortening the clip.

Note: *Adobe Premiere Elements proceeds to close the gap after the trim has been made and shortens the duration of the entire movie. This type of edit is known as a ripple edit.*

⑤ Place the current-time indicator where you want the action to end in the clip.

Note: *Scrub, or drag, the video back and forth so you can see where the Out point should be in the clip by viewing it in the Monitor panel.*

⑥ Position the mouse pointer over the right side of the clip, until a left-facing bracket with a double-headed arrow appears (⟷); then drag the clip to the right.

● The clip snaps to the current-time indicator, and the Out point of the clip is changed, shortening the clip.

Note: *Adobe Premiere Elements proceeds to close the gap after the trim has been made and shortens the duration of the entire movie.*

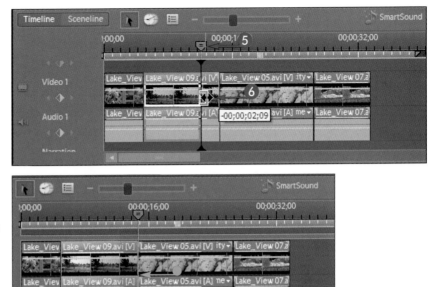

(TIP)

Why does a gap appear between my first and second clip when I change the In point for my first clip in the timeline?

This is an anomaly in Adobe Premiere Elements that occurs whether you are working in the Timeline or Sceneline workspace. When you change the In point of the first clip, Premiere Elements does not perform a ripple edit, and a gap is created that appears as black in the actual movie. Right-click within the gap and choose **Delete and Close Gap** from the pop-up menu (●).

Record a Voiceover in Adobe Premiere Elements

Adding a voiceover can help your viewing audience follow the story and can add a personal touch to your videos. To record a voiceover in Adobe Premiere Elements you must first connect a microphone to your computer. When the microphone is connected properly, you can begin recording narration in real-time while previewing the movie.

Record a Voiceover in Adobe Premiere Elements

1 Open a project.

2 Place the current-time indicator where you want the voiceover to begin in the timeline.

3 Click the **Add Narration** button (■).

The Record Voice Narration controls open.

4 While speaking into the microphone, drag the **Level** slider to set the record volume.

Note: Make sure that the Volume indicator moves when you talk into the microphone. As you talk into the microphone, if the meter hits in the yellow or red, lower the Level slider.

Note: You can uncheck **Mute audio while recording**, which un-mutes the sequence audio during the recording of the voiceover. Make sure that you wear headphones if you uncheck this option, or you will record the movie audio as well.

5 Click the **Record** button (■) to begin recording.

Premiere starts a countdown from three.

The video plays as Premiere Elements records the narration.

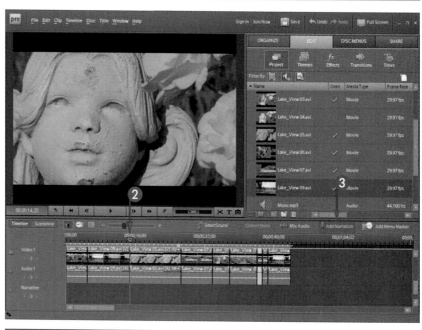

6 Click the **Stop** button (■).

7 Close the **Record Voice Narration** controls.

Record Voice Narration

Recording : 00;36;19

☐ Mute audio while recording

💡 For best results use headphones and uncheck mute. To reduce feedback while recording lower Input Level Volume slider.

● The audio appears in the narration track in the timeline and in both the Organize and Project views.

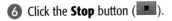

Lake_View Lake_View 09.avi [A] Lake_View 05.avi [A] ne ▾ Lake_View 07.a Lake_Vi Lake_View 0 V V Lake_Vie

Narration_5.wav Volume:Clip Volume ▾

 TIPS

How do I adjust the audio level of the voiceover after I have recorded it?

You can adjust the audio levels for recorded narration by clicking the **Mix Audio** button (), located in the upper-right portion of the timeline, and open up the Audio Mixer. You can then drag the audio slider for the narration in the Audio Mixer until the levels are acceptable.

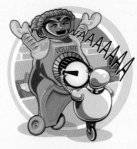

How do I delete the recorded narration from the timeline?

You can click the **Delete present narration** button () located in the Record Voice Narration controls. The narration is then removed from the Timeline or Sceneline workspace and remains in the Project view of the Tasks panel. To simply replace the narration, you can click the record button and record a new narration.

Mix Audio in Adobe Premiere Elements

When working with multiple audio tracks within a project, such as voiceovers, a soundtrack, and clip audio, you often need to adjust the audio levels so that the mix sounds right. Adobe Premiere Elements makes it easy for you to manage multi-track audio settings to find the perfect audio mix for your project. The Audio Mixer makes it possible to fade audio up and down to accommodate other audio tracks.

Mix Audio in Adobe Premiere Elements

① Open a project for which you want to adjust the audio.

② Click the **Mix Audio** button ().

The Audio Mixer opens, displaying controls for all available audio tracks.

③ Move the current-time indicator back to the beginning of the timeline.

Note: *Wherever you place the current-time indicator in the timeline is where the audio adjustments start.*

④ Click ▶.

The project plays in the Monitor panel.

⑤ Drag the slider to adjust the audio for the soundtrack.

The audio level adjusts in real time as the movie plays to the end. Key frames depicting the change in audio levels over time appear in the soundtrack.

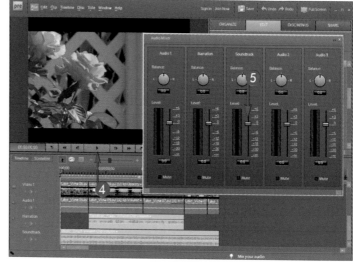

6 Place the current-time indicator at the beginning of the timeline.

7 Click .

8 Adjust the next track in the Audio Mixer.

In this example, the Narration track is being adjusted.

The audio level adjusts in real time as the movie plays. Keyframes depicting the change in audio levels over time appear in the soundtrack.

Note: *It is best to adjust each track from beginning to end one at a time. Do this for each track you want to adjust.*

Note: *One of the drawbacks to adjusting the audio in real time is that each time you adjust the sliders, attempting to find the right level, the audio for that particular section in the movie is changed, as the current-time indicator makes its way down the timeline.*

TIPS

Is there an alternative to using the Audio Mixer?

Yes. You can adjust the audio from the timeline. The yellow lines within each clip in the audio tracks represent the current audio level. You can drag the yellow overlays up or down to raise or lower the audio (●). This method does not allow you to gradually fade the audio up or down as when using the mixer.

What if I only want to gradually fade my soundtrack up after the narration ends?

You can place the current-time indicator at the spot where you want the adjustment to occur, then click the **Mix Audio** button (▮▮▮▮) to open the Audio Mixer. In the Audio Mixer you can raise the level for the soundtrack and play the timeline so that the audio in the clip gradually fades up. Key frames, or markers that define changes for specific points in time, are added to the timeline audio.

Use Still Images in Adobe Premiere Elements

Still photos are a great way to supplement your video projects in Adobe Premiere Elements. Each photo contained on your hard drive can be easily imported into Adobe Premiere Elements and edited into the timeline.

Use Still Images in Adobe Premiere Elements

① Open a project.

② Click **Organize**.

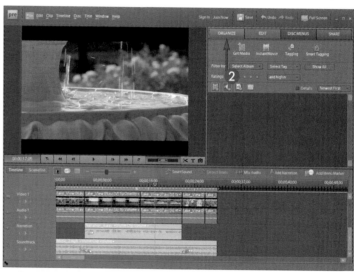

③ Click **Get Media**.

④ Click **PC Files and Folders**.

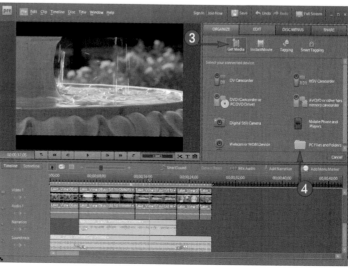

⑤ Browse to the location of the graphic on the hard drive.

⑥ Select the photo.

Note: *Make sure that the photo is very high resolution or Premiere Elements will enlarge it, resulting in a low-quality still image in the movie.*

Note: *Prep your photos in an image editing program so that they are the same aspect ratio and dimensions as your video project or black may appear on the sides or at the top and bottom of your stills when edited into the movie.*

⑦ Click **Open**.

The file is imported into the project and can be seen in the Organize and Edit views.

⑧ Click **Edit**.

⑨ Drag the still to the timeline.

The still image is edited into the movie.

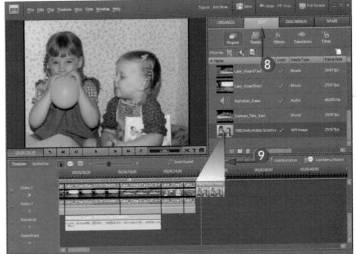

Is there a photo editor that you would recommend?

Yes. Consider purchasing Adobe Photoshop Elements to complement Adobe Premiere Elements. If you have not purchased either application, Adobe sells them as a bundle on its Web site. Photoshop Elements is a more scaled-down version of Adobe Photoshop, which is the industry leader in still image editing. Photoshop Elements can help you create graphics with dimensions and aspect ratios equal to those of your video project.

Why does my photo appear fuzzy or blurry when I play it back?

If the photo is high enough resolution for your project, it may just need rendering. A red bar may appear over the photo within the timeline to indicate that the clip requires processing (rendering) to display properly. If you play the timeline while this area is red, your photo will appear fuzzy. You can go to **Timeline** in the main menu and click **Render Work Area**. A green bar appears above the photo and it can now be played back properly.

Create a Soundtrack with SmartSound in Adobe Premiere Elements

SmartSound is a plug-in included with Adobe Premiere Elements that enables you to choose from a large collection of soundtracks to use in your video projects. SmartSound lets you customize the duration of the soundtrack to fit your movie so that the music begins and ends naturally for your project. Adding a soundtrack to your movies can take your video work to a whole other level creatively.

Edit a Soundtrack with SmartSound in Adobe Premiere Elements

① Open a project that requires music.

② Place the current-time indicator where you want the soundtrack to begin.

Note: *Take note of how long the movie is in the timeline. SmartSound enables you to create a soundtrack the same length.*

③ Click the **SmartSound** button ().

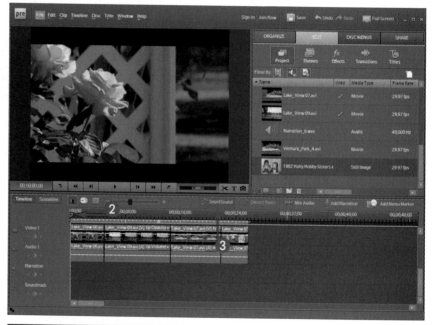

④ Click the **Click here to select music** option.

The SmartSound Maestro dialog box opens, displaying music selections.

⑤ Select the music track that you want.

Note: You can preview music tracks by double-clicking them.

⑥ Click **Select**.

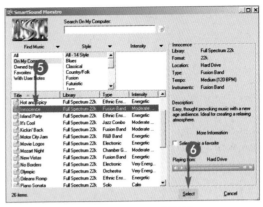

⑦ Type the length of your movie into the Length field.

⑧ Choose a **Variation**.

Note: SmartSound offers variations for compositions. Each selection provides a different beginning, middle, and end for the track you selected, providing you a little uniqueness to the soundtrack.

*Note: You can click the **Play** button (▶) in the Preview field to preview the variation.*

⑨ Click **OK**.

The Exporting SmartSound Soundtrack dialog box opens.

⑩ Type a new name if needed.

⑪ Choose where you want to save the file.

⑫ Click **Save**.

The file is saved at that location and is added to the project in the track labeled Soundtrack.

Note: You can click and drag the Soundtrack audio file within the timeline to another track or simply move it to begin at a later time.

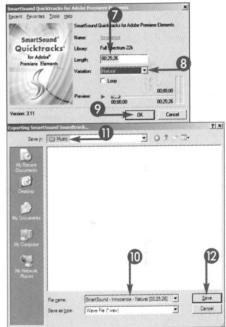

How do I adjust the audio level for my soundtrack?

You can drag the yellow overlays up or down in the audio tracking to lower or raise the audio. You can also adjust audio for the soundtrack in real time by clicking the **Mix Audio** button () and using the Audio Mixer. The Audio Mixer would be the best choice if you need to fade the soundtrack up or down.

CHAPTER 11

Creating Transitions, Titles, and Other Video Effects

Transitions, titles, and video effects enhance your videos not only by helping to advance the story or message, but also by providing a look and feel for the entire presentation. This chapter shows you how to apply and adjust transitions in iMovie and Adobe Premiere Elements as well as create titles and popular video effects that will take your videos to the next level. You also are given some tools for expanding the effects capabilities of your video editing application and shown how to export movies and archive finished projects.

Explore Elements of Video Look and Feel

At the end of the day, people are going to judge your video by how it looks as well as how well you conveyed your message. Camerawork, music, sound, lighting, and effects are elements that you can use to carefully craft a unique look and feel for your video work. Consider the impact of each of these elements before you begin.

Evaluating Camerawork

Shabby camerawork can ruin a good video presentation, but great, creative, well-choreographed camera movements can make for great video. Smooth camera movement makes your video appear polished and professional. Consider using a dolly to get those smooth tracking shots as your on-screen talent walks across the set. If you are mechanically inclined, the Internet is full of "Do It Yourself" blueprints for constructing homemade dollies and other camera stabilizing devices. You can also consider using a chair with wheels or a cart you can find at your local hardware store for short tracking shots. You will have to be on a very smooth surface to pull it off.

Consider the Music

Use royalty-free music to help set the feel for your video work. Prerecorded loop-based software applications like GarageBand and the Adobe plug-in SmartSound can enable you to make your own sinister, hip, or sorrow-filled soundtrack to match the creative aim of your movie. The right music can help you create suspense for your independent movie or provide that extra kick for a highlight reel. The next time you create a home video, try using music to help complement what your audience is viewing on-screen.

Exploring Sound

People are more likely to remain engaged in a movie that has no picture than one with no sound. Solid audio is a key component to any video production, and the skillful use of sound effects can make for some very interesting video. Look for opportunities to supplement the ambient audio in your video. Try enhancing the ambience to a scene by using a sound effect of birds chirping softly in the background as you shoot in the park. Birds may already be chirping on your audio track, but you can make them more profound. People want to watch your video for the experience.

Take It Easy on the Effects

Too many effects can turn your video production into a graveyard for special effects. Be mindful of how many fancy transitions, artistic color corrections, and other software effects you use in your video. Many times, the excessive use of effects is used as a coverup for bad video work or the absence of a good story. Make sure that the video effects you use complement your movie and do not become the movie.

Some intermediate and nearly all professional video editing applications use what are referred to as plug-ins to increase their available toolsets. Many software developers create plug-ins for specific video editing applications to expand the capabilities of that program. Plug-ins can provide you flexibility as an editor and keep your video editing application relevant for a longer period of time.

What Are Plug-ins?

Plug-ins are supplementary software programs that interact with a host software application, usually to extend the functionality of the host application. These programs are often accessible through the main interface of the host software application by way of a button or tab, or appear under a category such as Effects. Many of the plug-ins for video editing applications function as video filter effects for creating unique visual effects such as a pencil sketch or watercolor. Some plug-ins expand your transitions library, or the titling capabilities of the editor.

Use Plug-ins for Video Effects

You can use plug-ins to expand the effects library of your video editing application. Some third-party developers create collections of plug-ins that mimic classic film looks used in Hollywood. Other plug-ins can make your video appear to be an animated cartoon, provide 3-D text, create particles such as rain and snow, and simulate lens flares. Plug-ins also offer controls so that you can tweak the parameters of the effect. When shopping for effects plug-ins, make sure that they are compatible with the video editing application you are using. Higher-end video editing applications have the most plug-in options.

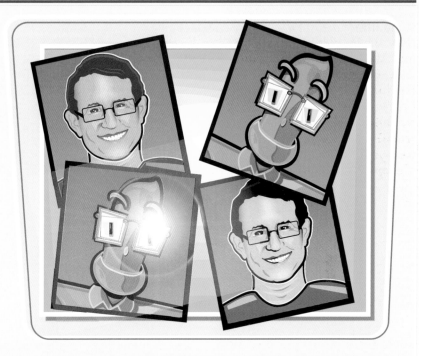

Explore Practical Plug-ins

Some plug-ins are used for practical purposes such as standards conversion from NTSC to PAL, or vice versa, and for upconverting SD to HD or converting interlaced video to non-interlaced video. You can also find plug-ins that are meant to fix video problems that occurred during the acquisition, such as noise reduction, color correction, and the removal of interlace flicker from imported graphics. Adobe Premiere Elements utilizes a plug-in by the name of SmartSound that enables you to add a soundtrack to your movie which you can then match to the duration of your video project.

Explore Lens Filters for Effects

Lens filters are specially crafted glass that attach directly to the camera lens and are used to manipulate light as it enters the camcorder lens. Effects filters are creative tools to help you set the look and feel for your video work. Before purchasing effects filters consider the positives and negatives of using them in your videos and what filters are available for your camera.

Examine the Benefit of Lens Filters

Before effects plug-ins, videographers relied much more heavily on lens filters to achieve a desired aesthetic for their video. Now, most of these effects can be achieved in postproduction with a video editing application. The real benefit to using lens filters is to avoid further compression of the video. When you add an effect to your video within a video editing program, it has to be rendered, or recompressed, to join the video and the audio with the effects. Because video is already highly compressed, recompression can greatly decrease the quality of the video. If the effect is achieved upon acquisition, you can avoid some compression later.

Understand the Negatives of Lens Filters

Just about any effect you can achieve by placing a lens filter on your camera, you can achieve with effects filters within a video editing program. The issue with using lens filters is that the effect becomes a permanent part of your video. Say that you used a Star Effect lens filter, which creates twinkling star patterns in the highlighted areas of your video, for an artsy video that you created. Later, you discover that you need that same piece of video as part of an industrial training DVD. The original video may no longer be of any use to you. Consider using effects filters in post for the same effect so you can repurpose that video at a later time.

Exploring Lens Filters and Video Cameras

Due to the discerning tastes and needs of professional videographers, there are a greater variety of effects lens filters made for larger, higher-end digital video cameras. When you look to purchase a filter kit, take note of the filter size of your camera because most filters screw onto the front of the camera lens. The majority of lens filters advertised for consumer cameras are ones considered essential or practical such as Ultraviolet (UV), Polarizing, and Neutral Density (ND).

Create Titles for Video in iMovie

You can add titles to your videos in iMovie with relative ease. Adding titles to your video enables you to set up your movie as well as provide important information to your viewing audience.

Create Titles for Video in iMovie

① Open the iMovie project that needs titles.

② Click the **Titles** browser button (T) in the taskbar to open the Titles browser.

③ Select the title style that you want to use.

Note: Some of the titles are animated. You can hold the mouse pointer () over the title to see a preview.

④ Drag the title selection to the project window over the location where you want it to appear.

● A blue title bar appears over the video where the title was placed and the title appears in the viewer window.

Note: As you hold the title over the video a purple overlay appears, showing you the frames of video over which the title will be placed.

5 Double-click in the text box in the viewer window and edit the text.

6 Click **Show Fonts**.

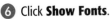

The Choose Font option opens.

7 Click an option to change the font color.

***Note:** You cannot change the font type for certain themed-styled font selections.*

***Note:** You can see a preview of the font change in the viewer window by simply positioning the ▶ over a selection.*

8 Click **Done** in the Choose Font box.

9 Click **Done** in the viewer window when finished editing the text.

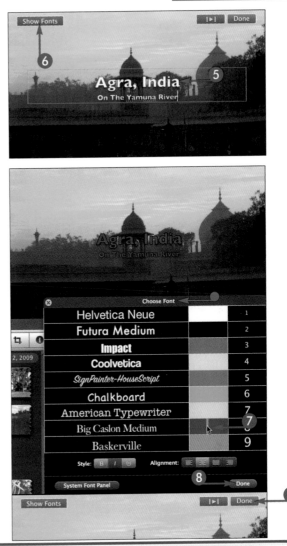

How do I make a title appear over a solid background and not over video?

When dragging the title from the Title browser to the project window, drop the title in between two clips or at the very beginning or end to have it appear over a solid background. When you drop the title selection, the Choose Background box opens. You can preview a background in the viewer window by positioning the ▶ over a selection.

How do I change the duration of my titles?

You can drag on the ends of the blue title icons in the project window to make them longer or shorter (●). You can also drag the title to a new location so that it appears over another section of the video. The title has a natural fade up at the beginning and fades down at the end of its duration. Some animating titles do not fade, but animate onto the screen.

Add and Replace Video Transitions in iMovie

Video transitions complement the flow of your movie by providing you a unique way to move from one scene to the next. Adobe Premiere Elements offers an extensive library of transition effects ranging from basic to ostentatious.

Add and Replace Video Transitions in iMovie

① Open an iMovie project that contains more than one video clip in the project window.

② Click the **Transitions** browser button ().

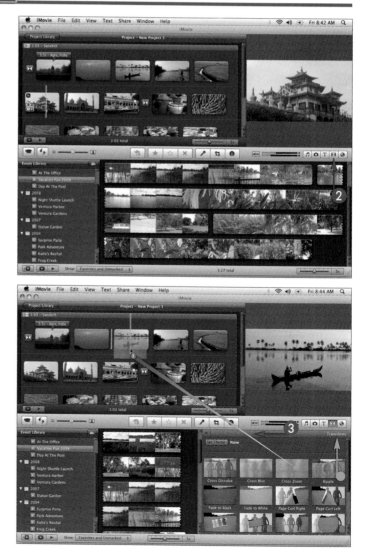

The Transitions browser opens.

③ Drag a transition from the Transitions browser to the project window and drop it between two clips.

● A transition icon appears in between the two clips.

Note: A green overlay appears as you hold the transition over the project window, signifying where the transition will be placed. Use this overlay to place the transition exactly where you want it.

Note: You can preview the transition in the viewer window by positioning the ▶ over it.

④ Double-click the transition.

The Inspector controls for the transition open.

⑤ Click the name of the transition in the Inspector.

The Choose Transition box opens.

⑥ Click a new transition.

The Choose Transition box closes and the new transition is applied.

⑦ Click **Done** to close the Inspector.

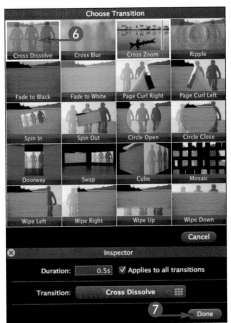

Can I set iMovie to automatically place a transition?

Yes. You can go into the Project Properties and configure iMovie to automatically insert transitions each time you edit a video clip into the project window. You can access the Project Properties by going to the main menu, clicking **File**, and choosing **Project Settings** from the menu. Select **Automatically add** (●) and choose the transition type.

Can I apply a different transition other than the one that I chose to insert automatically?

Yes. But you have to turn off automatic transitions. You can turn off automatic transitions by going into **Project Properties** and deselecting the **Automatically add** option. Or, you can simply drag a different transition to the project window. A warning opens, giving you the opportunity to turn off automatic transitions.

Create Video Transitions in Adobe Premiere Elements

Video transitions offer a unique way to progress from one video scene to the next. You can use transition effects for many creative purposes, including softening what would otherwise be an abrupt change from one clip to another, and to set a mood by slowing down the pace with a soft fade. Adobe Premiere Elements has a large library of transitions that range from basic to flashy.

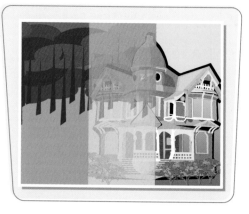

Create Video Transitions in Adobe Premiere Elements

1 Open a project that contains more than one video clip in the timeline.

2 Click **Edit** in the Tasks panel.

3 Click **Transitions**.

The Transitions library opens displaying Video Transitions.

Note: Adobe Premiere Elements also contains Audio Transitions that can be accessed from a drop-down menu in the Task panel.

4 Click and drag a transition between two clips in the timeline.

The transition is applied between the two clips and appears as a purple icon in the timeline.

Note: You can preview each transition by positioning the ![cursor] over it.

Note: A red line appearing above the transition in the timeline indicates that the effect needs to be rendered before it will play back properly. You can go to **Timeline** in the main menu and choose **Render Work Area** to render the timeline.

5 Click **Edit Transition** to tweak the effect.

Note: The transition has to be selected in the timeline, or the Edit Transition option is grayed out. You can also double-click any transition in the timeline to edit it.

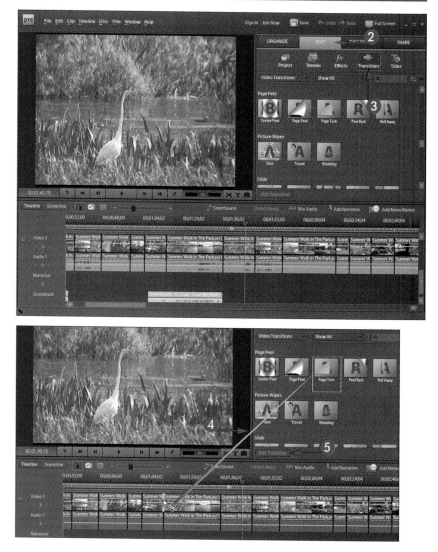

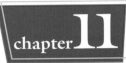
6 Drag to the right within the Duration field to increase the duration of the transition.

The purple transition icon lengthens in the timeline.

Note: Each transition has its own unique controls that enable you to customize it.

7 Click **Done**.

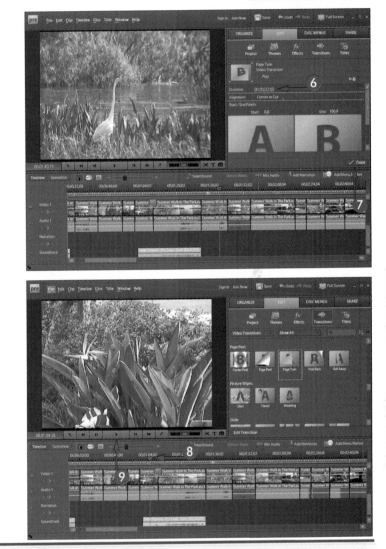

8 Place the current-time indicator before the effect in the timeline.

9 Click the **Play** button (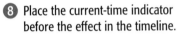) in the Monitor panel to review the effect.

TIPS

Can I change the position of the transition so that it starts at a different time?

Yes. When you double-click the transition in the timeline, you change the alignment of the transition between the clips. Your choices are **Center at Cut**, **Start at Cut**, **End at Cut**, and some transitions offer a **Custom Start** option. Where you choose to align the transition depends completely on how you want the edit to look. If there are not enough video frames at the head and tail of each clip to perform a transition, you may have only one alignment option.

Can I save my favorite transitions?

Yes. You can right-click the transition in the library and choose **Add to Favorites** from the menu. You can then filter the results in the transition view to access your favorite transitions. Saving your favorite transitions enables you to quickly access your most-used ones.

Create Titles for Video in Adobe Premiere Elements

You can add titles to your videos in Adobe Premiere Elements with relative ease. Adding titles to your video enables you to set up your movie as well as provide important information to your viewing audience.

Create Titles for Video in Adobe Premiere Elements

① Open a project that contains video in the timeline.

② Place the current-time indicator where you want the title to begin in the timeline.

③ Click the **Add default text** button (**T**).

● The Text Options open in the Tasks panel.

● The safe margins appear in the Monitor panel.

Note: *A clip representing the text appears in the timeline. You can drag the clip in the timeline to have the title occur at another point in the movie.*

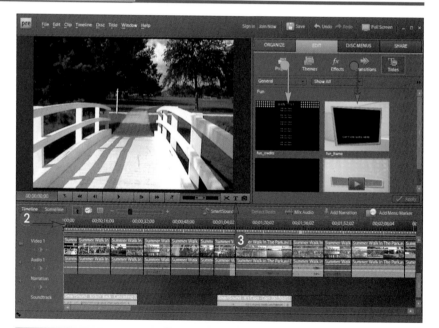

④ Type a new title in the Monitor panel.

⑤ Click in the font type field.

The list of fonts stored on your computer appears in a list.

⑥ Click a new font in the font list.

The old font type is replaced with the new font in the Monitor panel.

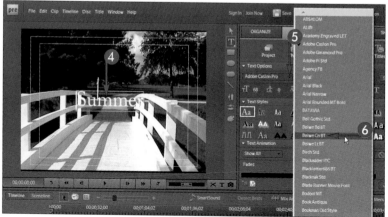

⑦ Click and drag to the left or right over the text size field to increase or decrease the size of the font.

⑧ Click the **Selection** tool (⬆).

⑨ Drag the text in the Monitor panel to reposition the text.

⑩ Click the **Color Properties** button (🎨).

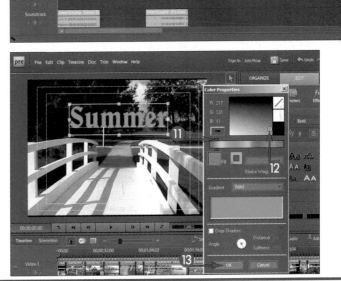

The Color Properties box opens.

⑪ Drag the color slider to designate the color range.

⑫ Pick a color by clicking.

Note: *You can also add a drop shadow by checking **Drop Shadow** in the Color Properties box.*

⑬ Click **OK**.

The color of the text is the specified color.

TIPS

How do I change the outline of my text?

By default, you can only change the fill of the text and not the stroke until you pick a new text style. The fill is the color on the inside of the font, and the stroke is the color for the outline of the font. Pick a new text style in the Tasks panel (●), and then you can choose to change the color for the fill or the stroke within the Color Properties box.

Can I animate my text to crawl across screen?

Yes. A quick way to animate your text is to access the Roll and Crawl option. Select the title in the timeline and click the **Roll/Crawl** icon (🔲) located in the bottom-left corner of the Tasks panel to reveal the options. You can pick an option and then choose the starting location in the **Roll/Crawl** options dialog box.

Make Your Video Look Like Film

Achieving the look of cinematic film for video is one of the most sought-after aesthetics for independent filmmakers. The "film look" has many aspects, such as depth of field, lighting, camera movement, and composition. There are a few things that you can do to get your video to look like it was shot on film.

Explore 24p and Cinema Mode Camera Features

By default, most video cameras are set to record at a frame rate of 60 interlaced fields (60i) per second, and provide an aesthetic quality for your video that is similar to what you see on the local news channels. Video cameras that record in the 24p progressive frame rate can provide more filmic images, because they are able to capture video in a way that provides a similar motion as feature films. Some digital video cameras also offer a cinema mode that enables you to achieve color and tonal characteristics similar to film. Purchasing a camera with 24p recording capability and cinema mode features helps you achieve a film aesthetic.

Purchase a 35mm Lens Adapter

The depth of field achieved with a film camera is vastly different than that achieved with a conventional video camera and is a defining characteristic of the "film look." A few companies offer adapters that enable you to use a 35mm single lens reflex (SLR) still camera lens with your video camera for a more shallow (filmic) depth of field. Not all 35mm lens adapters are created equal, so make sure that you do your research. Using these adapters also involves a learning curve, so make sure you know what you are signing up for.

Consider the Lighting

Lighting is a huge factor in the film experience. Most independent filmmakers do not possess the resources to achieve cinematic lighting, as you are accustomed to on the big screen. What you do have are the principles of three point lighting and volumes of books written on the subject. Purchase a lighting kit with three lights and practice lighting for depth by alternating the light and dark parts of a scene. Be an active observer and take note of the lighting used in the movies you watch and on primetime TV. You are operating on a much smaller scale, but you can learn a lot from the pros.

Examine Camera Movement

Smooth camera movements, particularly tracking shots, are another characteristic of film. These shots are achieved by placing the camera on a track, which allows the camera to follow actors as they walk, or to simply provide motion to an otherwise stationary subject. Consider using skateboards, shopping carts, chairs with wheels, or a dolly from a home improvement store on a smooth surface to get your camera moving. Lack of zoom is also a cinematic look.

Use Effect Filters in Postproduction

Plug-ins that convert your 60i video to 24 frames per second and alter the tonality of the image can help you achieve a film aesthetic in post. Several companies offer excellent solutions for making video footage look less like video. Red Giant Software (www. redgiantsoftware.com) and Digital Film Tools (www. digitalfilmtools.com) offer high-quality solutions for video.

Export a QuickTime Movie from iMovie

You can export a project in the form of a QuickTime movie to your computer hard drive. Each movie you export from iMovie has to compress, so depending on the size of the movie file, it could take a few minutes to complete. Exporting a QuickTime movie of your video is a convenient way to let others receive a preview of your work.

Export a QuickTime Movie from iMovie

① Open the iMovie project that you want to export.

② Click **Share** in the main menu.

③ Click **Export using QuickTime**.

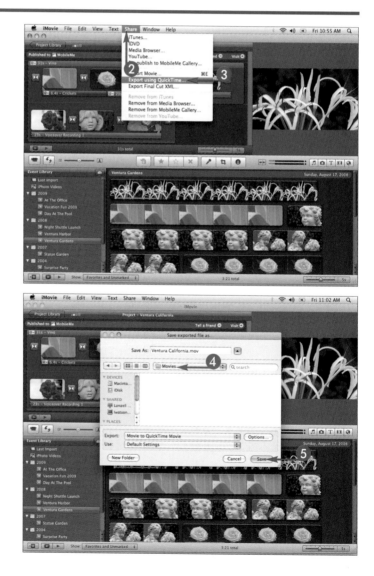

The Save exported file as dialog box opens.

④ Choose a location to save the QuickTime file.

⑤ Click **Save**.

The file is saved in the specified location.

Note: You can burn a CD of the movie file to show to those you may be collaborating with on a project.

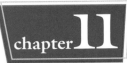

You can export a movie from iMovie to iTunes with just a few simple clicks. Exporting your movie to iTunes is a great way to share your finished movies with others and also provides a centralized place to store previews of your movies.

Export a Movie to iTunes

① Open the iMovie project that you want to export.

② Click **Share** in the main menu.

③ Click **iTunes**.

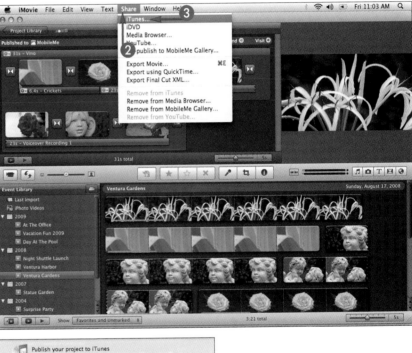

The Publish your project to iTunes options open.

Note: *Depending on the original resolution of your video, some of the size options may be grayed out. For example, if resolution of the footage was less than 960x540, the Large option may be grayed out.*

④ Choose a size.

Note: *You can choose multiple sizes for export.*

⑤ Click **Publish**.

iTunes opens and the movie is now listed under Movies in the iTunes Library.

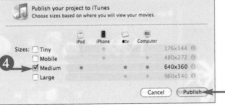

Archive a Project in Adobe Premiere Elements

After you have completed a project and have shared it, it is a good idea to archive your movies. Adobe Premiere archives only the video footage that was used in the movie and stores it in a location of your choosing. Archiving your projects enables you to return to them later and perform future edits.

Archive a Project in Adobe Premiere Elements

① Open the finished project you want to archive.

② Click **File** in the main menu.

③ Click **Project Archiver**.

Note: By default the option to archive only the footage used in the actual project is selected. You can also choose to copy the unused media you captured to the project along with the used video footage by selecting **Copy Project**.

Note: In the section labeled Disk Space you can view the original project size, including all captured files, and the new saved project size, with only the video used in the actual movie.

④ Click **Browse**.

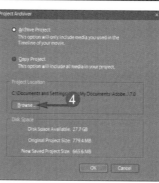

5 Designate a place on your hard drive to save the file.

6 Click **OK**.

Browse For Folder ? X

Please select the destination path for your resulting project.

- Desktop
 - My Documents
 - My Computer
 - My Network Places
 - Adobe CS3
 - Adobe Premiere Elements 7
 - Adobe Premiere Elements 7 Download
 - Archived_Projects ← **5**
 - backups
 - Book Backup
 - Chapte9_PCGraphics
 - Chapter 10_Graphics
 - Chapter 11_Graphics
 - Chapter 12_Graphics
 - Copy of Digital Field Guide Book 2
 - DFG First

Make New Folder **6** → OK Cancel

7 Click **OK** to close the Project Archiver box and begin archiving the project.

Project Archiver ✕

○ **Archive Project**
This option will only include media you used in the Timeline of your movie.

○ **Copy Project**
This option will include all media in your project.

Project Location
C:\Documents and Settings\User\Desktop\Archived_Projects

Browse...

Disk Space
Disk Space Available: 27.7 GB
Original Project Size: 779.4 MB **7**
New Saved Project Size: 665.6 MB

OK Cancel

 TIP

Do you have any advice on storing archived projects?
Archived projects can be large and take a significant amount of hard drive space on a computer. If you create a lot of projects you should consider archiving your projects to an external drive. You can also burn archived projects to DVDs or Blu-ray Disc.

Explore Color Correction Possibilities

Nearly every shot could benefit from some sort of color correction. Your goal may be to add warmth and vibrancy to a scene by increasing the color saturation, lower saturation to add a hint of blue for a cooler scene, or for the more practical purposes of fixing problems that occurred during the acquisition of the footage. Higher-end video editing applications provide a more in-depth array of color correcting tools. Color correction can help your footage be the best it can be.

Discover Image Controls

Many video editing applications are equipped with tools such as filters, sliders, and color wheels that can help you improve the images you have recorded in the field. Brightness controls can help you adjust video where the exposure was less than perfect. Contrast, hue, and saturation controls enable you to adjust images until they are the best that they can be. Some applications utilize filters that can be applied to a clip for an instant effect such as black and white and sepia, while offering more practical options that optimize your video for broadcasting on TV.

Correcting an Improper White Balance

Nothing trumps getting the white balance right as you acquire the footage, but color balancing tools can help you minimize the effects of an imperfect white balance. Some video editing programs have a fast color corrector that involves a selection tool called an eyedropper. The eyedropper enables you to click a spot in the video that represents white or neutral gray so that the color can automatically be adjusted for a proper white balance. More advanced video editing applications allow you to correct white balance for shadows, midtones, and highlights separately for more accuracy.

Be Creative

You can use color correcting tools for arresting effects such as creating stylized looks and turning day into night. You can lower the saturation and add a hint of blue to create a cooler, desaturated look, to emphasize the hardness of the city, or to create a post-sunset twilight for a quiet, little town. Creative color correcting can give your video a look that is entirely unique, which could prove to be your signature look. Keep in mind when shopping for a video editing program that the higher-end applications provide you with more options by way of a more robust toolset and the ability to utilize third-party effects filters.

Learn the Basics of Shooting for Green Screen Effects

Placing your on-screen talent in front of a green screen, so you can later composite that image with a different background, is a very popular effect. Many video editing applications ranging from basic to professional have included chroma keying as part of their toolset. Understanding the basics of setting up a green screen shoot helps you achieve the highest-quality effect.

What Is Keying

Keying is a technique used in video editing software or compositing software for mixing two images or frames in which a color, typically green or blue, is removed or made transparent, revealing another image. This technique is used in film as well as in your local meteorological forecast to display the weather map behind the on-air talent.

Purchasing a Backdrop

When you shop for backdrops on which to record your actors, your choices are mainly broken down into paint, paper, or cloth. Green or blue screen colors are specifically used because they are opposite colors to skin tones, making it easier for a video editing program to later isolate the background color and remove it. Although debatable, the color green has some technical advantages over blue for video. When purchasing a green screen, make sure that you purchase a pure, highly saturated color green to achieve the best results. Look for backdrops labeled as "chroma key green." Get the biggest backdrop you can afford.

Mind the Actors' Clothing

When using a green screen, make sure that your talent does not wear the color key (the color of the background) and do not have any other green objects in the shot. Any green in the actors' clothing can make the talent appear ghostly, because part of their clothing is removed due to the effect.

Light the Subject and Background Evenly

To successfully key a subject, the backdrop must be evenly lit; this means no shadows must appear on the subject or on the backdrop. Make sure that the subject is placed far enough in front of the green screen fabric to prevent shadows or any green color spill, and the fabric itself must be wrinkle free. If possible, frame the subject so that the camera cannot see beyond the green screen; this saves you a few steps when creating the actual effect in the video editor.

Replace Backgrounds in iMovie with Green Screen Effects

After recording a subject against a green screen backdrop, you can use what is referred to as a "green screen" effect to cut out the backdrop and replace it with another background. You can place the green screen clip over a solid background, animated graphic, or another video clip to give the appearance of a new environment for the subject. iMovie offers a quick and easy way to achieve this popular effect.

Replace Backgrounds in iMovie with Green Screen Effects

1. Open a project that contains the desired background and green screen footage.

2. Click **iMovie** in the main menu.

3. Click **Preferences**.

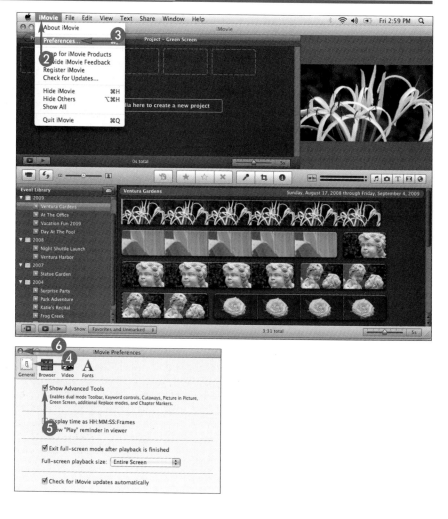

4. Click **General**.

5. Click **Show Advanced Tools**.

Note: If Show Advanced Tools has not been selected, you will not get the option to key out the green screen when you drop one clip over another in the project window.

6. Close the preferences.

⑦ Edit the background footage into the project window.

⑧ Select the part of the green screen footage you want to use in the Event browser.

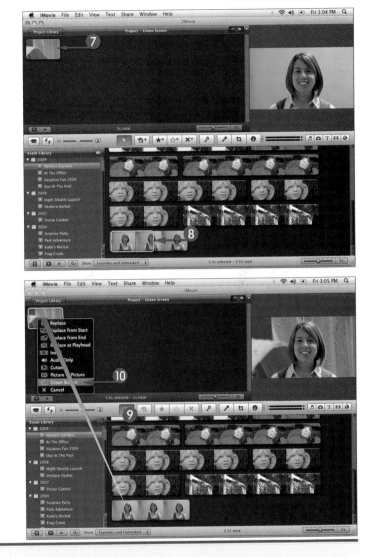

⑨ Drag the green screen clip to the project window and drop it over the video that you want to use as the background.

The edit options appear.

⑩ Click **Green Screen** in the menu.

The green screen clip appears above the background clip.

Note: If both the green screen clip and the background clip have audio, they both play simultaneously in the project. You can use the **Action** pop-up menu (⚙) that appears in the lower-left corner of the clip when the ▶ hovers over it to access audio controls for each individual clip and lower the audio for one of the clips.

Note: If you place the green screen clip over a transition effect, the transition does not play.

Can I crop my green screen clip?

Yes. You can crop out extraneous space around the subject. This is particularly useful if there is an unwanted object in the shot or if your background is not big enough. You can click the green screen clip in the project window to reveal the crop tools. Then drag handles located at the top of the clip to crop a tighter shot.

Any other tips for keying in iMovie?

Yes. When recording your subject on green screen, consider shooting a frame at the end of just the green backdrop, without the subject. iMovie has a Subtract Last Frame function that enables you to produce a higher-quality effect by using the information in the last frame to determine which color to isolate. Double-click the green screen clip to select the **Subtract last frame** option in the Inspector.

Replace Backgrounds in Adobe Premiere Elements with Green Screen Effects

After recording a subject against a green screen backdrop, you can use what is referred to as a green screen or keying effect to make the backdrop transparent so that another clip shows through as the background. You can replace the green backdrop of a clip with a solid color, animated graphic, or another video clip to give the appearance of a new environment for the subject.

Replace Backgrounds in Adobe Premiere Elements with Green Screen Effects

① Open a project that contains both the green screen clip and the desired background clip.

② Click **Edit**.

③ Drag the clip that you want to use as the background into Video track 1.

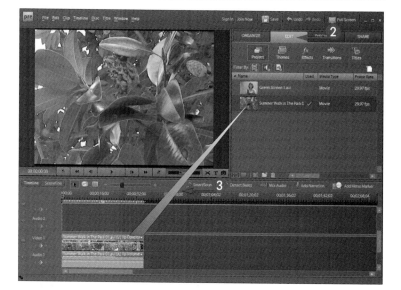

④ Drag the clip for which you want to remove the background into Video track 2.

The Videomerge dialog box opens.

⑤ Click **No** in the Videomerge dialog box.

Note: *The Green Screen Key effect gives you more control over the effect than does the Videomerge option.*

⑥ Click **Effects**.

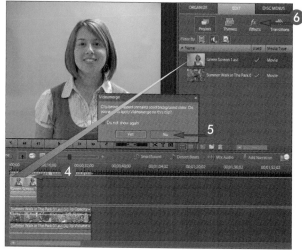

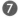

The Effects view opens.

7 Drag The **Green Screen Key** effect to the clip in Video track 2.

● The clip on track 1 becomes the background of the clip in track 2.

*Note: It may be quicker to locate the green screen effect by typing **green screen** in the search field rather than scrolling.*

8 Click **Edit Effects**.

The Properties view opens.

9 Adjust the Green Screen Effect controls to perfect the key.

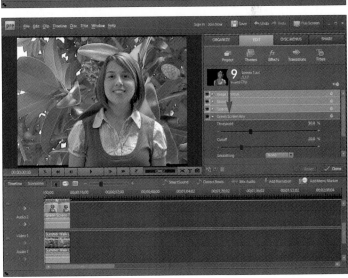

TIPS

Is there another quick way to make my backdrop transparent?

Yes. You can use the Videomerge feature. When you edit the second clip into Video track 2, the Videomerge dialog box opens asking if you want to apply Videomerge on this clip. Choose **Yes**. Premiere Elements then analyzes the clip for a dominant color and automatically makes that color transparent. The Green Screen Key effect gives you more control over the effect.

Can I crop out an object that appears toward the edges of my green screen video after I performed a key effect?

Yes. You can use what is called a Garbage Matte to remove extraneous objects in the key. The Garbage Matte options can be found under Effects. Your choices are Eight-Point Garbage Matte, Four-Point Garbage Matte, and Sixteen-Point Garbage Matte. The more points in the matte, the more handles and control you have to crop out unwanted parts of the green screen video.

CHAPTER 12

Sharing Your Video with the World

There are many different options for you to share your video with friends and family. You can create high-quality DVDs for your finished movies; export to mobile devices such as the iPod and iPhone; or upload video to popular video sharing sites such as YouTube, MySpace, and many others. You can also create your own personal Web site to showcase your video works of art.

DVDs remain a very popular way to showcase and distribute your video work. DVDs provide higher quality and a longer shelf life than VHS tapes. Video editing software with built-in DVD recording capabilities has made it very easy to record DVDs, but before you begin, you should be aware of the hardware requirements. This section shows you what you need to create your own DVDs.

Get Ready to Make a DVD

You need a drive that not only plays DVDs, but can also burn DVDs installed on your computer. Most new computers have DVD burners built in. If your computer does not have a built-in DVD burner, you can either buy an internal DVD burner that replaces your CD-ROM drive or an external DVD burner that connects to your computer via FireWire or USB cable. Blu-ray Disc burners that enable you to burn Blu-ray discs are more expensive than conventional burners. Take note which format your burner supports: DVD-R or DVD+R. If possible, buy a drive that supports both formats. Double-layer drives enable you to use higher-capacity DVDs.

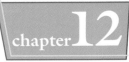
Recordable DVDs

Purchase recordable DVDs that are compatible with your particular DVD burner. Some DVD drives may be compatible with the DVD-R (DVD-Recordable) format but not the DVD+R format. When shopping for DVDs, it is important to know the relevant acronyms. DVD-R (DVD-Recordable) discs allow you to record to them only once. DVD-RW (DVD-Rewritable) discs enable you to record something to the disc, erase it, and then record something else. Many of the new PCs and Macs come equipped with DVD burners that support both formats. Dual Layer (DL) DVDs possess almost twice the storage space as standard DVDs and are more expensive.

DVD Authoring Software

You need software on your computer to properly format and burn DVDs. Many video editing applications, ranging from beginner to professional, come equipped with DVD authoring capabilities that not only burn DVDs, but also enable you to build a high-quality DVD menu system. The more professional/expensive video editing applications offer a more complete and professional toolset for authoring high-end DVDs.

Create a DVD
with Apple iLife

It is very easy to share your finished movie from within iMovie straight to iDVD, which is part of the iLife suite of applications. Sharing your videos to iDVD enables you to make sleek, high-end DVDs complete with menus. Within iDVD you can change menu themes, edit menus, and add more movies.

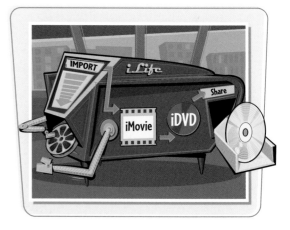

Create a DVD with Apple iLife

Note: *You will need a blank DVD inserted into your computer for this task.*

① Click **Project Library**.

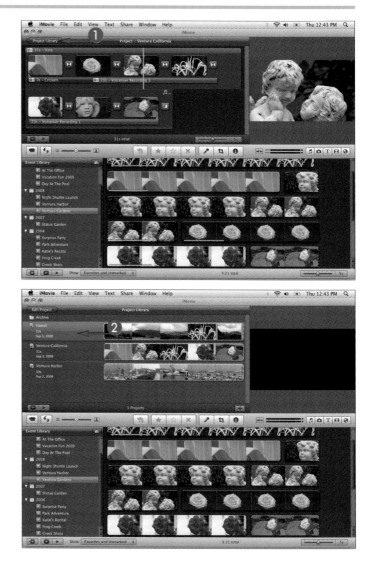

② Choose the project you want to make into a DVD.

③ Click **Share** in the main menu.

④ Click **iDVD**.

The movie is rendered and sent to iDVD; iDVD opens.

A button is automatically created in the DVD menu with the name of the iMovie project.

Note: *Depending of the length of the movie, rendering can take a while.*

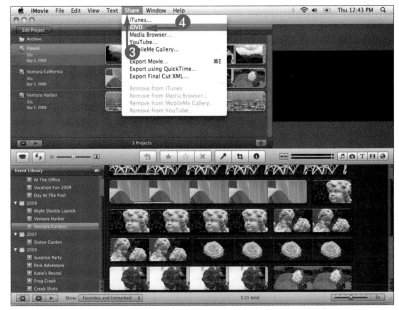

⑤ Choose an iDVD theme.

The theme opens with the video included.

Note: *If you are using standard 4:3 footage, a dialog box may appear, asking if you want to change the project aspect ratio from standard to widescreen. Click **Keep** if you will be viewing the disk in 4:3 standard format.*

TIP

Can I preview the DVD before I burn the disk?
Yes. You can run a simulation of your DVD before burning it by following these steps:

① Click the **Preview DVD** button (▶) located next to the Burn button (▣).

② Click the **Enter** button (⊜) in the remote control to play the movie.

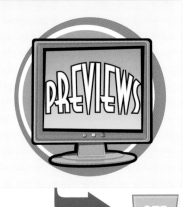

continued

You can personalize the menu of your DVD by adding different video clips and music; and editing the text in the theme. Inserting a video clip or music file into a DVD menu is as simple as dragging it from the Media Browser and dropping it in the iDVD main viewing area.

Create a DVD with Apple iLife (continued)

6 Double-click the text in the iDVD theme to edit the text.

As you begin to edit the text, the options for font type, typeface, and button size appear.

7 Click **Media**.

You can now browse for audio, photos, and movies on your computer hard drive.

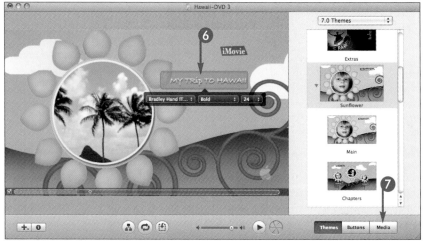

8 Click **Movies**.

The movies within the Movies folder appear.

9 Drag a video clip from the Media Browser that you want to use in the DVD menu, and drop it in the Drop Zone in the iDVD main viewing area.

The video now appears in the DVD menu.

10 Click **Audio**.

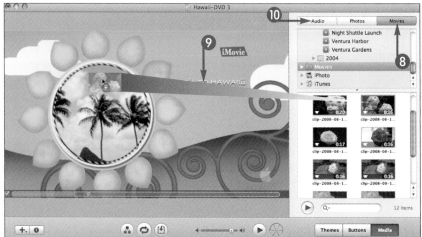

⑪ Click **Music**.

The files in your Music folder appear.

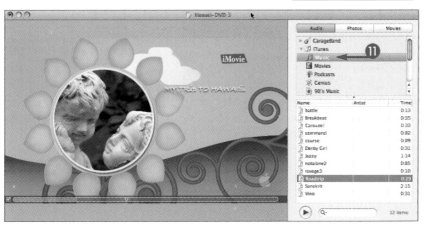

⑫ Click and drag the song you want to use for the DVD menu and drop it on the menu.

The new music plays.

The burning process begins.

Note: You can create high-quality labels for your DVDs. Some manufacturers' Web sites, such as Hewlett Packard's, offer templates for printing on CDs and DVDs .

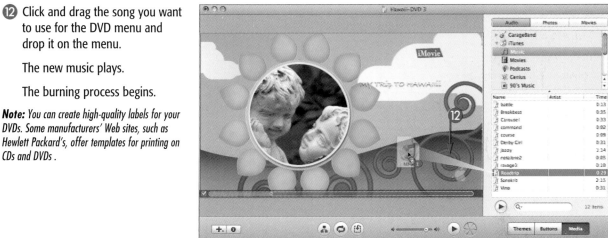

Can I add a movie to an iDVD project already in progress?
Yes. Open the project you want to add. Click **Share** in the main iMovie menu and choose **Media Browser**. When iMovie prompts you, choose the largest movie size available. Your project is then rendered and is made accessible to all of the iLife applications. You can then open iDVD and add the movie to an iDVD project already in progress.

Put Your Video on the Internet

Placing your videos on the Internet for others to view and share may very well prove to be the second golden age of the Internet. In order for you to get involved, you need to know what services are available to you for posting your own movies online. In this section you receive information on Web hosting services, video sharing sites, and some tips on protecting your online identity.

Hosting Your Videos Online

In order for you to place your own Web page on the Internet and have others view and download your movies, you need a Web hosting service. Companies that provide Web hosting services, such as Apple's MobileMe, Godaddy.com, and HugeHost.com, provide space on a server that they lease to you for a monthly fee. Prices vary due to the amount of space you lease on the server. Many Internet Service Providers (ISPs) may offer free Web hosting services if they already provide your business or home access to the Internet. Hosting services come with e-mail accounts, security features, and a specified amount of storage space. Make sure you do your research to determine which is the best fit for you.

Upload Your Videos to Sharing Sites

Video sharing Web sites such as YouTube, MySpace, and Vimeo showcase a wide variety of user-generated video content such as short films, video blogs, and music videos 24 hours a day, 7 days a week. Users without accounts are free to watch videos but must register in order to upload content of their own. Video sites such as these have made reaching millions of people around the world accessible for the weekend video warrior as well as the seasoned professional. If your content is compelling, you could cultivate a following of loyal viewers. Some video editing applications provide a streamlined process to get your movies on popular video sharing Web sites such as YouTube.

Name: Jon Collins
DOB: 10-30-50
Workplace: Algernon Press
Title: Manager
Work ph: 317-555-5500
Home ph: 317-555-0505
Address: 322 Lister Dr. Covington, IN 45673
Bank: Indiana Farming Trust
Password: 4D5S6V

Use Discretion When Posting Videos Online

The Internet is a powerful vehicle through which you can reach many viewers, but it can also offer an unintended eye into your personal life. Be mindful of the content that you post; you never know who is watching. Many employers often Google the names of prospective employees before meeting them. If you publish something controversial on the Internet, be prepared to live with the consequences. Avoid posting highly personal information about yourself such as addresses, phone numbers, or where you work. Consider withholding your real name and go by a user name, or just not revealing your last name.

Bring Your Movie into iWeb

You can create high-end Web sites with Apple's iWeb application, which is part of the iLife suite of applications. You can share your iMovie project to the Media Browser and then bring that movie into iWeb to design your very own Web site with video. The Media Browser enables you to use photos and movies to construct a Web site. In order to publish to a Web site you must have an online hosting account.

Bring Your Movie into iWeb

① Open the iMovie project of which you want to create a DVD.

② Click **Share** in the main menu.

③ Click **Media Browser**.

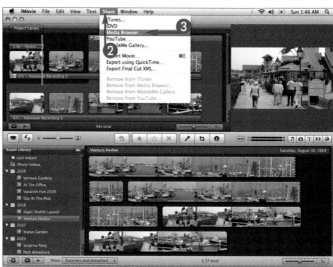

④ Select **Mobile**.

Note: Smaller movies reduce the download time on Web pages.

⑤ Click **Publish**.

The movie is rendered and sent to the Media Browser.

Note: Depending on the length of the movie, rendering can take a while.

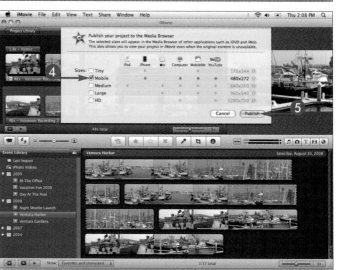

6 Open iWeb.

Note: If this is your first time opening iWeb you may be prompted to sign into your MobileMe account. MobileMe is a Web hosting service provided by Apple. You can publish sites using a hosting service other than MobileMe, but MobileMe is a great option for taking advantage of all the features of iWeb.

7 Click **File** in the main menu.

8 Click **New Site**.

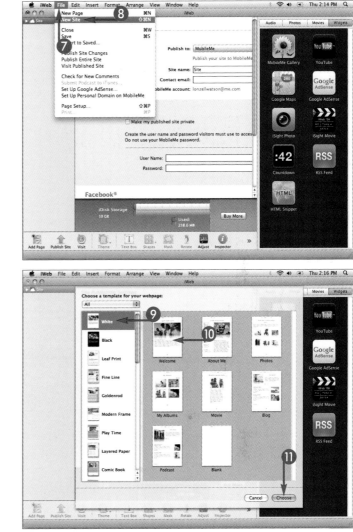

The site templates appear.

9 Choose a template category.

10 Choose a **Welcome** page.

Note: You can navigate the many different iWeb themes by scrolling in the sidebar.

11 Click **Choose**.

The new template page opens.

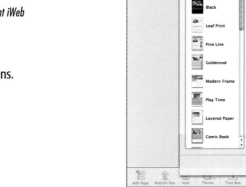

Can I change my theme once I have chosen one?

Yes. You can switch to a different theme simply by clicking the **Theme** button () at the bottom of the interface and choosing another one. Once the new theme is chosen, the photos or video you placed in the previous theme is placed into the new template theme.

continued

You can add photos and movies simply by dragging them from the Media Browser and dropping them into an iWeb template. By adding your Web hosting information into iMovie, you can publish to your Web site with a simple click.

⑫ Click **Photos**.

The Media Browser opens.

Note: *If the Media Browser is hidden, you may need to click the **Show Media** button () located at the bottom-right corner of the interface.*

⑬ Click **Photos**.

⑭ Drag a photo to the Web site template.

The photo is placed in the template.

Note: *You can double-click in the template text to personalize it.*

⑮ Click **Add Page** ().

The template options open.

⑯ Choose a Movie template.

⑰ Click **Choose**.

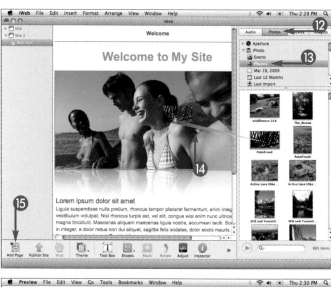

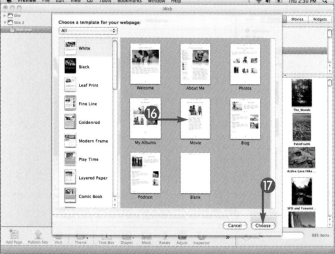

The new page template opens.

Note: The link for each new page appears at the top of the template and serves as a navigation bar for moving between pages.

⓲ Click **Movies**.

The Media Browser opens.

⓳ Drag the movie that you want and drop it in the template.

The movie appears in the template.

*Note: If you drag a large file into the template, a dialog box may open stating that the file is large and may result in longer download times. You can click **OK** or export your project at a smaller size from iMovie.*

⓴ Click **Publish Site** (⬆) to upload to your hosting service when you are finished designing the site.

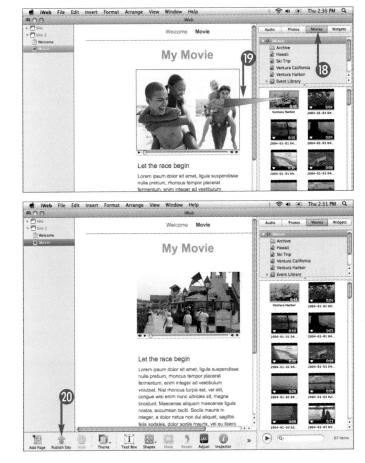

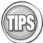

TIPS

How do I enter in my Web hosting information?

You can enter your Web hosting information by selecting the site in the sidebar. If you do not have a MobileMe account, you can choose your method of upload from the Publish To options. If you are using a MobileMe account, the process is a bit more streamlined.

How do I set my movie to autoplay once the page is accessed?

You can set your video to autoplay by accessing the Inspector. Select the movie in the template. Click the **Inspector** button (ⓘ) and choose the **QuickTime** icon () in the Inspector to open the movie settings. Select **Autoplay** (●) in the menu.

Publish Directly to YouTube in iMovie

iMovie streamlines the process of publishing your videos to the popular video sharing Web site, YouTube. Before you can place your video on the site, you need to create an account. YouTube is an excellent way to get your videos seen by many people around the world.

Publish Directly to YouTube in iMovie

① Open an iMovie project that you want to share to YouTube.

② Click **Share** in the main menu.

③ Click **YouTube**.

Note: If you do not have a YouTube account you can click **Add** to be guided through the process.

④ Choose the YouTube account to which you want to publish.

⑤ Type the password to your YouTube account.

⑥ Choose the category that best describes your video.

⑦ Type a title for the movie.

⑧ Type a description for the movie.

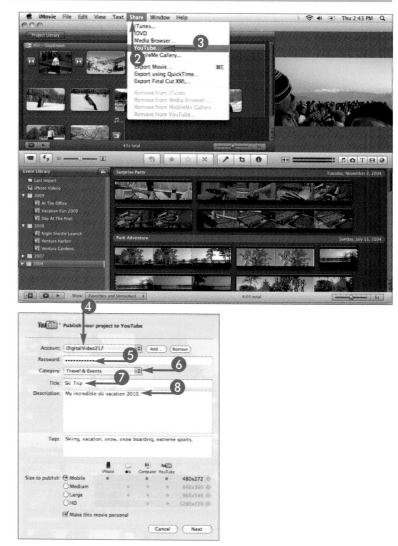

9 Add keywords in the Tags field.

Note: *Keywords/tags help viewers find your video when conducting a search.*

10 Select a size.

Note: *The Mobile size is easier to watch for viewers with slow Internet connections.*

Note: *You can select **Make this movie personal** if you want your video to be viewable only by contacts you specify with your YouTube account. Deselecting this option makes your movie viewable to everyone.*

11 Click **Next**.

Note: *Read the terms of service so that you understand the types of content you are permitted to publish on YouTube.*

The YouTube Terms of Service opens.

12 Click **Publish**.

iMovie uploads the movie to YouTube. Published to YouTube appears in the title bar of the project.

Note: *It could take a few minutes or hours before your video can actually be seen on YouTube.*

How can I delete my movie from the YouTube Web site?

You can delete your movie from YouTube by selecting the published project within the Project Library and then clicking **Share** and **Remove from YouTube** in the main menu. Click **Go to YouTube** and log into your YouTube account. Click **Done** in iMovie to remove the published status from your project.

Will my movie be updated if I make changes to it in iMovie?

When you make new edits to a movie that has previously been posted on YouTube, iMovie alerts you that the project is out of date and needs to be published again. After you render the movie again, the old version of the project is deleted and replaced by the new project on YouTube.

Prepare a Project for DVD Burning in Adobe Premiere Elements

Before you burn a DVD, you can add markers in the timeline that instruct Premiere Elements on how to set up the DVD's menu system. A basic menu system for a DVD consists of a main menu and a scene menu. Scene markers enable viewers to quickly navigate to different points in the movie on the DVD.

① Open the project you want to prepare for DVD burning.

② Move the current-time indicator to the beginning of the timeline.

③ Click the **Add Menu Marker** button (▣).

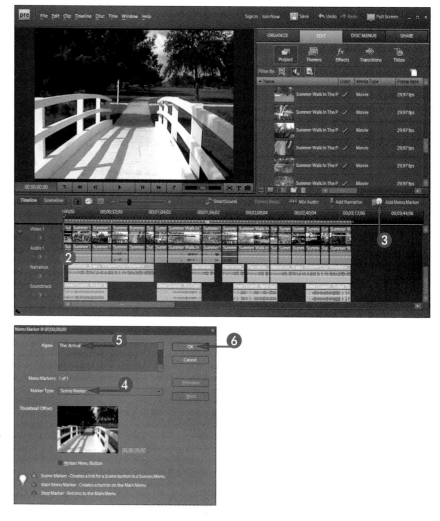

The Menu Marker dialog box opens.

④ Select **Scene Marker** in the Marker Type field.

⑤ Type a name for the opening scene.

Note: *Adobe Premiere Elements uses the first frame of video on which the current-time indicator is parked to represent the scene button for the DVD menu.*

⑥ Click **OK**.

286

A green marker is placed in the timeline.

⑦ Move the current-time indicator to the start of a new scene in the movie.

Note: You can use the Page Up and Page Down buttons on the keyboard to snap the current-time indicator to edit points.

Note: Think of scene markers as chapters in a book, and place scene markers at points in the movie where there is a clean break between actions.

⑧ Click 🖼.

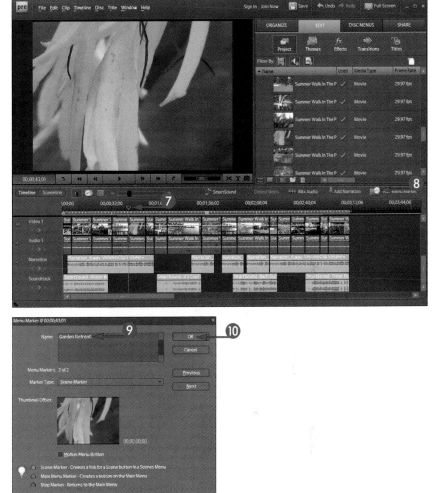

The Menu Marker dialog box opens.

⑨ Type a name for the second scene.

⑩ Click **OK**.

A green marker is placed in the timeline.

TIP

How many scenes can I have on one scene menu?
The limit is four scenes per menu. If you create five or more scene markers, the extras are automatically placed on a second scene menu.

menu
• Scene 1
• Scene 2
• Scene 3
• Scene 4

continued ➤

A stop marker lets Adobe Premiere know that the end of the program has been reached. Adobe Premiere then returns viewers to the main menu.

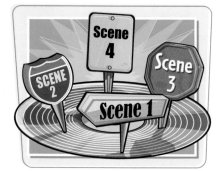

⑪ Move the current-time indicator to the start of a new scene.

⑫ Click ⬛.

The Menu Marker dialog box opens.

⑬ Type a name for the third scene.

⑭ Click **OK**.

A green marker is placed in the timeline.

Note: *When you create the DVD, the scene selection menu will have three buttons representing scenes.*

⑮ Place the current-time indicator at the end of the sequence in the timeline.

⑯ Click .

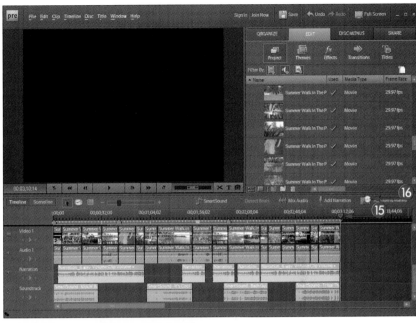

The Menu Marker dialog box opens.

⑰ Select **Stop Marker** in the Marker Type field.

Note: *The Stop Marker tells Premiere Elements that this is the end of the video. Premiere Elements then returns to the main menu after playing the last frame of the video.*

⑱ Click **OK**.

Note: *The project is now prepared for creating automatic DVD menus.*

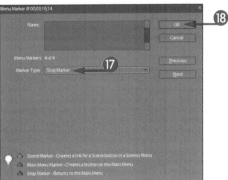

TIP

Can I place more than one movie in the timeline?
Yes. You can put some space between the first movie and the second movie, and add a second movie in the timeline. You then need to place a Main Menu Marker and a Scene Marker at the beginning of the new sequence. Later, you will need to rename the main menu, as Adobe Premiere Elements labels it as a **Scene Menu** after it automatically creates DVD menus for the project.

Create a DVD with Adobe Premiere Elements

After placing the proper markers into the movie timeline, creating a main menu and a scene selection menu for your DVD is relatively simple. A well-planned DVD menu system enables viewers to navigate your DVD with ease.

1 Open the project that contains DVD markers.

2 Click **Disk Menus**.

A library of menu templates appears.

3 Choose a template category.

The template options are filtered according to the specified category.

4 Select a template.

5 Click **Apply**.

Adobe Premiere Elements analyzes the timeline and places the movie inside the Main menu and the designated movie scenes inside the Scene menu of the template.

The Main menu is loaded into the Monitor panel.

6 Double-click the text in the Main menu template loaded in the Monitor panel to edit the text.

The Change Text box opens.

7 Type the new text.

8 Click **OK**.

Note: You can adjust the size of the text box by clicking in the template and dragging the handles.

Note: When you select text in the template, the text settings appear. You can change the font type, style, size, and color.

The text is updated in the template.

9 Click in the background in the template to gain access to its settings.

10 Click **Browse** in the Menu Background field.

The Select Background Media window opens.

11 Browse to the location of a video clip or still image file on your hard drive that you want to use in the template.

12 Select the file.

13 Click **Open**.

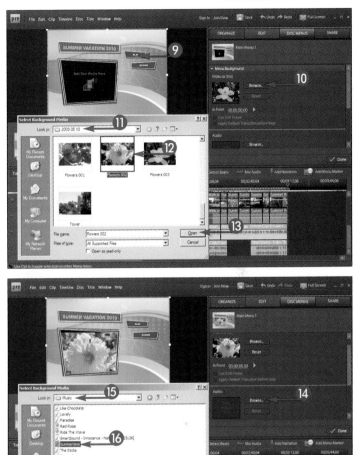

The background is replaced with the video clip or still image.

14 Click **Browse** in the Audio field.

15 Browse to the location on your hard drive where an audio file you want to use for the menu is located.

16 Select the audio file.

17 Click **Open**.

The audio file is added to the DVD template.

*Note: You can click **Preview** at the bottom of the Monitor pane to play back the menu.*

Note: You can use the same methods shown in the Main menu to construct the Scene menu.

TIP

Do I have to create a menu for my DVD?
No. You can create Auto-play discs, which contain no menus and begin playing as soon as you insert them into a DVD player. Click **Share** in the Tasks panel for your project that does not contain menus, and burn a disk. Auto-play discs work best when you have a single movie that you want to review from start to finish. Auto-play discs are the easiest discs to create.

Burn a Standard DVD or Blu-ray Disc with Adobe Premiere Elements

Adobe Premiere Elements enables you to burn a standard DVD or a Blu-ray disc to distribute your movie. The ability to burn a DVD of your work is not only convenient, but can also make a great gift for friends and family members to document momentous occasions.

Note: *A recordable DVD should be inserted into the DVD burner before following these steps.*

Burn a Standard DVD or Blu-ray Disc with Adobe Premiere Elements

1 Open the project you want to burn to a DVD.

2 Click **Share**.

The Share options open.

3 Click **Disc**.

The option for burning a DVD opens.

Note: *You can choose to create a DVD or a Blu-ray Disc.*

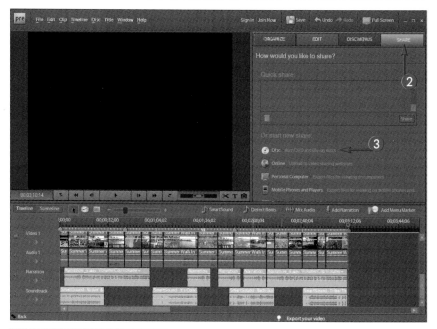

4 Click **DVD**.

Note: *You will need a Blu-ray burner and a recordable Blu-ray disc to burn a Blu-ray DVD. You also need a Blu-Rry player to play back the disc.*

5 Choose a preset based on the format of the video in your project.

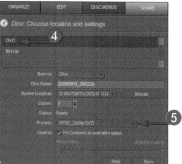

6 Uncheck **Fit Contents to available space**.

Note: If your movie exceeds the capacity of the DVD, leave this option checked.

7 Drag the slider to Highest Quality.

Note: Premiere gives you the space required to create a DVD at the highest quality underneath the slider.

| ORGANIZE | EDIT | DISC MENUS | SHARE |

Disc: Choose location and settings

DVD

Blu-ray

Burn to: Disc

Disc Name: 20090903_200226

Burner Location: D: MATSHITA DVD-R UJ-{ ▾ Rescan

Copies: 1

Status: Ready

Presets: NTSC_Dolby DVD

Quality: ☐ Fit Contents to available space

Most Video Highest Quality

6 **7**

Back Burn

8 Click **Burn**.

The project is burned to the DVD.

| ORGANIZE | EDIT | DISC MENUS | SHARE |

Disc: Choose location and settings

DVD

Blu-ray

Burn to: Disc

Disc Name: 20090903_200226

Burner Location: D: MATSHITA DVD-R UJ-{ ▾ Rescan

Copies: 1

Status: Ready

Presets: NTSC_Dolby DVD

Quality: ☐ Fit Contents to available space

Most Video Highest Quality

Back Burn **8**

TIP

What if I have a large project that exceeds the storage capacity of the DVD I am using?

If you have a massive project, you can check **Fit Contents to available space** in the Quality field of the DVD settings. Adobe Premiere Elements makes the content fit on the DVD. This option is checked by default and does not alter projects that fit on a disk when left checked. You can also use a dual layer disk that has a higher storage capacity.

Share iMovie Projects to Your MobileMe Account

iMovie enables you to publish your videos directly to your MobileMe gallery. MobileMe galleries enable friends and family to actively participate in the sharing of your video by viewing and downloading your videos. If you do not have a MobileMe account, you can set one up during the sharing process.

Share iMovie Projects to Your MobileMe Account

1 Open the iMovie project that you want to share.

Note: You can also select the project in the Project Library.

2 Click **Share** in the main menu.

3 Click **MobileMe Gallery**.

Note: If you do not have a MobileMe account, a dialog box asks if you want more information.

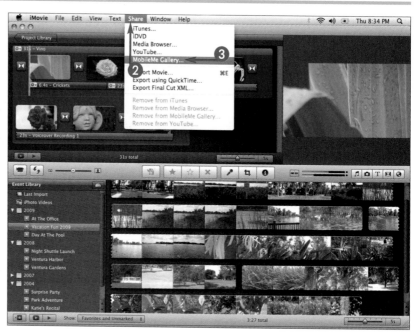

4 Type a name for the movie.

5 Type a description for the movie.

6 Choose a size for the movie.

7 Choose **Everyone** in the Viewable by options.

*Note: You can also choose **Only me**, where users are required to enter your user name and password to view the video. You can also choose **Edit Names and Passwords** which allows you to create user names and passwords for friends and family so they can view your videos.*

⑧ Select **Allow movie to be downloaded**.

Note: This option allows those with access to your video to download it to their hard drive.

⑨ Click **Publish**.

The movie is uploaded to your MobileMe Gallery and Published to MobileMe appears in the taskbar.

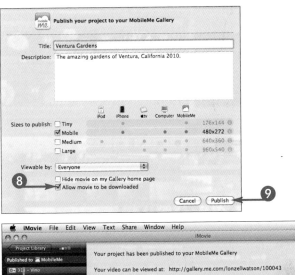

⑩ Click **View** to visit your MobileMe Gallery.

*Note: You can choose to **Alert** your friends that you have uploaded a video.*

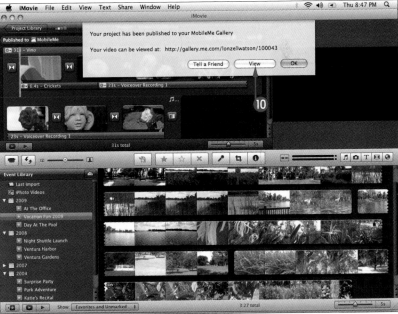

TIPS

Will my movie be updated if I make changes to it in iMovie?

When you make new edits to a movie that has previously been shared to your MobileMe account, iMovie alerts you that the project is out of date and needs to be rendered again. After you publish the movie again by clicking **Share** and **Republish to MobileMe Gallery**, the old version of the project is deleted and replaced with the new project.

How do I delete my video from the MobileMe Gallery?

You can delete your video from the MobileMe Gallery by choosing **Share** in the main iMovie menu and selecting **Remove from MobileMe Gallery**. The video is then deleted from the MobileMe Gallery.

Send Movies to iTunes for Download to an iPod

Before you can place your movie project onto your iPod or iPhone, you first need to send it to iTunes. When you share to iTunes, you can create one or several movies of various sizes. iMovie then optimizes the video for playback on targeted mobile devices. After sharing is complete, you can connect your iPod or iPhone to your computer and proceed to download the movies. Downloading your movies to an iPod is a great way to take your movies on the road and showcase them to others.

① Open an iMovie project that contains the video you want to download to your iPod.

Note: *You can also select the project in the Project browser.*

② Click **Share** in the main menu.

③ Click **iTunes**.

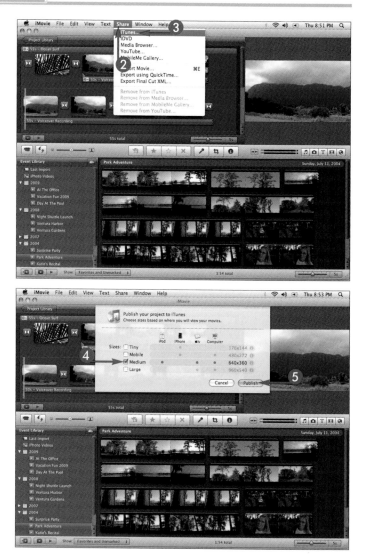

④ Select **Medium**.

Note: *You can select multiple sizes to accommodate more than one device.*

Note: *If the Large option is not available, the original project video is simply not large enough to accommodate that size.*

⑤ Click **Publish**.

iTunes launches after sharing is complete.

⑥ Click **Movies** to view the project.

Note: Now you can connect your iPod to the computer and download the movie.

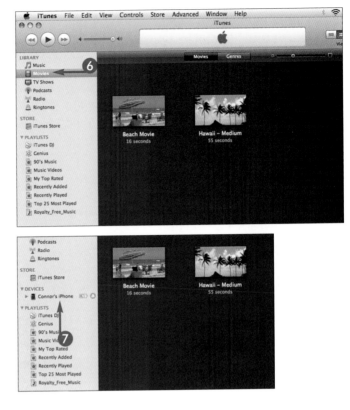

⑦ Mount your iPod or iPhone to iTunes by connecting it to the computer and download the file.

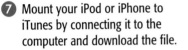

Will my movie be updated if I make changes to it in iMovie?
When you make new edits to a movie that has previously been shared to iTunes, the title bar in the Project Library alerts you that the project is out of date and needs to be rendered again. After you render the movie again, the old version of the project is deleted and replaced with the new project in iTunes.

Published to iTunes

You have modified your project. The published movie on iTunes is now out of date.

You will need to re-publish your project to iTunes when you are finished editing it.

Undo OK

Are there other ways to view my movies on my iPod touch or iPhone?
Yes. If you have a MobileMe account or a YouTube account, you can publish your movies to those sites and stream them over the Internet for viewing on an iPod touch or iPhone.

Share to Mobile Devices with Adobe Premiere Elements

You can optimize your projects in Adobe Premiere Elements for devices such as an iPod, iPhone, mobile phones, and more. Sharing to portable devices is another convenient way to take your movies on the road and share them with others.

Share to Mobile Devices with Adobe Premiere Elements

① Open the project you want to share to a mobile device.

② Click **Share**.

The Share options open.

③ Click **Mobile Phones and Players**.

Note: You can optimize video for YouTube or upload to your own Web site via FTP by choosing the **Online** option.

④ Choose the device to which you want to export.

Apple iPod and iPhone was chosen in this example.

⑤ Select a preset from the Presets menu.

6 Type a name for the exported file.

7 Click **Browse** and choose a location to save the file.

8 Click **OK**.

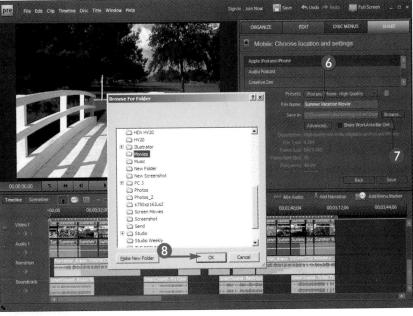

9 Click **Save**.

Adobe Premiere renders the project that can then be copied to the mobile device.

TIP

How do I access the export settings?
You can access the export settings by clicking **Advanced** in the Mobile settings. The Export Settings dialog box contains advanced settings for the current export such as video codecs, TV standard, frame rate, and pixel aspect ratio. Use the export settings to further customize your export to a mobile device.

Export Settings

Index

Index

Index

voiceover narration, 143, 214–215, 232–233
volume, 67, 73, 213. *See also* audio considerations

W

WDM device, 187
weather considerations, 55–57
Web, uploading video to, 40, 172–173, 278–285
webcam device, 187
whip zoom, 137
white balance, 102–109, 263
wide shot, 164
widescreen display, 12, 21, 37, 77

Windows-based personal computer (PC), 42–45. *See also* Adobe
 Premiere Elements
windy conditions and microphone, 69, 77

Y

YouTube publishing, 284–285

Z

zoom lever, 29
zoom speed, 136
zooming, 26, 123, 129, 136–137, 163

Want instruction in other topics?

Check out these

All designed for visual learners—just like you!

978-0-470-43638-7 978-0-470-50386-7 978-0-470-10150-6

For a complete listing of *Teach Yourself VISUALLY*™ titles and other Visual books, go to wiley.com/go/visual